ERIKA
KNIGHT

THE COLLECTION

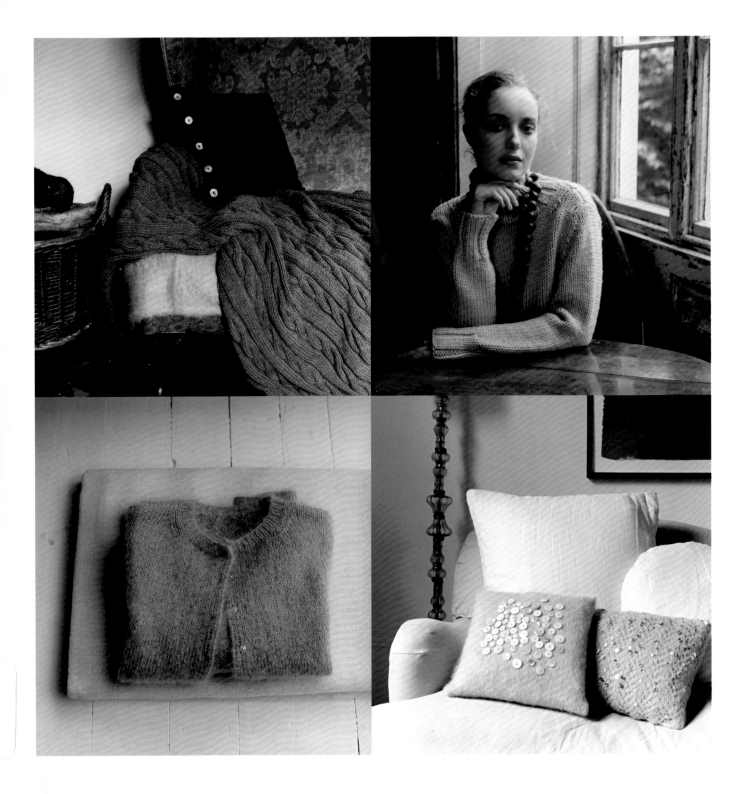

ERIKA KNIGHT

THE COLLECTION

50 timeless designs to knit and keep forever

Photography by Katya de Grunwald

quadrille

Publishing Director Sarah Lavelle
Commissioning Editor Lisa Pendreigh
Pattern Checkers Eva Yates and Sally Harding
Creative Director Helen Lewis
Designers Claire Peters and Emily Lapworth
Photographer Katya de Grunwald
Photographer's Assistant Amy Gwatkin
Stylist Beth Dadswell
Hair and Make-up Artist Anita Keeling
Models Amy Browne at Premier Model Management and
Laure Brosson at Select Model Management
Pattern Illustrator Anthony Duke
Production Director Vincent Smith
Production Controller Emily Noto

This edition first published in 2016 by
Quadrille Publishing Limited
Pentagon House
52–54 Southwark Street
London SE1 1UN
www.quadrille.co.uk

Quadrille is an imprint of Hardie Grant
www.hardiegrant.com.au

Text and project designs
 © 2006 Erika Knight
Photography
 © 2006 Katya de Grunwald
Design and layout
 © 2016 Quadrille Publishing Limited

British Library Cataloguing-in-Publication
Data: a catalogue record for this book is
available from the British Library.

ISBN 978-184949-773-2

Printed and bound in China

introduction

Erika Knight: The Collection is an edited portfolio of some of my own favourite pieces to knit; either to wear or to make for the home.

My persona when designing knitwear very much reflects my personality, with two distinct and often juxtaposed styles – either pared down and very simple or opulent and over embellished.

In this book you will find classic knits, designed in some of my favourite natural

fibres, including wool, cotton and hemp, and using basic stitches, along with more decorative pieces designed with an easy glamour in mind for both everyday interiors and evening wear.

The fifty projects that make up Erika Knight: The Collection are my signature pieces, written with simple instructions that form basic recipes to inspire you to create your own style, both for yourself and for your home.

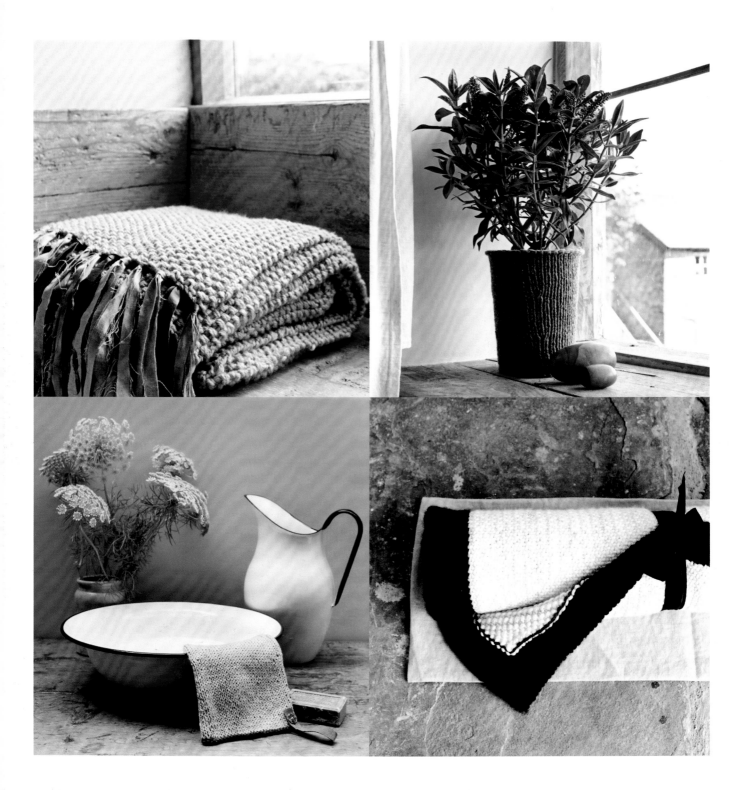

classic
at home

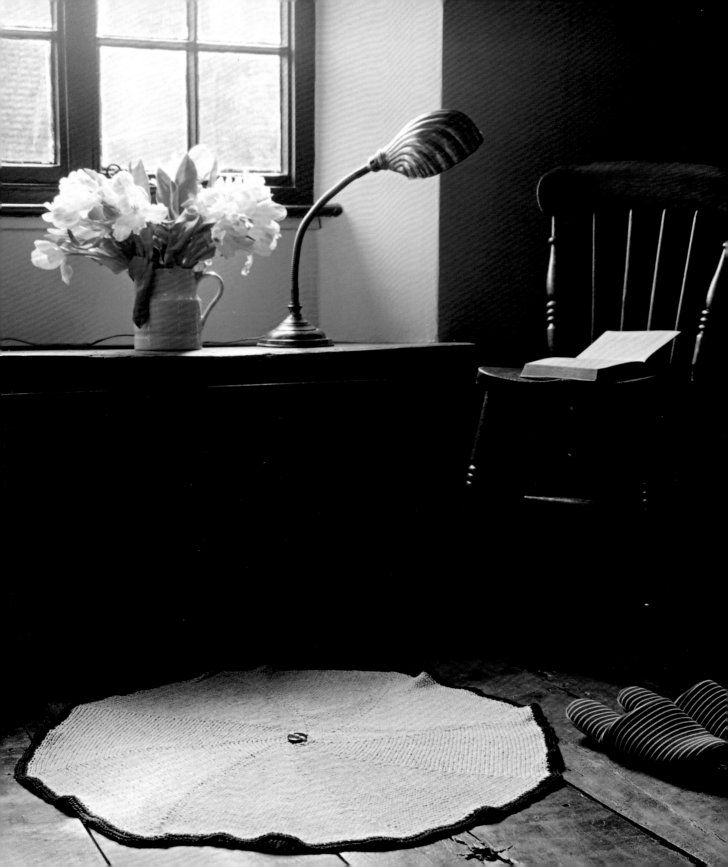

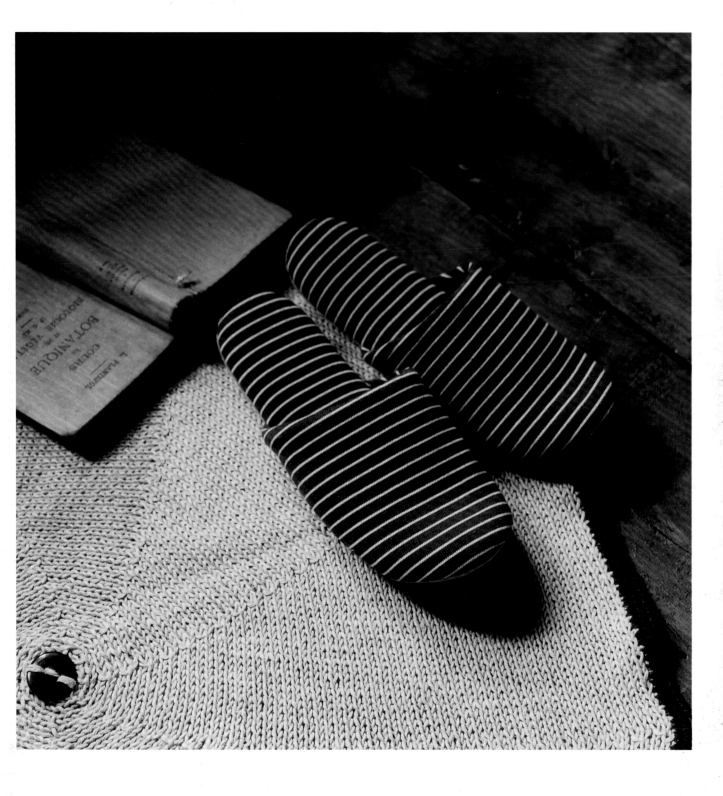

round rug

materials
Any double-knitting-weight hemp or linen-mix yarn, such as
 Lanaknits *Allhemp6* or Rowan *Creative Linen*
 A: 5 x 100g (3½oz) skeins of *Allhemp6* or 4 x 100g (3½oz) skeins of
 Creative Linen in main colour
 B: 1 x 100g (3½oz) skein in contrasting colour, for border
Pair of 4.5mm (US size 7) knitting needles
4mm (US size G–6) crochet hook
One large 30mm (1¼in) button

size
One size, approximately 75cm (29½in) in diameter

tension (gauge)
17 sts and 21 rows to 10cm (4in) over st st using A and 4.5mm (US size 7)
 needles or size necessary to obtain tension (US gauge).

pattern note
• For the short-row shaping, when the instructions say 'turn' at the end
 the row, this means that the remaining stitches are not worked. To avoid
 creating a hole when turning on a knit row, work a wrap stitch – knit as
 far as instructed, then slip the next stitch purlwise onto the right-hand
 needle, bring the yarn forward between the two needles, slip the stitch
 back to the left-hand needle and take the yarn to the back between the
 two needles, turn and purl to the end of the next row.

To make rug

Using 4.5mm (US size 7) needles and A, cast on 60 sts.

Work in st st and short rows as foll:

Row 1: K all sts.

Row 2: P all sts.

Row 3: K to last 2 sts, turn (see Pattern Note, page 12).

Row 4: P.

Row 5: K to last 4 sts, turn.

Row 6: P.

Cont working in short rows as set, leaving 2 more sts unworked on every knit row until there are no more sts to knit.

This completes first segment of circle.

Start again with row 1 and cont until 8 segments have been worked. Do not cast off (US bind off) sts, but join last segment to first segment by grafting one st from needle with corresponding st on cast-on edge.

To finish

Weave in any loose yarn ends.

Edging

Using 4mm (US size G–6) crochet hook and B, work 2 rows of double crochet (US single crochet) around outer edge of rug.

Lay work out flat and gently steam. Sew on button over hole in centre of rug.

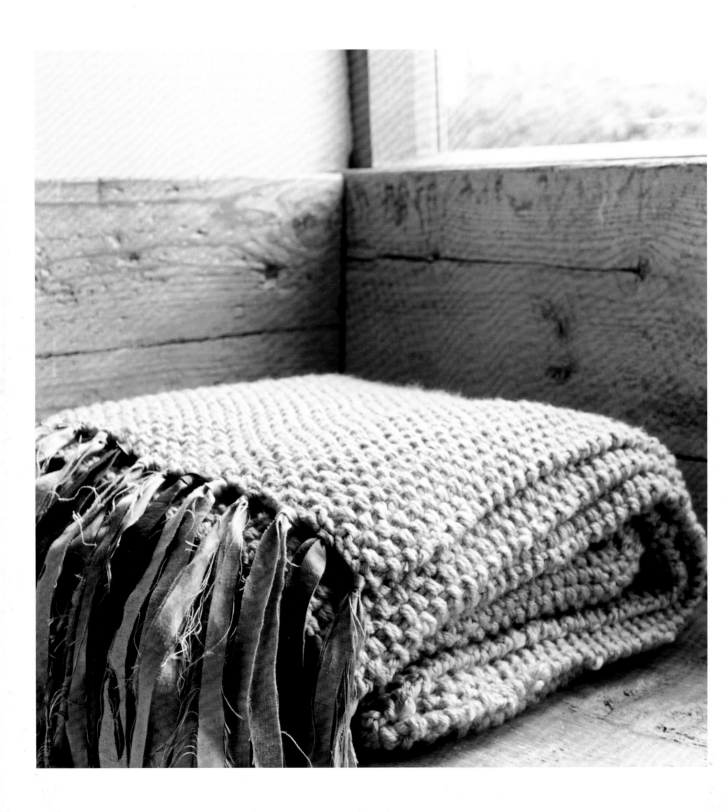

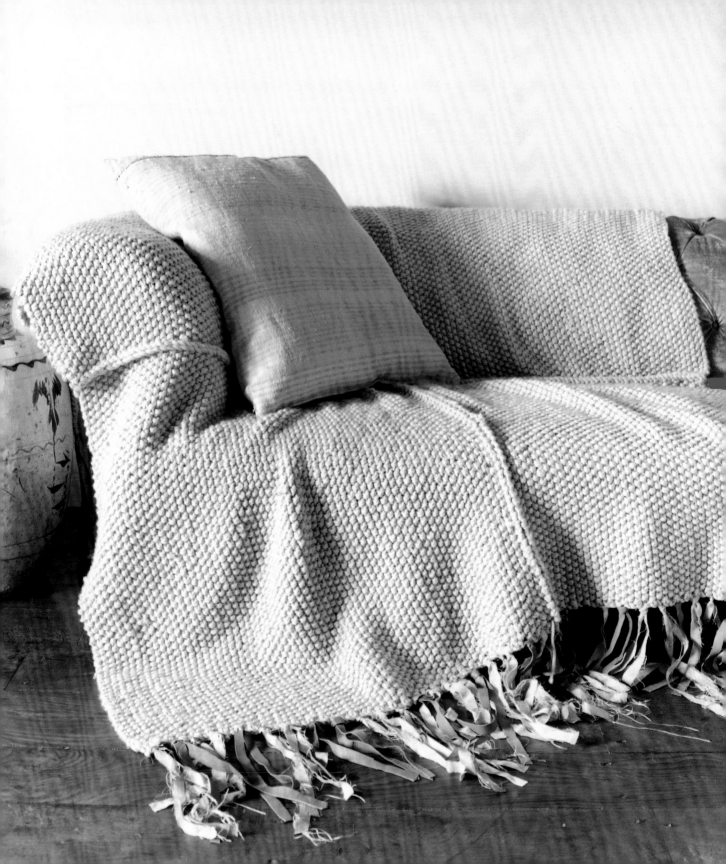

texture throw

materials

Any super-chunk/bulky-weight wool yarn, such as Erika Knight for
 John Lewis *Super Chunky* or Erika Knight *Maxi Wool* (yarn used double)
 Approximately 43 x 100g (3½oz) balls of *Super Chunky* or
 41 x 100g (3½oz) skeins of *Maxi Wool*
Pair of 9mm (US size 13) knitting needles
Scraps of suede, silk and linen fabric to trim,
 approximately 50cm (½yd) of each
Crochet hook (any size)

size

One size, approximately 152cm x 152cm (60in x 60in)
Each square measures approximately 76cm x 76cm (30in x 30in)

tension (gauge)

9½ sts and 16 rows to 10cm (4in) over moss stitch (US seed stitch)
 using yarn doubled and 9mm (US size 13) needles or size necessary
 to obtain tension (US gauge).

To make throw panels (make 4)

Using 9mm (US size 13) needles
and two strands of yarn held
together throughout, cast on 69 sts.
Row 1: K1, *p1, k1; rep from *
to end.
Rep last row to form moss st
(US seed st) and cont until work
measures 76cm (30in).
Cast off (US bind off).

To finish

Weave in any loose yarn ends.
Lay work out flat and gently steam.
Lay four panels out flat and arrange
to form a large square, with cast-
on edges along top and bottom
of throw. With WS together, sew
panels together using backstitch to
create a raised seam on RS.

Fringe

For fringe, cut strips of fabric
approximately 33cm (13in) long and
1.5cm (½in) wide.
Fold one strip in half, and using a
crochet hook, pull loop through a
stitch at top edge of throw, pull strip
ends through loop, and tighten to
form a knot.
Add fringe all along top and bottom
edge in same way, spacing knots
equally apart as shown.

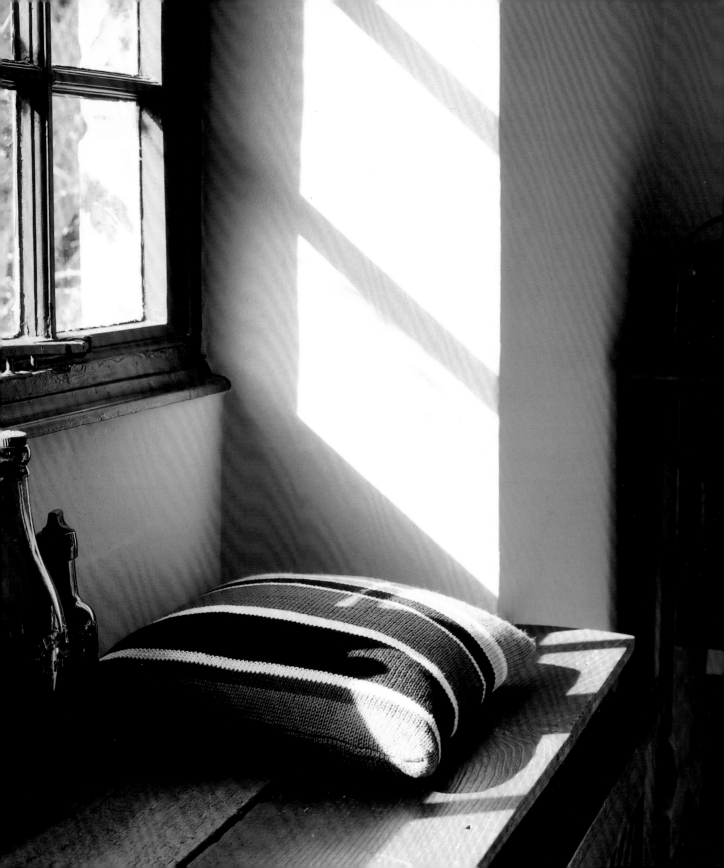

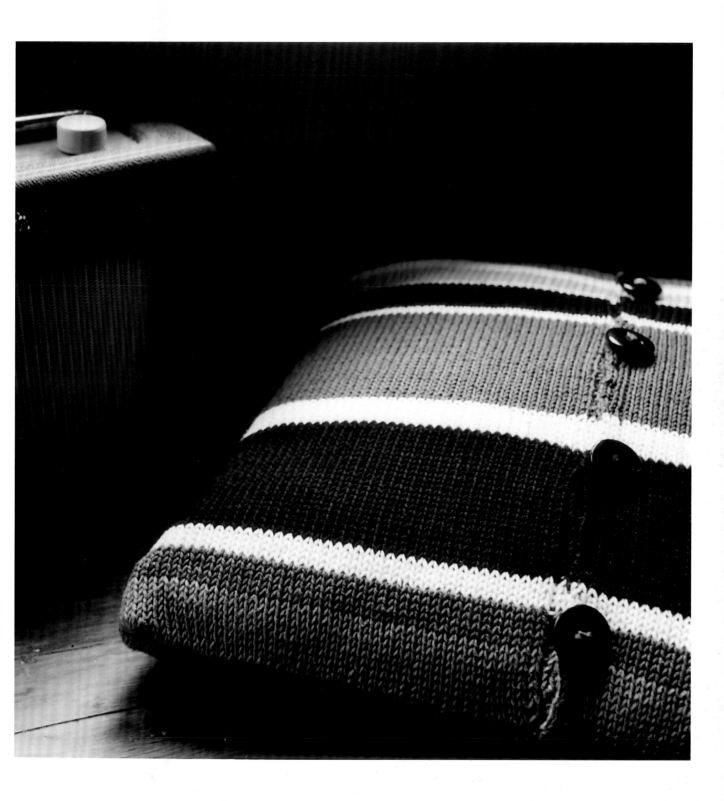

stripe cushion

materials

Any fine-weight mercerized cotton yarn, such as Rowan *Cotton Glacé*

A: 2 x 50g (1¾oz) balls in ochre
B: 2 x 50g (1¾oz) balls in grey
C: 1 x 50g (1¾oz) ball in ecru
D: 2 x 50g (1¾oz) balls in black
E: 1 x 50g (1¾oz) ball in lime

Pair of 3.25mm (US size 3) knitting needles
Five medium 25mm (1in) buttons and 5 large press studs (US snaps)
40cm x 40cm (16in x 16in) feather-filled cushion pad (US pillow form)

size

One size, approximately 40cm x 40cm (16in x 16in)

tension (gauge)

23 sts and 32 rows to 10cm (4in) over st st using 3.25mm (US size 3)
needles or size necessary to obtain tension (US gauge).

stripe colour sequence

2 rows B
2 rows C
26 rows A
4 rows C
7 rows E
1 row C
10 rows D
2 rows C
27 rows B
6 rows C
23 rows D
4 rows C
5 rows B
11 rows A

To make cushion (US pillow)
Using 3.25mm (US size 3) needles
and B, cast on 190 sts.
Work the front and back of the
cover in one piece as follows:
Row 1 (RS): [P1, k1] twice, p1,
k to last 5 sts, [p1, k1] twice, p1.
Row 2: [K1, p1] twice, k1, p to last
5 sts, [k1, p1] twice, k1.
Rep last 2 rows using stripe colour
sequence above, noting that 2 rows
B have already been worked.
Cast off (US bind off) in patt.

To finish
Weave in any loose yarn ends.
Lay work out flat and gently steam.
Lay work WS up, then fold side
edges into centre, overlapping by
about 2.5cm (1in) so that cover
forms a 40cm (16in) square.
Using mattress stitch, sew top seam
of cover, including overlap in seam.
Sew bottom seam in same way.
Sew press studs (US snaps) in
position, starting at centre and
working outward, placing two at
each side of centre spaced equally
apart.
Sew buttons on top of press studs
(US snaps) for decoration.
Insert cushion pad (US pillow
form).

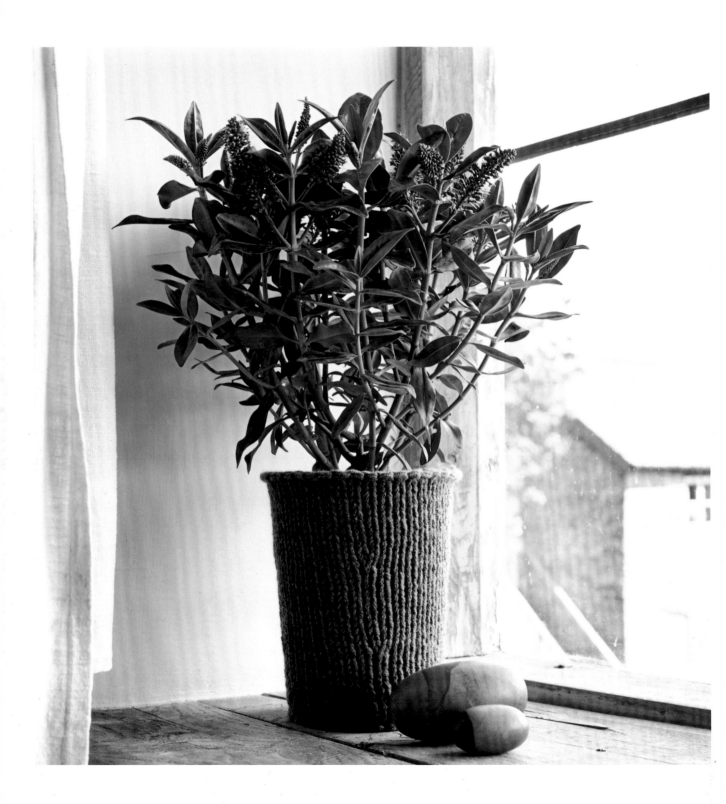

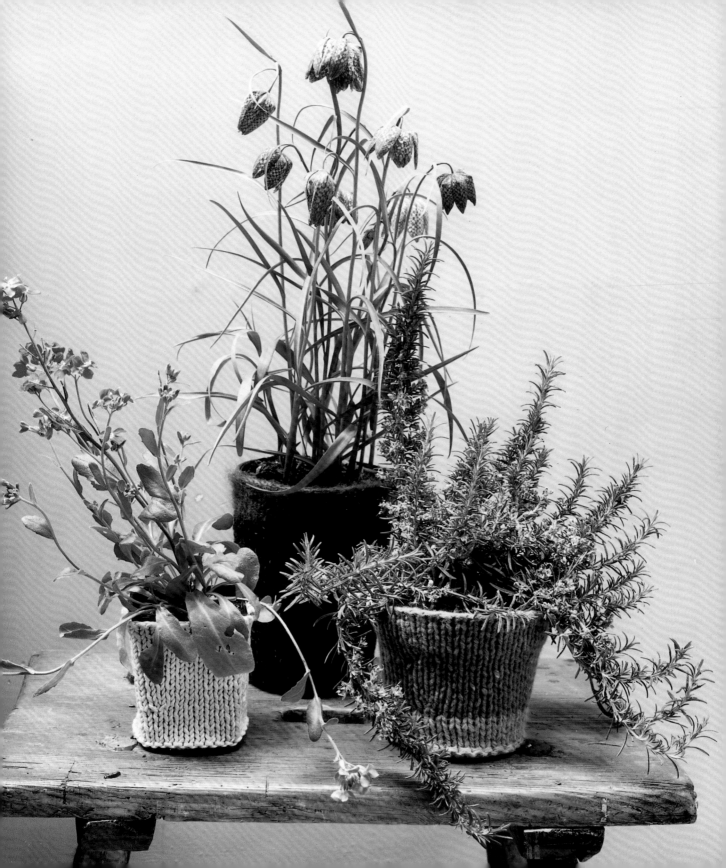

plant pot covers

materials

small string pot
Medium-weight parcel string
 1 x 40m (44yd) ball
Pair of 4mm (US size 6) knitting needles

small one-colour pot
Any chunky/bulky-weight wool yarn, such as Erika Knight for
 John Lewis *Chunky* or Debbie Bliss *Rialto Chunky*
 1 x 100g (3½oz) ball of *Chunky* or 1 x 50g (1¾oz) ball of *Rialto Chunky*
Pair of 6mm (US size 10) knitting needles

small two-colour pot
Any chunky/bulky-weight wool yarn, such as Erika Knight for
 John Lewis *Chunky* or Debbie Bliss *Rialto Chunky*
 1 x 100g (3½oz) ball of *Chunky* or 1 x 50g (1¾oz) ball of *Rialto Chunky*
 in each of two contrasting colours
Pair of 6mm (US size 10) knitting needles

large two-colour pot
Any aran-weight hemp or wool yarn, such as Rowan *Hemp Tweed* or
 Rowan *Felted Tweed Aran*
 2 x 50g (1¾oz) balls
Any fine-weight mohair yarn, such as Rowan *Kidsilk Haze*
 1 x 25g (⅞oz) ball (yarn used three strands together)
Pair of 5mm (US size 8) knitting needles

large one-colour pot
Any chunky/bulky-weight wool yarn, such as Erika Knight for
 John Lewis *Chunky* or Debbie Bliss *Rialto Chunky*
 2 x 100g (3½oz) balls of *Chunky* or 3 x 50g (1¾woz) balls of *Rialto*
 Chunky (yarn used double)
Pair of 7mm (US size 10½) knitting needles

sizes

Small – approximately 11cm (4¼in) in diameter and 10–12cm
(4–4¾in) tall

Large* – approximately 14cm (5½in) in diameter and 19cm
(7½in) tall

*For large pots, work figures in parentheses ().

pattern notes

- Experiment with various yarn textures. This pattern will work with
 any yarn using the needle size on the yarn label. Knit a tension (US
 gauge) swatch when using two, three or more strands held together
 to create a thicker yarn to determine the correct needle size.
- For the small two-colour pot, change to the second colour after last
 decrease row before base.
- For the large two-colour pot, cast on loosely using three strands
 of fine mohair yarn held together. Work the first six rows of the
 pattern in stocking stitch (US stockinette stitch), change to the aran-
 weight yarn and continue following the pattern.

To make plant pot covers

Using desired needles and yarn, cast
on 44 sts loosely.

Beg with a k row, work 8 (14) rows
in st st, ending with RS facing for
next row.

Next row (RS): K4, [k2tog, k9]
3 times, k2tog, k5. *40 sts.*

Cont in st st throughout, work
without shaping for 7 (13) rows,
ending with RS facing for next row.

Next row (RS): K4, [k2tog, k8]
3 times, k2tog, k4. *36 sts.*

Work without shaping for 6 (12)
rows, ending with WS facing for
next row.

K next row (a WS row) to make
ridge on RS for base.

Beg with a k row, work 4 rows in
st st, ending with RS facing for
next row.

Shape base

Row 1 (RS): [K2, k2tog] 9 times.
27 sts.

**Row 2 and every alternate
row:** P.

Row 3: [K1, k2tog] 7 times. *18 sts.*

Row 5: [K2tog] 9 times. *9 sts.*

Leave sts on needle.

To finish

Cut working yarn, leaving a long
end, and thread yarn end through
remaining 9 sts.

Gather sts very tightly, then sew
base seam and side seam of cover
using mattress stitch.

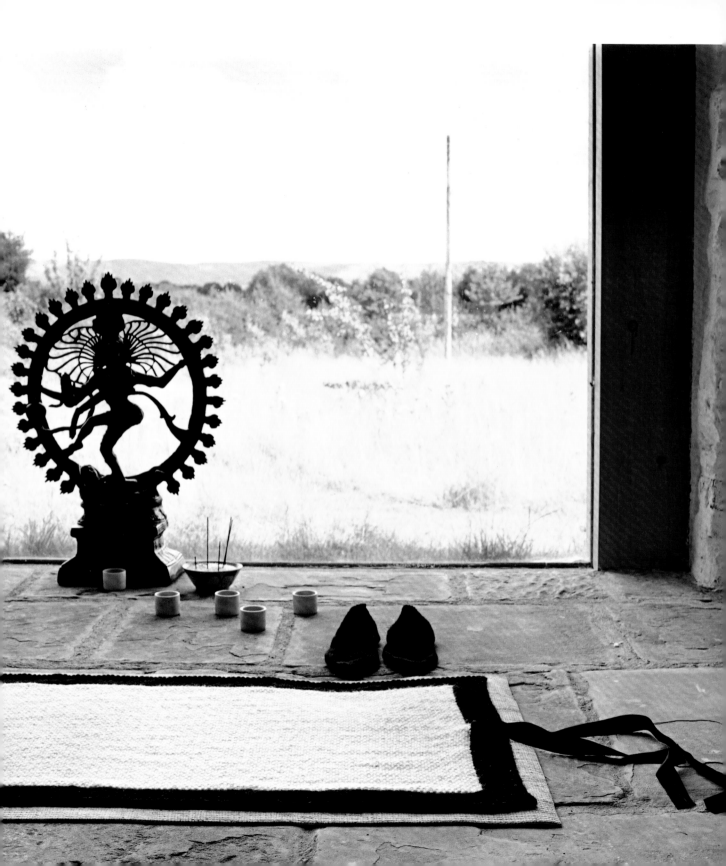

yoga mat

materials

yoga mat
Any super-chunky/bulky-weight wool yarn, such as Erika Knight for
 John Lewis *Super Chunky* or Erika Knight *Maxi Wool*
 A: 10 x 100g (3½oz) balls in ecru
 B: 4 x 100g (3½oz) balls in black
Pair of 8mm (US size 11) knitting needles
Approximately 1m (1yd) of black cotton tape, 2.5cm (1in) wide

linen bag
Approximately 1m (1yd) of stone linen fabric, 54cm (22in) wide
Sewing thread
Approximately 1.5m (1½yds) of black cotton tape, 2.5cm (1in) wide

size

Yoga mat: One size, approximately 175cm x 60cm (69in x 23¾in)
Linen bag: One size, approximately 72cm x 25cm (28½in x 10in)

tension (gauge)

15 sts and 24 rows to 10cm (4in) over stitch pattern using 8mm
 (US size 11) needles or size necessary to obtain tension (US gauge).

pattern note

- When changing from one yarn colour to another in a row, twist
 the yarns together on the wrong side to avoid making a hole.
- This knitted mat is meant to be used with your existing floor
 mat underneath it for full cushioning.

tweed stitch

Row 1 (RS): K1, *yarn to front of work between two needles, sl 1 purlwise, yarn to back of work between two needles, k1; rep from * to end.

Row 2: P2, *yarn to back of work between two needles, sl 1 purlwise, yarn to front of work between two needles, p1; rep from * to last st, p1.

Rep last 2 rows to form tweed st.

To make yoga mat

Using 8mm (US size 11) needles and B, cast on 89 sts.

Work 5cm (2in) in tweed st, ending with RS facing for next row.

Next row (RS): Work first 8 sts in tweed st using B, join in A and k next 73 sts, then join in a second ball of B and work last 8 sts in tweed st.

Next row: Work first 8 sts in tweed st using B, next 73 sts in tweed st using A, then last 8 sts in tweed st using B.

Rep last 2 rows (working all sts in tweed st and keeping black borders and ecru centre) until work measures 170cm (67in), ending with RS facing for next row.

Cut off A and cont with B only as foll:

Next row (RS): Work 8 sts in tweed st, k next 73 sts, work last 8 sts in tweed st.

Cont in tweed st for 5cm (2in) more.

Cast off (US bind off).

To finish

Weave in any loose yarn ends on WS. Lay work out flat and gently steam.

Fold cotton tape widthwise so that one end is slightly longer than the other and sew at the fold to centre of one short edge of mat.

Roll up mat and tie tape ends together.

To make linen bag

Cut a piece of linen 53cm x 78.5cm (21¼in x 31¼in).

Along top edge of bag (one of shorter edges), fold and press first 1cm (½in) then 4cm (1½in) to wrong side and stitch in place close to the first fold.

With wrong sides together, fold fabric in half lengthwise, and taking a 6mm (¼in) seam, stitch down side edge and along bottom edge.

Turn inside out. Making sure raw edges are inside seam and taking a 1cm (⅜in) seam, stitch side and bottom seams again to form a French seam.

Turn right-side out.

Fold remaining cotton tape in half widthwise and stitch fold to outside of bag 8cm (3½in) below top edge.

Insert mat, gather top of bag with cotton tape and tie in a simple bow.

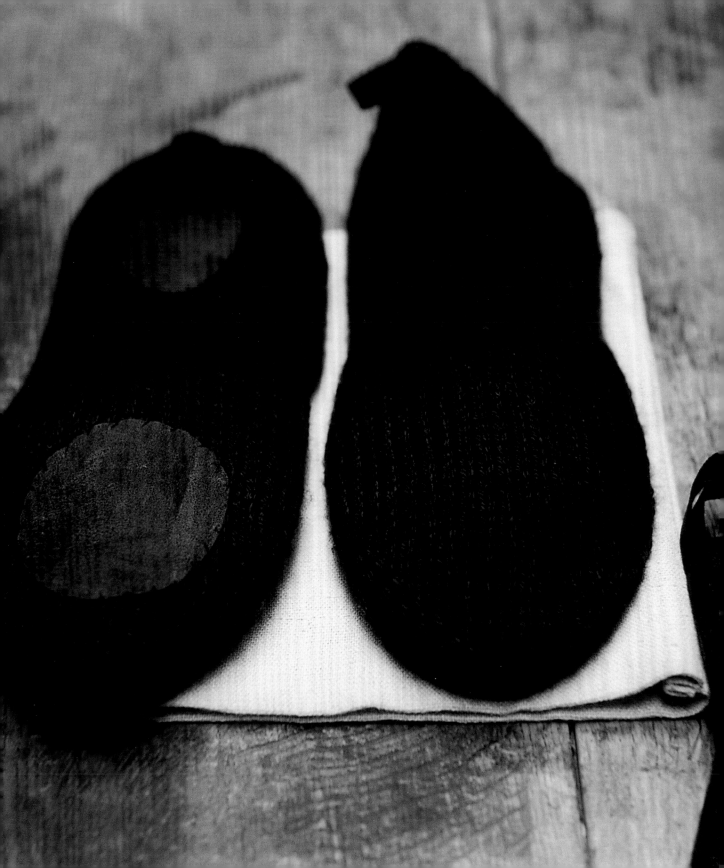

yoga slippers

materials

Any aran-weight wool yarn, such as Erika Knight *Vintage Wool*,
 Rowan *Super Fine Merino Aran* or Erika Knight for John Lewis *Aran*
 2 x 50g (1¾oz) balls of *Vintage Wool or Super Fine Merino Aran* or
 1 x 100g (3½oz) ball of *Aran*
Pair each of 4mm (US size 6) and 4.5mm (US size 7) knitting needles
Scrap of soft suede for soles and pull-on tabs, approximately
 15cm x 15cm (6in x 6in)
Sewing thread and sewing needle for sewing on suede

size

One size, to fit UK sizes 5–6 shoe (US sizes 6½–7½ shoe),
 approximately 23cm (9in) long

tension (gauge)

20 sts and 28 rows to 10cm (4in) over st st using 4.5mm (US size 7)
 needles or size necessary to obtain tension (US gauge).

To make left sole

Using 4.5mm (US size 7) needles, cast on 5 sts and k 1 row.

Beg with a p row and cont in st st throughout, start shaping sole as foll:

Cast on 2 sts at beg of next 4 rows. *13 sts.*

Work without shaping until work measures 10cm (4in) from cast-on edge, ending with RS facing for next row.

Inc row (RS): K2, m1, k to end.

Next row: P.

Rep last 2 rows until there are 17 sts.

Work without shaping until work measures 19.5cm (7¾in) from cast-on edge, ending with RS facing for next row.

Dec row (RS): K2, k2tog, k to last 4 sts, k2tog tbl, k2.

Next row: P.

Rep last 2 rows until 7 sts remain.

Cast off (US bind off).

To make right sole

Work as for left sole, but work increase row as foll:

Inc row (RS): K to last 2 sts, m1, k2.

To make uppers (make 2)

Using 4.5mm (US size 7) needles, cast on 9 sts.

Row 1: K3, m1, k to last 3 sts, m1, k3.

Row 2: P.

Rep last 2 rows until there are 27 sts.

Work without shaping until work measures 11cm (4¼in) from cast-on edge, ending with RS facing for next row.

Next row (RS): K13, cast off (US bind off) next st, k to end.

Next row: P first 13 sts, then turn, leaving remaining sts on a st holder.

Work each side separately as foll:

Next row: K3, k2tog, k to end.

Next row: P.

Rep last 2 rows once more. *11 sts.*

Work without shaping until work measures 19cm (7½in) from cast-on edge, ending with RS facing for next row.

Next row (RS): K3, m1, k to end.

Work without shaping for 5 rows.

Rep last 6 rows twice more. *14 sts.*

Cast off (US bind off).

With WS of work facing, rejoin yarn to remaining 13 sts and p to end.

Next row: K to last 5 sts, k2tog tbl, k3.

Next row: P.

Rep last 2 rows once more. *11 sts.*

Work without shaping until work measures 19cm (7½in) from cast-on edge, ending with RS facing for next row.

Next row (RS): K to last 3 sts, m1, k3.

Work without shaping for 5 rows.

Rep last 6 rows twice more. *14 sts.*

Cast off (US bind off).

To finish

Weave in any loose yarn ends.

Lay work out flat and gently steam.

Edging on uppers

With RS of work facing and using 4mm (US size 6) needles, pick up and knit 83 sts evenly around inside edge of upper.

Cast off (US bind off) knitwise.

With WS together, sew cast-off (bound-off) ends of each sole together to form an outside seam at heel.

With WS together, pin sole to upper, easing to fit, and sew together using mattress stitch.

Oval soles

Cut out two ovals from suede for sole of each slipper – one large and one small. Using sewing thread, sew large oval to ball of sole as shown, working small stitches all around. Sew small oval to heel end of slipper in same way.

Pull-on tabs

Cut two strips of suede about 1cm (⅜in) wide and 8cm (3¼in) long. Fold each strip in half widthwise, pin to inside back seam at heel and sew in place with a few firm hand stitches.

If desired, make a linen bag to fit your slippers as for bag on page 29.

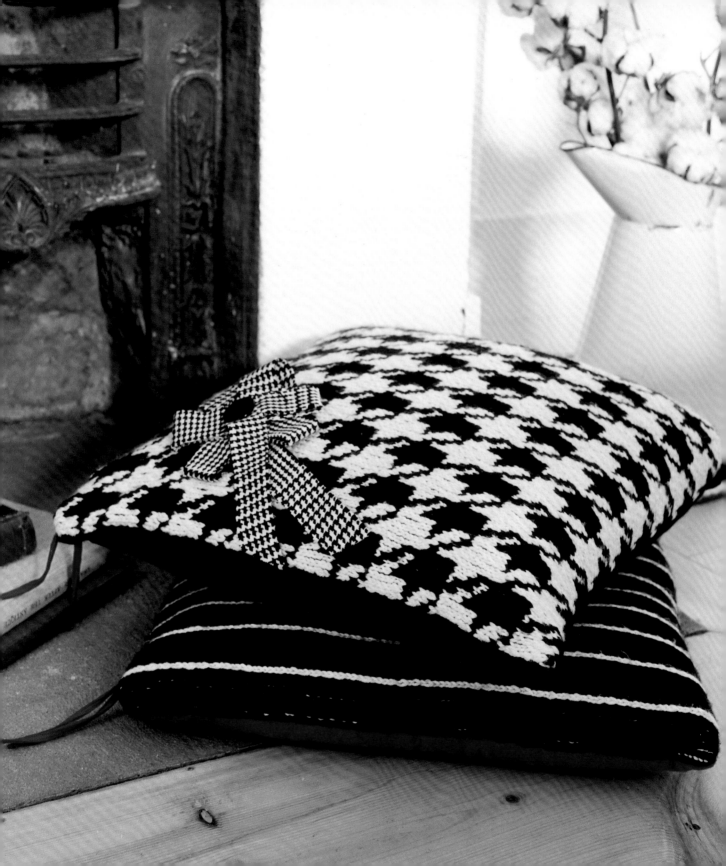

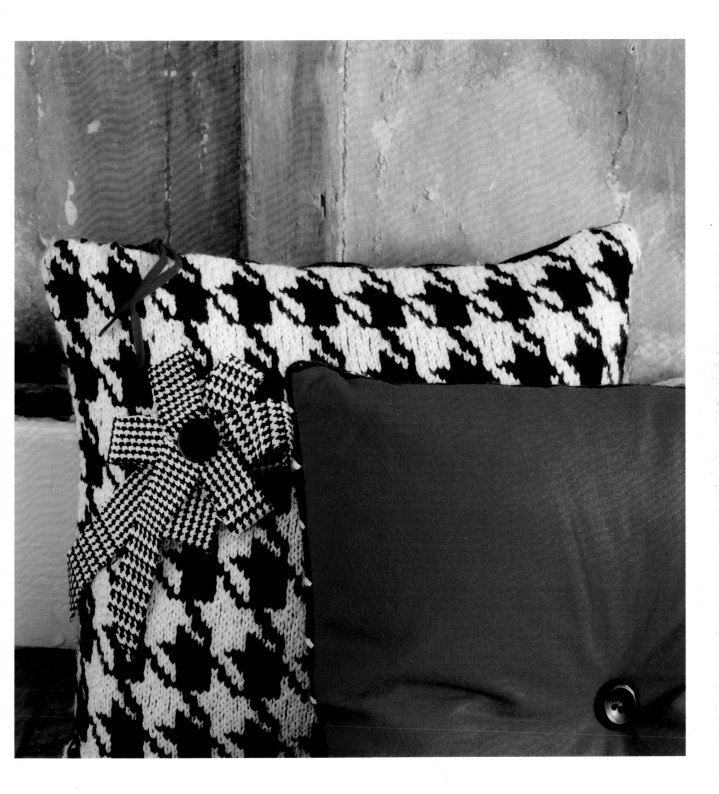

classic cushions

materials

houndstooth cushion

Any double-knitting-weight wool yarn, such as Erika Knight for John
 Lewis *Double Knit*, Rowan *Super Fine Merino DK* or Erika Knight
 British Blue Wool
 A: black – 2 x 50g (1¾oz) balls of *Double Knit* or *Super Fine Merino DK*
 or 4 x 25g (⅞oz) balls of *British Blue Wool*
 B: ecru – 2 x 50g (1¾oz) balls of *Double Knit* or *Super Fine Merino DK*
 or 4 x 25g (⅞oz) balls of *British Blue Wool*
Pair of 4mm (US size 6) knitting needles
45cm x 45cm (18in x 18in) feather-filled cushion pad (US pillow form)
50cm x 50cm (20in x 20in) of black felt, for back of cover and zipper
 puller
40cm (16in) chunky black zipper and sewing thread

for the corsage

Piece of tweed fabric to make a strip 2.5cm x 150cm (1in x 59in)
One medium-size button
Safety pin

striped cushion

Any double-knitting-weight wool yarn, such as Erika Knight for John
 Lewis *Double Knit*, Rowan *Super Fine Merino DK* or Erika Knight
 British Blue Wool
 A: black – 3 x 50g (1¾oz) balls of *Double Knit* or *Super Fine Merino DK*
 or 6 x 25g (⅞oz) balls of *British Blue Wool*
 B: ecru – 1 x 50g (1¾oz) ball of *Double Knit* or *Super Fine Merino DK*
 or 2 x 25g (⅞oz) balls of *British Blue Wool*
Pair of 4mm (US size 6) needles
45cm x 45cm (18in x 18in) feather-filled cushion pad (US pillow form)
50cm x 50cm (20in x 20in) of red felt, for backing and zipper puller
40cm (16in) chunky black zipper and sewing thread
Two large buttons

size

One size, approximately 45cm x 45cm (18in x 18in)

tension (gauge)

22 sts and 25 rows to 10cm (4in) over colourwork pattern using 4mm (US size 6) needles or size necessary to obtain tension (US gauge).

pattern notes

- The houndstooth pattern is given as both row-by-row instructions and in chart form.
- Work the houndstooth and stripe patterns using the Fair Isle technique, stranding the yarn not in use loosely across the back of the work. Do not carry the yarn over more than three stitches at a time, but weave it under and over the colour being worked.

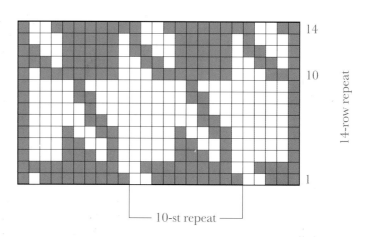

14

10

14-row repeat

1

— 10-st repeat —

A black

B ecru

houndstooth cushion

To make cover front

Using 4mm (US size 6) needles and A, cast on 105 sts.
P 1 row.
Beg with a k row, work in st st and houndstooth patt as foll:
Row 1 (RS): K3 A, k2 B, *k8 A, k2 B; rep from * to last 10 sts, k8 A, k1 B, k1 A.
Row 2: P1 A, *p8 A, p2 B; rep from * to last 4 sts, p4 A.
Row 3: K1 A, *k5 B, k1 A, k1 B, k3 A; rep from * to last 4 sts, k3 B, k1 A.
Row 4: P1 A, p3 B, *p2 A, p2 B, p1 A, p5 B; rep from * to last st, p1 A.
Row 5: K1 A, *k5 B, k2 A, k2 B, k1 A; rep from * to last 4 sts, k3 B, k1 A.
Row 6: P1 A, p5 B, *p2 A, p8 B; rep from * to last 9 sts, p2 A, p6 B, p1 A.
Row 7: K1 A, k7 B, *k1 A, k9 B; rep from * to last 7 sts, k1 A, k5 B, k1 A.
Row 8: P1 A, p4 B, *p2 A, p8 B; rep from * to last 10 sts, p2 A, p7 B, p1 A.
Row 9: K1 A, k8 B, k1 A, *k9 B, k1 A; rep from * to last 5 sts, k4 B, k1 A.
Row 10: P1 A, p1 B, *p7 A, p3 B; rep from * to last 3 sts, p3 A.
Row 11: K1 A, *k1 B, k2 A, k2 B, k5 A; rep from * to last 4 sts, k1 B, k3 A. **Row 12:** *P2 A, p2 B, p5 A, p1 B; rep from * to last 5 sts, p2 A, p2 B, p1 A.
Row 13: K1 A, *k3 B, k1 A, k1 B, k5 A; rep from * to last 4 sts, k3 B, k1 A.
Row 14: P1 A, *p2 B, p8 A; rep from * to last 4 sts, p2 B, p2 A.
Rep last 14 rows until work measures 45cm (18in), ending with WS facing for next row.
Cut off B.
P 1 row in A.
Cast off (US bind off).

To make corsage

Cut a strip of fabric approximately 150cm (59in) long and 2.5cm (1in) wide (if necessary, piece strip by stitching flat overlapping seam). Leaving a tail approximately 20cm (8in) long, make a rosette or star shape by folding strip out and back onto itself into centre, holding it in place with your thumb, until six looped 'points' have been folded. Secure loops at centre with a stitch, and leave another tail approximately 20cm (8in) long at back.
Sew a button to centre front of corsage and sew a safety pin to back.

striped cushion

To make cover front

Using 4mm (US size 6) needles and A, cast on 105 sts. P 1 row.
Beg with a k row, work in st st and stripe patt as foll:
Row 1 (RS): K8 A, k1 B, *k7 A, k1 B; rep from * to last 8 sts, k8 A.
Row 2: P8 A, p1 B, *p7 A, p1 B; rep from * to last 8 sts, p8 A.
Rep last 2 rows until work measures 45cm (18in), ending with WS facing for next row. Cut off B.
P 1 row in A.
Cast off (US bind off).

To finish both covers

Weave in any loose yarn ends.
Lay work out flat and gently steam.
Cut out a piece of felt 48cm x 48cm (19in x19in) for back of cover.
Sew zipper in place along top of cover, taking a 1.5cm (½in) seam on felt and stitching close to edge of knitting; then sew other three seams.
Cut a felt strip 1.5cm x 23cm (½in x 9in), fold in half lengthwise, and stitch along each long edge, close to fold and raw edges. Trim close to stitching, and loop onto zipper puller. Pin corsage to houndstooth version as shown. Place one large button at centre of each side of striped version and stitch together through cushion (US pillow).

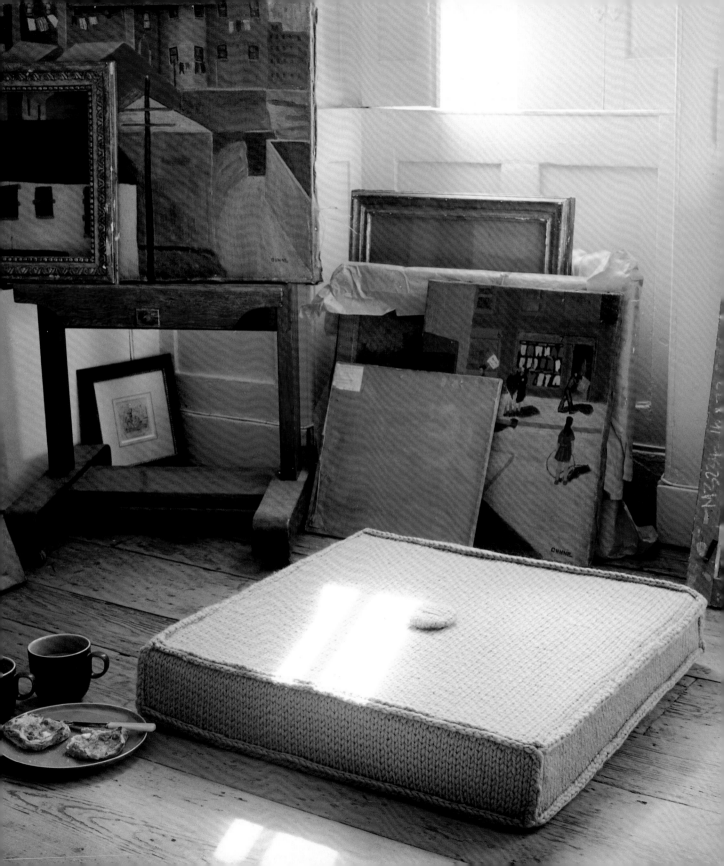

floor cushion

materials

Any super-chunky/bulky-weight wool yarn, such as Erika Knight
 Maxi Wool
 7 x 100g (3½oz) balls
Pair each of 10mm (US size 15) and 8mm (US size 11) knitting needles
Satin-like lining fabric, approximately 154cm x 91cm
 (60in x 36in)
Firm foam cushion block, 61cm x 61cm x 10cm (24in x 24in x 4in)

size

One size, approximately 61cm x 61cm x 10cm (24in x 24in x 4in)

tension (gauge)

10 sts and 13 rows to 10cm (4in) measured over st st using 10mm
 (US size 15) needles or size necessary to obtain tension (US gauge).

To make square panel (make 2)
Using 10mm (US size 15) needles,
cast on 63 sts.
Beg with a k row, work in st st until
work measures 61cm (24in).
Cast off (US bind off).
Work another piece in same way.

To make side panel (make 4)
Using 10mm (US size 15) needles,
cast on 63 sts.
Beg with a k row, work in st st until
work measures 10cm (4in).
Cast off (US bind off).
Work three more pieces in same way.

To make knitted button
Using 8mm (US size 11) needles,
cast on 8 sts.
Beg with a k row, work in st st, inc
1 st at each end of 3rd row and
then at each end of every alt row
until there are 14 sts.
Cont in st st throughout, dec 1 st at
each end of every alt row until there
are 8 sts, ending with WS facing for
next row.
P 1 row.
Cast off (US bind off), leaving a
long end of yarn. Using a blunt-
tipped yarn needle and the long
end of yarn, work a running stitch
all around edge of knitting, pull up
tightly and secure.

To finish
Weave in any loose yarn ends.
Lay work out flat and gently steam.
Sew top and bottom square panels
to side panels with seams on
outside, leaving a large enough
opening at one side and at top to
insert foam.
Cover foam pad with lining fabric.
Insert covered pad into knitted
cover and sew opening closed.
Sew knitted button to centre of top
of cushion with two simple stitches.

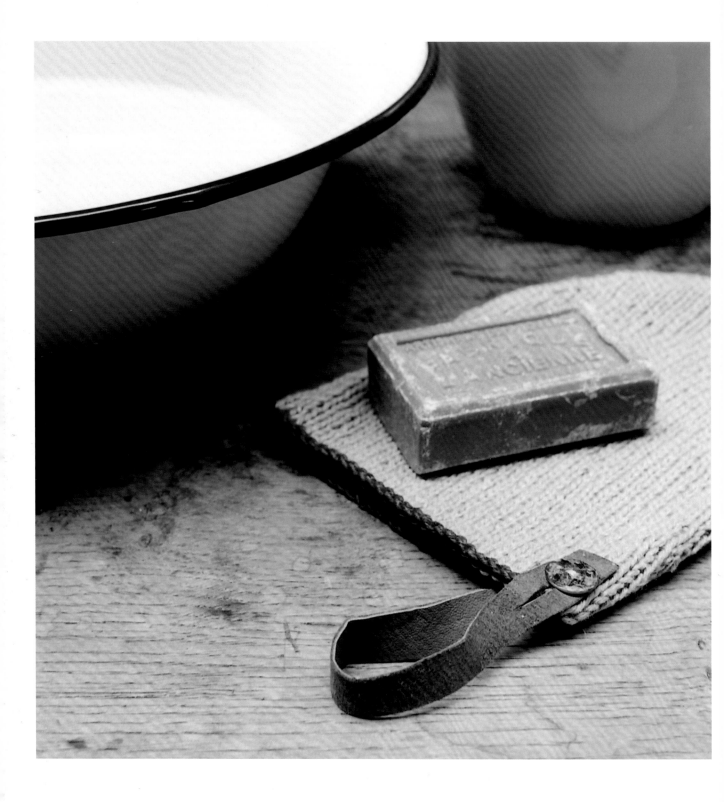

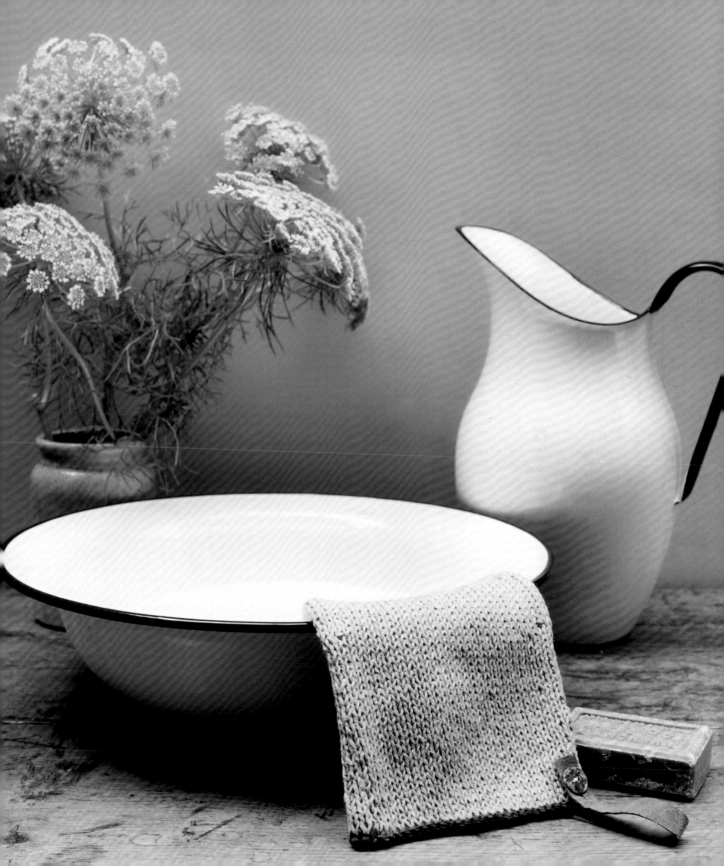

wash mitt

materials

Any double-knitting-weight hemp or linen-cotton yarn, such as
Lanaknits *Allhemp6* or Rowan *Creative Linen*
A: 1 x 100g (3½oz) skein in main colour
B: 1 x 100g (3½oz) skein (or small amount) in contrasting colour,
for border
Pair of 3.75mm (US size 5) knitting needles
Strip of soft suede, 1.5cm x 20cm (⅝in x 8in) for loop
Two small mother-of-pearl buttons

size

One size – to fit average-size hand – approximately 15cm x 21cm
(6in x 8¼in)

tension (gauge)

20 sts and 26 rows to 10cm (4in) over st st using 3.75mm (US size 5)
needles or size necessary to obtain tension (US gauge).

pattern note

- To obtain the fully-fashioned detail, work the decreases as follows:
 On a knit row: K3, k2tog, k to last 5 sts, k2tog tbl, k3.
 On a purl row: P3, p2tog tbl, p to last 5 sts, p2tog, p3.

To make wash mitt front

Using 3.75mm (US size 5) needles and B, cast on 32 sts.

K 2 rows (for garter st border).

Change to A and beg with a k row, work in st st for 10cm (4in), ending with RS facing for next row.

Cont in st st throughout, inc 1 st at each end of next row. *34 sts.*

Work without shaping until work measures 14cm (5½in) from cast-on edge, ending with RS facing for next row.

Dec 1 st at each end of next row and every foll 3rd row until there are 22 sts.

Work without shaping for 1 row.

Cast off (US bind off) 4 sts at beg of next 4 rows.

Cast off (US bind off) remaining 6 sts.

To make wash mitt back

Work exactly as for front.

To finish

Weave in any loose yarn ends.

Lay work out flat and gently steam.

Sew front and back together, using mattress stitch and leaving border edge open for hand.

Sew one button to each side of one corner of wash mitt. Then cut a buttonhole slit at each end of suede strip and fasten it to buttons.

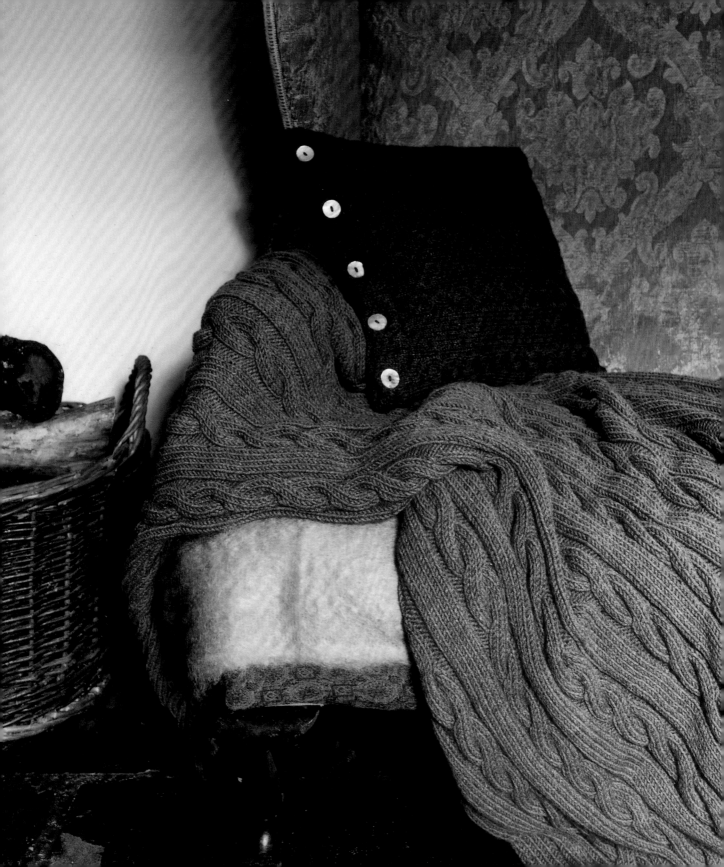

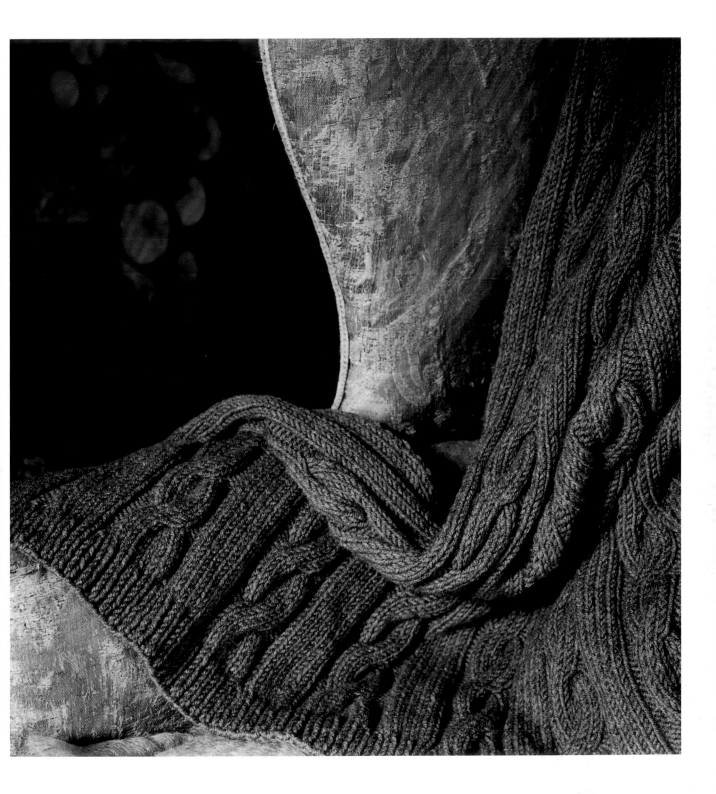

cable throw

materials

Any chunky/bulky-weight wool yarn, such as Erika Knight for
 John Lewis *Chunky* or Debbie Bliss *Rialto Chunky*
 20 x 100g (3½oz) balls of *Chunky* or 38 x 50g (1¾oz) balls of
 Rialto Chunky
7mm (US size 10½) long circular knitting needle
Cable needle

size

One size, approximately 122cm x 152cm (48in x 59¾in)

tension (gauge)

14 sts and 16 rows to 10cm (4in) over cable and rib stitch using
 7mm (US size 10½) needles or size necessary to obtain tension
 (US gauge).

pattern note

• Throw is worked in one piece back and forth in rows on a long
 circular needle.

To make throw

Using 7mm (US size 10½) circular needle, cast on 202 sts.

Work in k1, p1 rib for 4cm (1½in), ending with WS facing for next row.

Next row (WS): [Rib 28 sts, inc in next st] 6 times, rib 28 sts. *208 sts.*

Cont in cable patt with 8-st k1, p1 borders as foll:

Row 1 (RS): Rib first 8 sts as set, *p3, k6, p3, k8; rep from * to last 20 sts, p3, k6, p3, rib last 8 sts as set.

Row 2: Rib first 8 sts, *k3, p6, k3, p8; rep from * to last 20 sts, k3, p6, k3, rib last 8 sts.

Row 3: Rep row 1.
Row 4: Rep row 2.
Row 5: Rep row 1.
Row 6: Rep row 2.
Row 7: Rib first 8 sts, *p3, k6, p3, slip next 4 sts onto cable needle and hold at back of work, k4, then k4 from cable needle; rep from * to last 20 sts, p3, k6, p3, rib last 8 sts.
Row 8: Rep row 2.
Row 9: Rep row 1.
Row 10: Rep row 2.
Row 11: Rep row 1.
Row 12: Rep row 2.
Rep last 12 rows until work measures 148cm (58¼in) from cast-on edge, ending with RS facing for next row.

Dec row (RS): [Work 28 sts in patt, k2tog] 6 times, work 28 sts in patt. *202 sts.*

Work in k1, p1 rib across all sts for 4cm (1½in).

Cast off (US bind off) in rib.

To finish

Weave in any loose yarn ends.
Lay work out flat and gently steam.

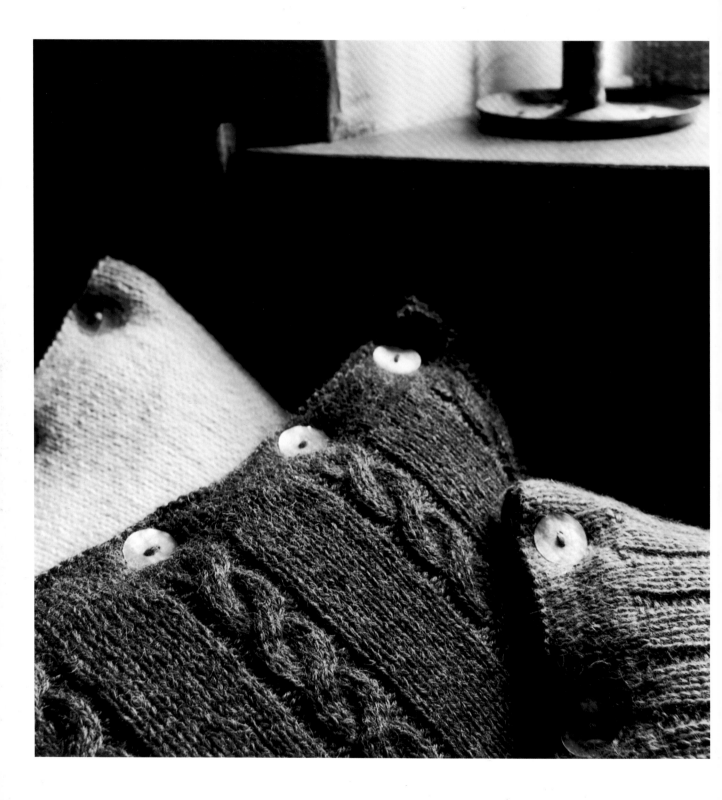

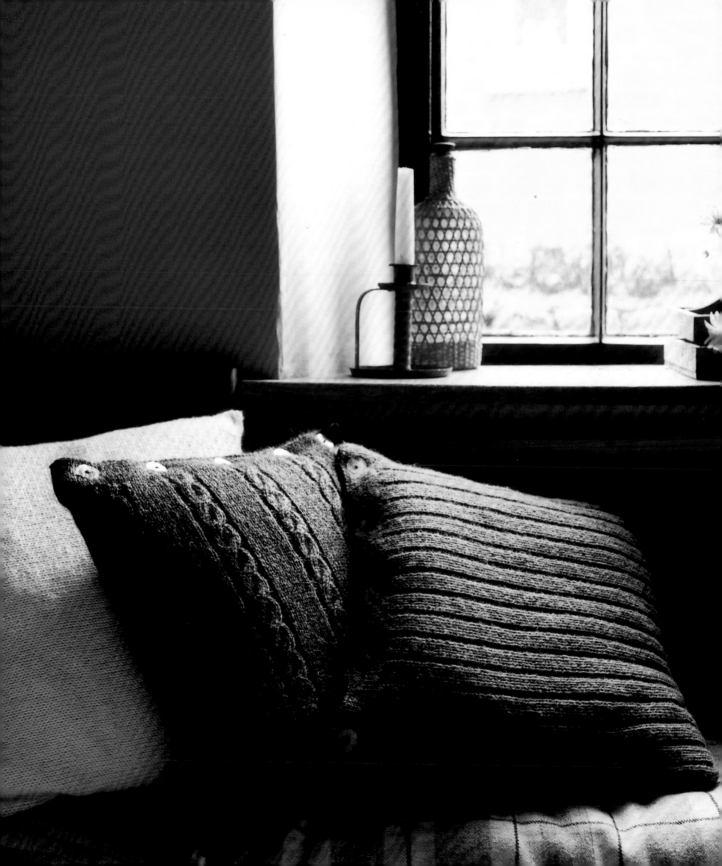

stitch cushions

materials

Any double-knitting-weight alpaca-mix yarn, such as Rowan *Alpaca Merino DK*

 5 x 25g (⅞oz) balls for each cushion

Pair each of 3.75mm (US size 5) and 4mm (US size 6) knitting needles

Cable needle, for cable pattern cushion

Five 28mm (1in) mother-of-pearl buttons for each cushion

40cm x 40cm (16in x 16in) feather-filled cushion pad (US pillow form) for each cushion

size

One size, approximately 40cm x 40cm (16in x 16in)

tension (gauge)

22 sts and 30 rows to 10cm (4in) over st st using 4mm (US size 6) needles or size necessary to obtain tension (US gauge).

stitches

stocking stitch (US stockinette stitch)

Row 1 (RS): K.

Row 2: P.

Rep last 2 rows to form st st.

rib pattern

Row 1 (RS): P2, *k3, p2; rep from * to end.

Row 2: K2, *p3, k2; rep from * to end.

Rep last 2 rows to form rib patt.

cable pattern

Row 1 (WS): P5, k2, p6, k2, [p8, k2, p6, k2] 4 times, p5.

Row 2: K5, [p2, k6, p2, k8] 4 times, p2, k6, p2, k5.

Row 3: Rep row 1.

Row 4: K5, [p2, slip next 3 sts onto cable needle and hold at back, k3, then k3 from cable needle, p2, k8] 4 times, p2, slip next 3 sts onto cable needle and hold at back, k3, then k3 from cable needle, p2, k5.

Rows 5–8: Rep rows 1 and 2 twice.

Rep last 8 rows to form cable patt.

To make cushion (US pillow)

Using 4mm (US size 6) needles, cast on 87 sts.

Work the front and back of the cover in one piece as follows:

Beg with a k row, work 10 rows in st st.

Next row (RS): Using a 3.75mm (US size 5) needle, p to end (to make a neat folding row).

Change back to 4mm (US size 6) needles.

Beg with a p row, work 9 rows in st st, ending with RS facing for next row.

Place a marker at each end of last row.

This completes button band.

You are now ready to work the cover in your chosen stitch patt – st st, rib patt or cable patt.

Cable version only

Inc row (RS): K9, inc in next st, [k16, inc in next st] 4 times, k9. *92 sts.*

All versions

Cont in your chosen stitch patt until work measures 80cm (32in) from markers, ending with RS facing for next row if working in st st or rib patt and WS facing for next row if working cable patt.

Cable version only

Dec row (WS): P9, p2tog, [p16, p2tog] 4 times, p9. *87 sts.*

All versions

Work buttonhole band as follows:

Beg a k row, work 4 rows in st st.

Buttonhole row 1 (RS): K first 6 sts, cast off (US bind off) next 3 sts, [k until there are 15 sts on right needle, cast off (US bind off) next 3 sts] 4 times, k last 5 sts.

Buttonhole row 2: P across row, casting on 3 sts over those cast off (US bound off) in previous row.

Work 4 rows in st st.

Next row (RS): Using a 3.75mm (US size 5) needle, p to end (to make a neat folding row).

Change back to 4mm (US size 6) needles.

Beg with a p row, work 3 rows in st st.

Work 2 buttonhole rows as before.

Work 4 rows in st st.

Cast off (US bind off).

To finish

Weave in any loose yarn ends.

Lay work out flat and gently steam.

Fold work in half and sew both side seams using mattress stitch.

Fold button and buttonhole bands in half along purl-stitch row and sew to inside.

Sew on buttons to correspond with buttonholes.

Insert cushion pad (US pillow form).

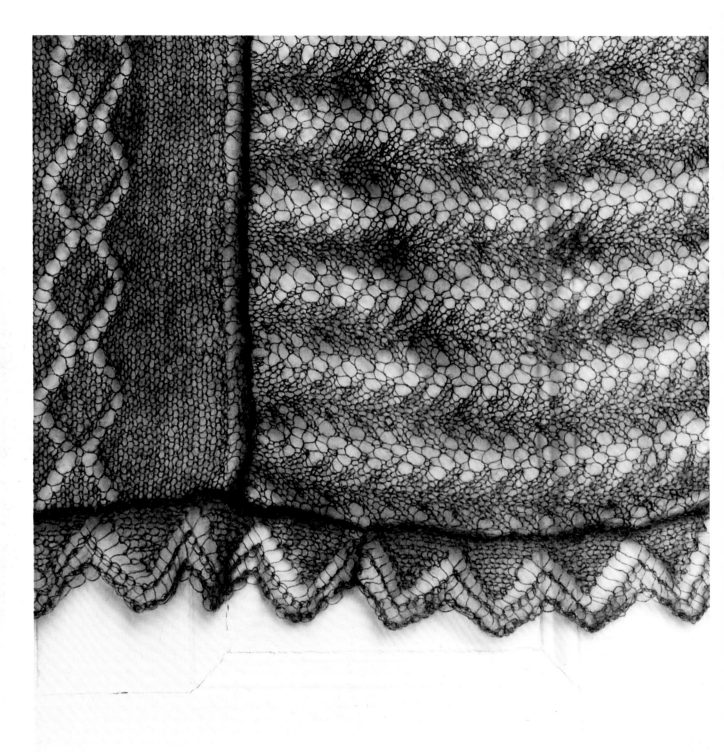

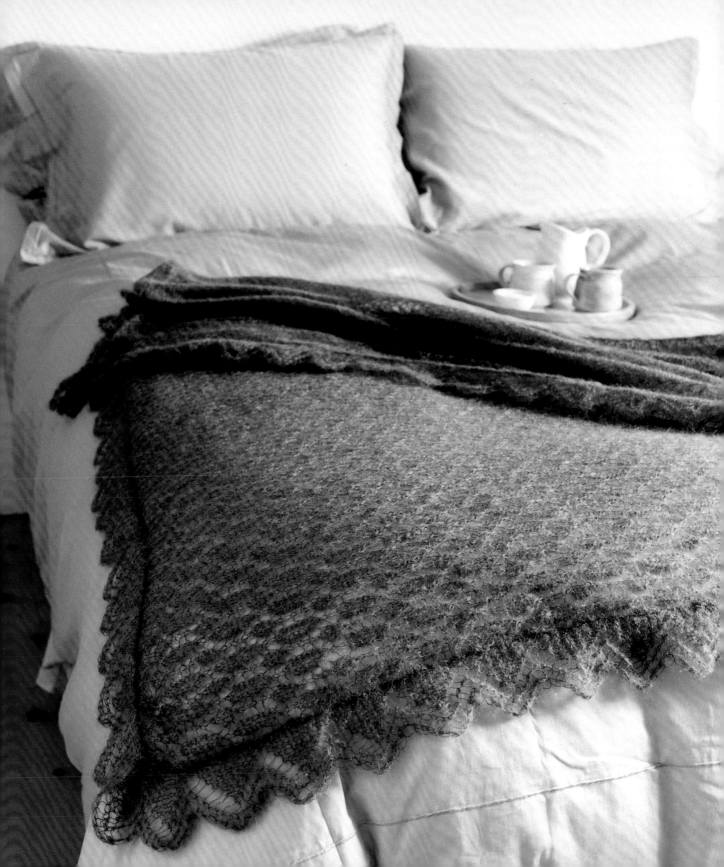

lace throw

materials

Any fine-weight mohair yarn, such as Rowan *Kidsilk Haze*
 10 x 25g (⅞oz) balls
Pair of 5mm (US size 8) knitting needles or 5mm (US size 8) circular
 needle

size

One size, approximately 150cm x 150cm (59in x 59in), excluding edging

tension (gauge)

15 sts and 26 rows to 10cm (4in) over st st using 5mm (US size 8)
 needles or size necessary to obtain tension (US gauge).

pattern notes

• The throw is worked in four panels (A, B, C and D), plus an edging.
• Cast on each of the four panels loosely or with a larger size needle.
• Note that yfwd, yfrn and yrn are all yarn-over increases (US yo) as
 explained in Abbreviations on page 239.

To make throw panels
A – Shetland lace panel
Cast on 76 sts.
Beg with a k row, work 30cm (12in) in st st, ending with RS facing for next row.
Next row(RS): K1, *yfwd, k2tog, k3; rep from * to end.
Beg with a p row, work 2 rows in st st, ending with WS facing for next row.

Cont in lace patt as follows:
Row 1 (WS): P.
Row 2: K3, *yfwd, k2, sl 1, k1, psso, k2tog, k2, yfwd, k1; rep from * to last st, k1.
Row 3: P.
Row 4: K2, *yfwd, k2, sl 1, k1, psso, k2tog, k2, yfwd, k1; rep from * to last 2 sts, k2.
Rep last 4 rows until work measures

107cm (42in), from cast-on edge.
Cast off (US bind off) very loosely.

B – Honeycomb lace panel
Cast on 75 sts.
Work in lace patt as foll:
Row 1 (RS): K2, *yfwd, sl 1, k2tog, psso, yfwd, k1; rep from * to last st, k1.
Row 2: P.

Row 3: K1, k2tog, yfwd, k1, *yfwd, sl 1, k2tog, psso, yfwd, k1; rep from * to last 3 sts, yfwd, sl 1, k1, psso, k1.
Row 4: P.
Rep last 4 rows until work measures 107cm (42in) from cast-on edge.
Cast off (US bind off) very loosely.

C – Beginner's lace panel
Cast on 97 sts.
Work in lace patt as foll:
Row 1 (WS) and all alt rows: P.
Rows 2, 4 and 6: K1, *yfwd, sl 1, k1, psso, k1, k2tog, yfwd, k1; rep from * to end.
Row 8: K2, *yfwd, sl 1, k2tog, psso, yfwd, k3; rep from *, ending last rep k2.
Row 10: K1, *k2tog, yfwd, k1, yfwd, sl 1, k1, psso, k1; rep from * to end.
Row 12: K2tog, *yfwd, k3, yfwd, sl 1, k2tog, psso; rep from *, ending yfwd, k3, yfwd, sl 1, k1, psso.
Rep last 12 rows until work measures 61cm (24in), ending with RS facing for next row.
Beg with a p row, cont in rev st st until work measures 107cm (42in) from cast-on edge.
Cast off (US bind off) very loosely.

D – Diamond eyelet panel
Cast on 89 sts.
Beg with a k row, work 2 rows in st st.
Cont in lace patt as foll:
Row 1 (RS): K3, yfwd, k2tog, k10, [yfwd, sl 1, k1, psso, k5, k2tog, yfwd, k16] twice, yfwd, sl 1, k1, psso, k5, k2tog, yfwd, k10, k2tog, yfwd, k3.
Row 2: P.
Row 3: K16, [yfwd, sl 1, k1, psso,

k3, k2tog, yfwd, k18] twice, yfwd, sl 1, k1, psso, k3, k2tog, yfwd, k16.
Row 4: P.
Row 5: K3, yfwd, k2tog, k12, [yfwd, sl 1, k1, psso, k1, k2tog, yfwd, k20] twice, yfwd, sl 1, k1, psso, k1, k2tog, yfwd, k12, k2tog, yfwd, k3.
Row 6: P.
Row 7: K18, [yfwd, sl 1, k2tog, psso, yfwd, k22] twice, yfwd, sl 1, k2tog, psso, yfwd, k18.
Row 8: P.
Row 9: K3, yfwd, k2tog, k12, [k2tog, yfwd, k1, yfwd, sl 1, k1, psso, k20] twice, k2tog, yfwd, k1, yfwd, sl 1, k1, psso, k12, k2tog, yfwd, k3.
Row 10: P.
Row 11: K16, [k2tog, yfwd, k3, yfwd, sl 1, k1, psso, k18] twice, k2tog, yfwd, k3, yfwd, sl 1, k1, psso, k16.
Row 12: P.
Row 13: K3, yfwd, k2tog, k10, [k2tog, yfwd, k5, yfwd, sl 1, k1, psso, k16] twice, k2tog, yfwd, k5, yfwd, sl 1, k1, psso, k10, k2tog, yfwd, k3.
Row 14: P.
Row 15: K14, [k2tog, yfwd, k7, yfwd, sl 1, k1, psso, k14] 3 times.
Row 16: P.
Rep last 16 rows until work measures 150cm (59in).
Cast off (US bind off) very loosely.

To make lace edging
Cast on 7 sts.
Row 1: [Yfwd, k2tog] twice, yfrn, p3.
Row 2: P4, yrn, p2tog, yrn, p2.
Row 3: [Yfwd, k2tog] twice, yfrn, p5.
Row 4: P6, yrn, p2tog, yrn, p2.
Row 5: [Yfwd, k2tog] twice, yfrn, p7.

Row 6: P8, yrn, p2tog, yrn, p2.
Row 7: [Yfwd, k2tog] twice, yfrn, p9.
Row 8: P7, [p2tog, yrn] twice, p2tog, p1.
Row 9: Yfwd, k3tog, [yfwd, k2tog] twice, p6.
Row 10: P5, [p2tog, yrn] twice, p2tog, p1.
Row 11: Yfwd, k3tog, [yfwd, k2tog] twice, p4.
Row 12: P3, p2tog, [yrn, p2tog] twice, p1.
Row 13: Yfwd, k3tog, [yfwd, k2tog] twice, p2.
Row 14: P1, p2tog, [yrn, p2tog] twice, p1.
Rep last 14 rows until edging measures approximately 7.5m (8¼yds).
Cast off (US bind off).

To finish
Weave in any loose yarn ends.
Lay panels out flat. With cast-off ends aligned side by side, sew panels A and B together along selvedges (US selvages), using mattress stitch, but keeping a 'light touch' as fabric is so airy; then sew panels B and C together also along selvedges (US selvages). Finally, sew panel D along one selvedge (US selvage) to cast-off (US bound-off) edges of other three panels A, B and C.
Pin and stitch lace edging in place around throw, making a full gather at each corner – working along one section at a time makes it easier.
Gently steam.

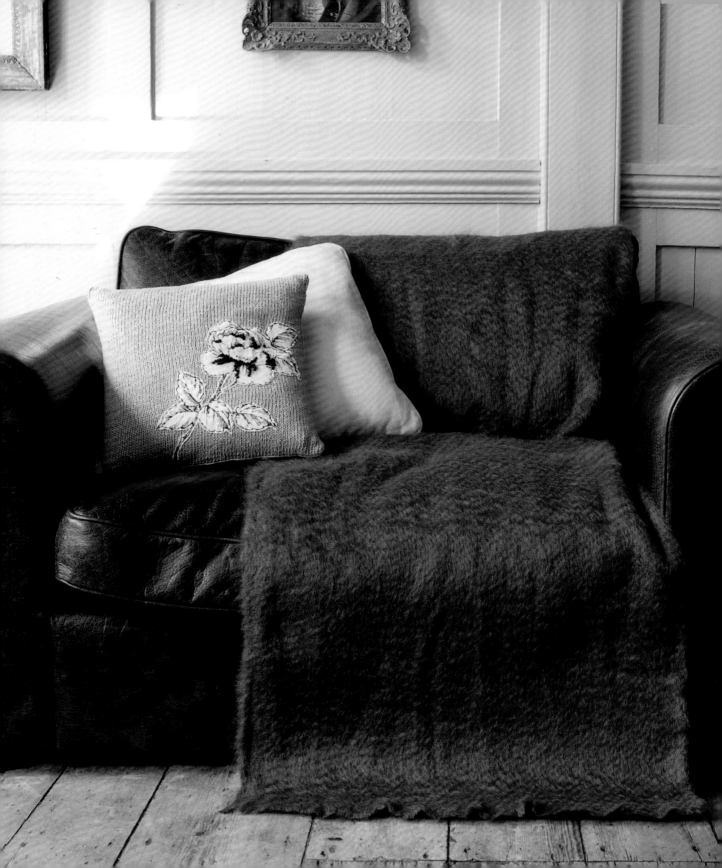

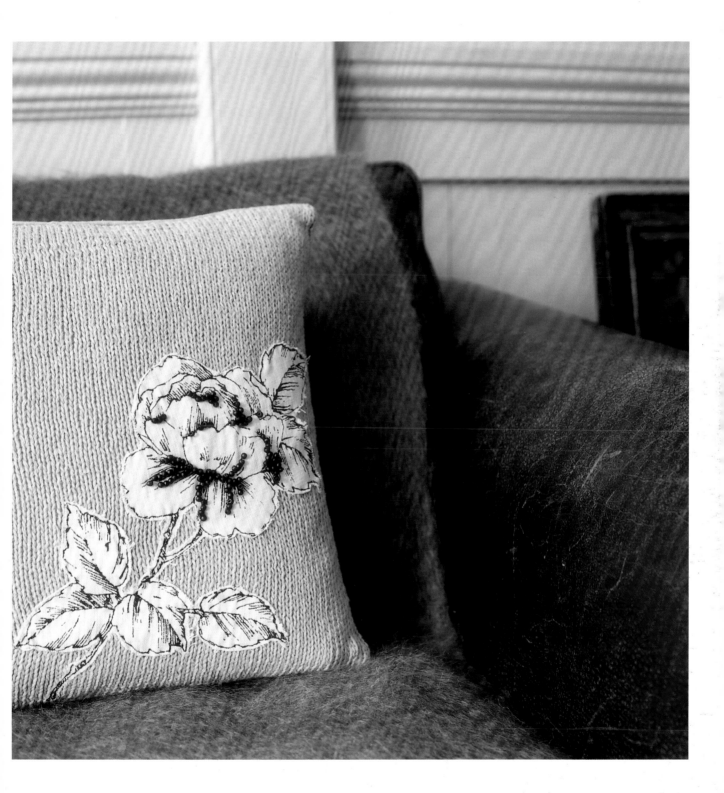

cut-out cushion

materials

Any double-knitting-weight hemp or linen-cotton yarn, such as
 Lanaknits *Allhemp6* or Rowan *Creative Linen*
 2 x 100g (3½oz) skeins
Pair of 4.5mm (US size 7) knitting needles
Approximately 100 small wooden beads
Approximately 50cm (½yd) of natural linen fabric, for back of cover
Approximately 112cm (44in) of narrow cotton tape for ties
40cm x 40cm (16in x 16in) feather-filled cushion pad (US pillow form)
Small piece of printed fabric, such as cotton or linen, with a large
 floral motif, for appliqué
Sheet of appliqué bonding web adhesive
Sewing needle and thread

size

One size, approximately 40cm x 40cm (16in x 16in)

tension (gauge)

18½ stitches and 24 rows to 10cm (4in) over st s using 4.5mm
 (US size 7) needles or size necessary to obtain tension (US gauge).

To make cover front
Using 4.5mm (US size 7) needles, cast on 76 sts.
Beg with a k row, work in st st for 40cm (16in).
Cast off (US bind off).

Appliqué and beading
Take fabric with large floral motif and cut around motif, leaving narrow border.
Press appliqué onto knitted cover front using appliqué bonding web adhesive.
Hand stitch around motif outline and along details inside motif, such as petal outlines and leaf veins.

Further embellish with beads to enhance motif.

To finish
Weave in any loose ends on knitting, then lay out flat and gently steam.
Cover back
Cut two pieces of fabric, each 32.5cm x 43cm (12½in x 17in). Along one long edge of each piece fold 1.5cm (½in) to wrong side twice and stitch to form a double hem. Lay knitting right-side up and place both back pieces wrong-side down on top, so that raw edges extend 1.5cm (½in) past edges of knitting and hemmed edges overlap at centre.

Pin and stitch around all sides, taking a 1.5cm (qin) seam on fabric and stitching close to edge on knitting. Turn right-side out.
Cotton-tape ties
Cut cotton tape into four pieces, each 28cm (11in) long – two for each side of back opening. Hem one end of each piece, then fold hem at other end and sew this end to cover back with a cross stitch, positioning each pair of ties about 20cm (8in) apart at centre of back opening.
Insert cushion pad (US pillow form) and tie tapes into bows.

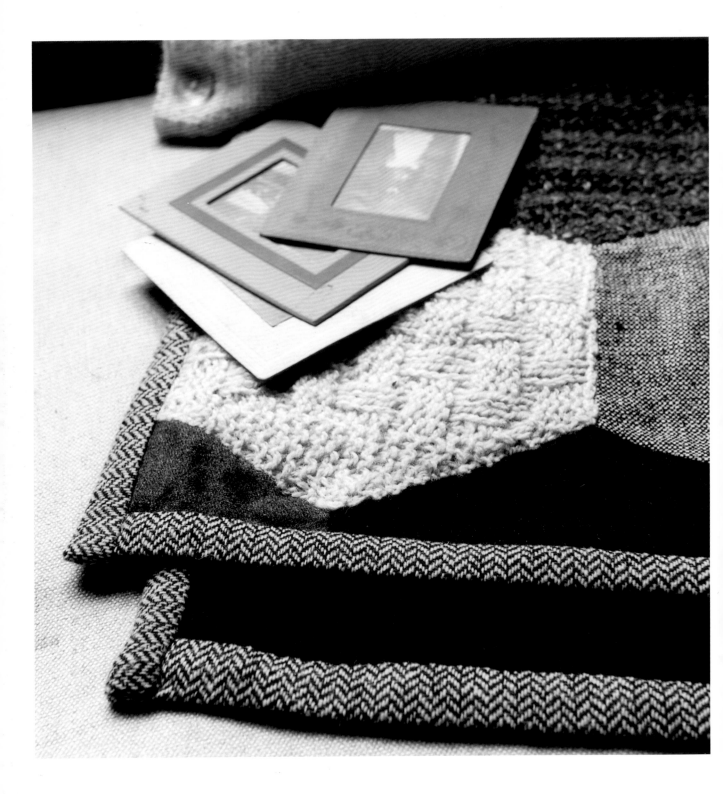

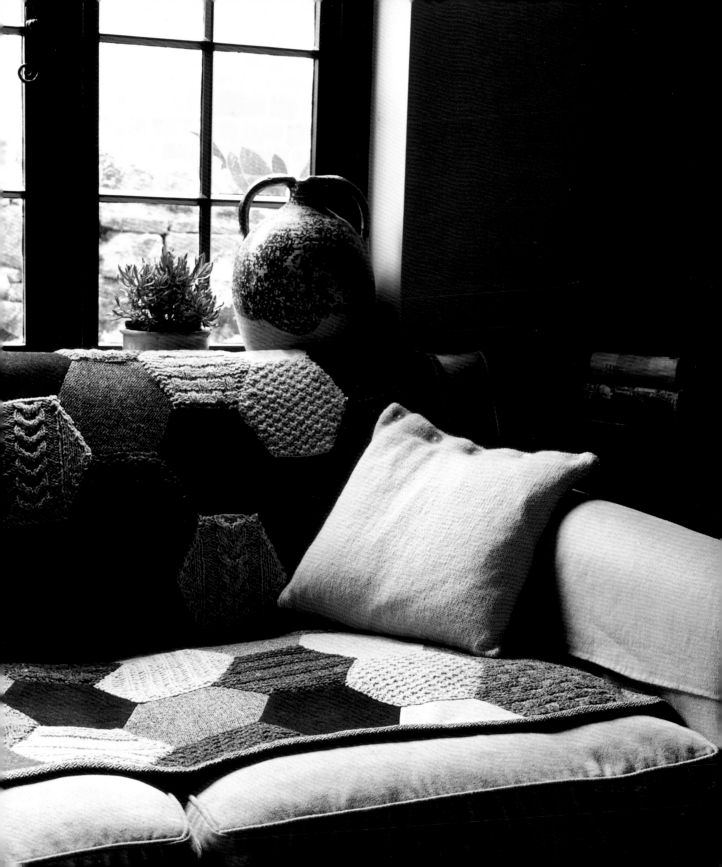

patchwork throw

materials

Any aran-weight wool yarn, such as Rowan *Felted Tweed Aran*

A: 2 x 50g (1¾oz) balls in light grey or similar medium-toned colour
B: 2 x 50g (1¾oz) balls in dark grey or similar dark colour
C: 2 x 50g (1¾oz) balls in beige or similar light colour
D: 2 x 50g (1¾oz) balls in ecru or similar very pale colour

Pair of 5mm (US size 8) knitting needles
Cable needle
Assorted fabrics (and matching thread) for patchwork in six different
 textures and/or colours

E: beige herringbone
F: black and white herringbone
G: black flannel
H: grey flannel
I: woven beige
J: woven black

1.5m (1¾yds) of corduroy (137cm/54in wide) for backing
Microfilament sewing thread

size

One size, approximately 112cm x 112cm (43½in x 43½in)

tension (gauge)

16 sts and 23 rows to 10cm (4in) over st st using 5mm (US size 8)
 needles or size necessary to obtain tension (US gauge).

pattern notes

- A total of 20 knitted whole hexagons and 2 half-hexagons is required to make the throw. The knitted hexagons measure approximately 18cm by 18cm (7in x 7in). When cutting out the fabric hexagons, cut approximately 36 to allow for making the edging pieces. For the fabric hexagons, cut to the same size as the knitted hexagons but add a 2cm (¾in) seam allowance all around the edge.
- To create a neat edge when knitting the hexagons, always increase or decrease one stitch in from the side edges.

To make knitted hexagons

Using 5mm (US size 8) needles, cast on 16 sts.

Work first 2 rows of chosen stitch patt, ending with RS facing for next row. Keeping chosen stitch patt correct throughout and working inc sts in stitch patt (unless stated otherwise), inc 1 st at each end of next row and then at each end of every foll 3rd row until there are 30 sts.

Work without shaping for 2 rows.

Half hexagon only

Work without shaping for 2 rows more.

Cast off (US bind off).

Full hexagon only

Dec 1 st at each end of next row and then at each end of every foll 3rd row until there are 16 sts.

Work without shaping for 1 row.

Cast off (US bind off). *43 rows in total.*

Stitch patterns

Follow instructions for knitted hexagons while working one of following stitch patterns. Sample each stitch patt to familiarize yourself with increases/decreases. Work inc sts in individual stitch patt except where stated otherwise.

Double moss stitch

Make one hexagon in each of A, C and D, plus one half hexagon in B.

Worked across a multiple of 4 sts.

Row 1 (RS): *K2, p2; rep from * to end.

Row 2: Rep row 1.

Rows 3 and 4: *P2, k2; rep from * to end.

Rep last 4 rows to form double moss st patt.

Basket stitch

Make one hexagon in each of A, B, C and D.

Worked across a 16-st panel.

Work inc sts in garter st.

Row 1 (RS): K.

Row 2: P.

Row 3: K2, [k1, p4, k1] twice, k2.

Row 4: K2, [p1, k4, p1] twice, k2.

Rows 5 and 6: Rep rows 3 and 4.

Rows 7 and 8: Rep rows 1 and 2.

Row 9: K2, [p2, k2, p2] twice, k2.

Row 10: K2, [k2, p2, k2] twice, k2.

Rows 11 and 12: Rep rows 9 and 10.

Rep last 12 rows to form patt.

Reverse cable rib

Make one hexagon in each of A, B, C and D.

Worked across a 16-st panel.

Work inc sts in st st.

Row 1 (RS): K1, p3, k8, p3, k1.

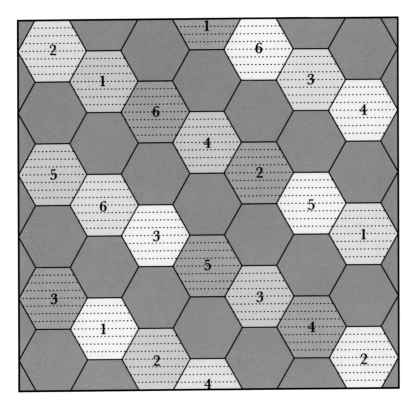

■ fabric	1 double moss stitch
▨ knitting	2 basket stitch
☐ **A** light grey	3 reverse cable rib
■ **B** dark grey	4 moss stitch rib (US seed stitch rib)
▨ **C** beige	5 moss stitch stripe (US seed stitch stripe)
☐ **D** ecru	6 st st and garter stitch stripe

Row 2: P1, k3, p8, k3, p1.
Rows 3 and 4: Rep rows 1 and 2.
Row 5: K1, p3, slip next 2 sts onto cable needle and leave at back of work, k2, k2 from cable needle, slip next 2 sts onto cable needle and leave at front of work, k2, k2 from cable needle, p3, k1.
Row 6: Rep row 2.
Rep last 6 rows to form patt.

Moss stitch (US seed stitch) rib
Make one hexagon in each of B, C and D, plus one half hexagon in A.
Worked across a multiple of 4 sts.
Row 1: *K3, p1; rep from * to end.
Row 2: *K2, p1, k1; rep from * to end.
Rep last 2 rows to form patt.

Moss stitch (US seed stitch) stripe
Make one hexagon in each of B, C and D.
Beg with a RS row, work 4 rows in moss stitch (US seed stitch), ending with RS facing for next row.
Beg with a k row, work 4 rows in st st.
Rep last 8 rows to form patt.

St st and garter stitch stripe
Make one hexagon in each of A, B and D.
K 7 rows.
**P 1 row.
K 1 row.
P 1 row.
K 9 rows.**
Rep from ** to ** twice more.

To finish
Cut about 36 fabric hexagons from assorted fabrics (see Pattern Notes on page 67).

Patch arrangement
Lay out fabric and knitted hexagons, following diagram opposite for knitted hexagons and distributing fabric pieces evenly.
Make a chart of your final arrangement, numbering each hexagon, then pin a label to each hexagon to match your chart.

Patchwork seams
Hand sew each diagonal row of knitted hexagons together, and machine stitch each diagonal row of fabric hexagons together, including partial hexagons at ends of diagonal rows.

Pin knitted rows of hexagons on top of seam allowances of rows of fabric hexagons, aligning knitted edge with seam line on fabric hexagons. Baste in place and remove pins. Baste partial fabric hexagons in place at ends of knitted rows.
Using microfilament thread, machine zigzag rows together along knitted edges.

Patchwork backing
Gently press patchwork and place on top of backing, with wrong sides together. Sew patchwork to backing around edge and trim off any excess backing around edge.

Edging
Cut four edging strips from fabric, each 7.5cm (2¾in) wide and length of throw plus 1.5cm (½in) hem allowance at each end of strip.
Machine stitch a strip to two opposite edges of patchwork, with RS together and taking a 2cm (¾in) seam. Turn edging to back, fold under 1.5cm (½in), and hand sew in place.
Sew on other two strips in same way, folding in ends at corner edges.

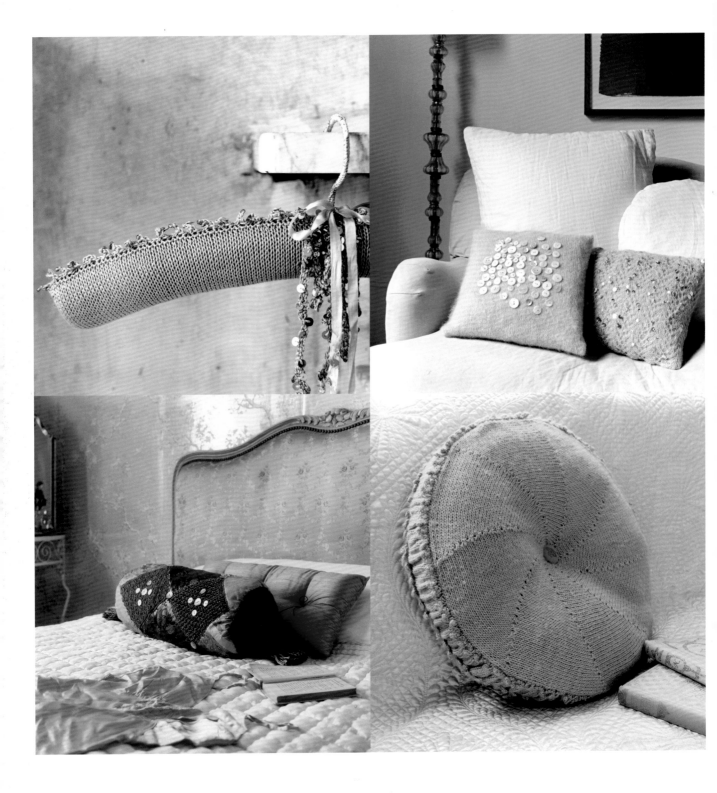

glamour
at home

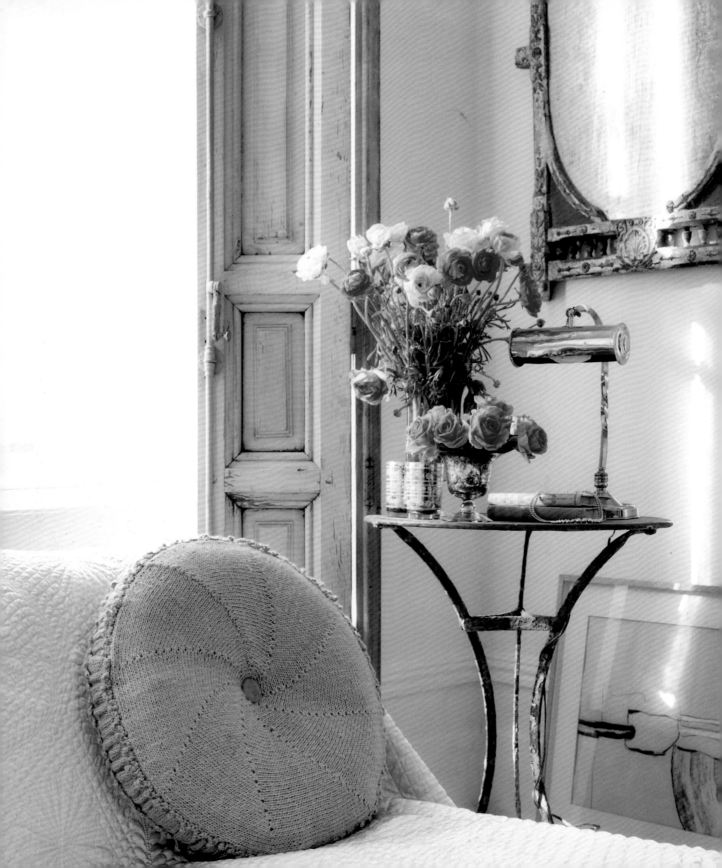

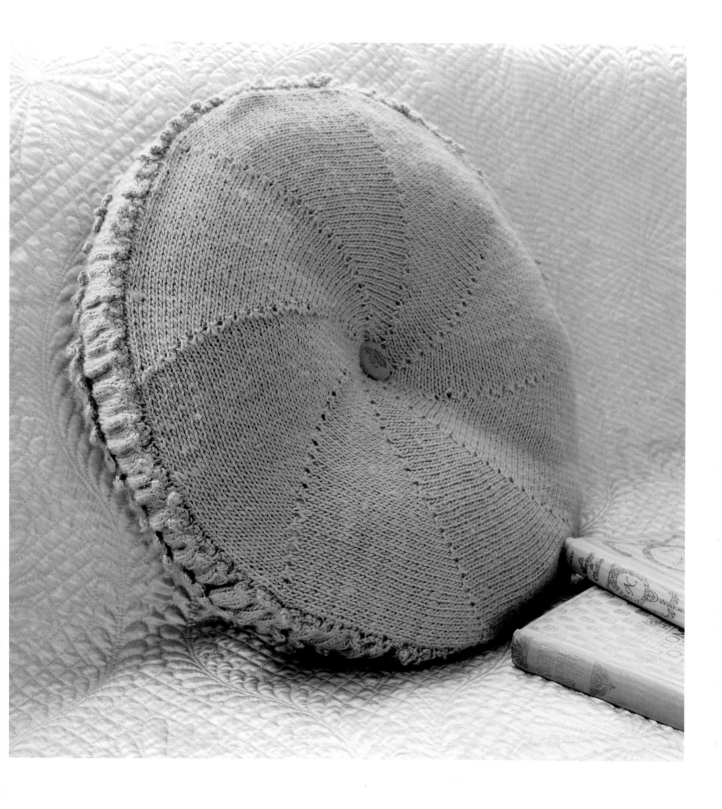

round ruched cushion

materials

Any double-knitting-weight silk yarn, such as Debbie Bliss *Luxury Silk DK*
 5 x 50g (1¾oz) balls
Pair of 4mm (US size 6) knitting needles
3.75mm (US size 5) long circular knitting needle
40cm (16in) round cushion pad (US pillow form) with gusset
Two large 30mm (1¼in) self-cover buttons
Scrap of green silk fabric or ribbon to cover buttons

size

One size, approximately 40cm (16in) in diameter

tension (gauge)

24 sts and 32 rows to 10cm (4in) over st st using 4mm (US size 6) needles or size
 necessary to obtain tension (US gauge).

pattern notes

- For the short-row shaping, when the instructions say 'turn' at the end of
 the row, this means that the remaining stitches are not worked. To avoid
 creating a hole when turning on a knit row, work a wrap stitch – knit as
 far as instructed, then slip the next stitch purlwise onto the right-hand
 needle, bring the yarn forward between the two needles, slip the stitch
 back to the left-hand needle and take the yarn to the back between the
 two needles, turn, and purl to the end of the next row.
- Keep precious yarns, such as silk, in a pillowcase while you work to
 avoid snagging the yarn.

To make cover front

Using 4mm (US size 6) needles, cast on 44 sts.

Work in st st and short rows as foll:

Row 1: K all sts.

Row 2: P all sts.

Row 3: K to last 2 sts, turn (see Pattern Notes on page 74).

Row 4: P.

Row 5: K to last 4 sts, turn.

Row 6: P.

Cont working in short rows as set, leaving 2 more sts unworked on every knit row until there are no more sts to knit.

This completes the first segment of circle.

Start again with row 1 and cont until 8 segments have been worked to form a full circle.

Do not cast off (US bind off) sts, but join last segment to first segment by grafting one st from needle with corresponding st on cast-on edge.

To make cover back

Work cover back exactly as for cushion front.

To make ruched gusset

Using 3.75mm (US size 5) circular needle, work picot cast-on edging as foll:

*Cast on 6 sts onto left needle using knit-on cast-on method, cast off (US bind off) 3 sts, slip st left on right needle onto left needle; rep from * until 276 sts have been cast on onto left needle.

Working back and forth in rows on circular needle and beg with a k row, work 4 rows in st st, ending with RS facing for next row.

Next row (RS): K1, *k into front and back of next st; rep from * to last st, k1.

Beg with a p row, work 6 rows in st st, ending with WS facing for next row.

Next row (WS): P1, *p2tog; rep from * to last st, p1.

Beg with a k row, work 4 rows in st st, ending with RS facing for next row.

Work a picot cast-off (US bind-off) edge as foll:

*Cast off (US bind off) 6 sts, slip st left on right needle onto left needle, cast on 3 sts; rep from * to end.

To finish

Weave in any loose yarn ends.

Lay front and back out flat and gently steam. (Do not steam ruched gusset.)

Sew together row ends of ruched gusset to form a circle.

The gusset is sewn to cushion (US pillow) leaving picot edgings free. To make it easier to sew on, measure gusset, then divide into eight equal sections, and mark them with a pin. Pin each section on one side of gusset to a segment of cover front and sew gusset to front. Hand stitch gusset to cover back in same way, leaving an opening for inserting cushon (US pillow form). Insert cushion pad (US pillow form) and sew opening closed. Cover buttons with silk fabric. Position one button at centre of each side of cushion (US pillow) and sew them together, stitching through cushion (US pillow) and pulling thread tightly to indent centre of cushion (US pillow).

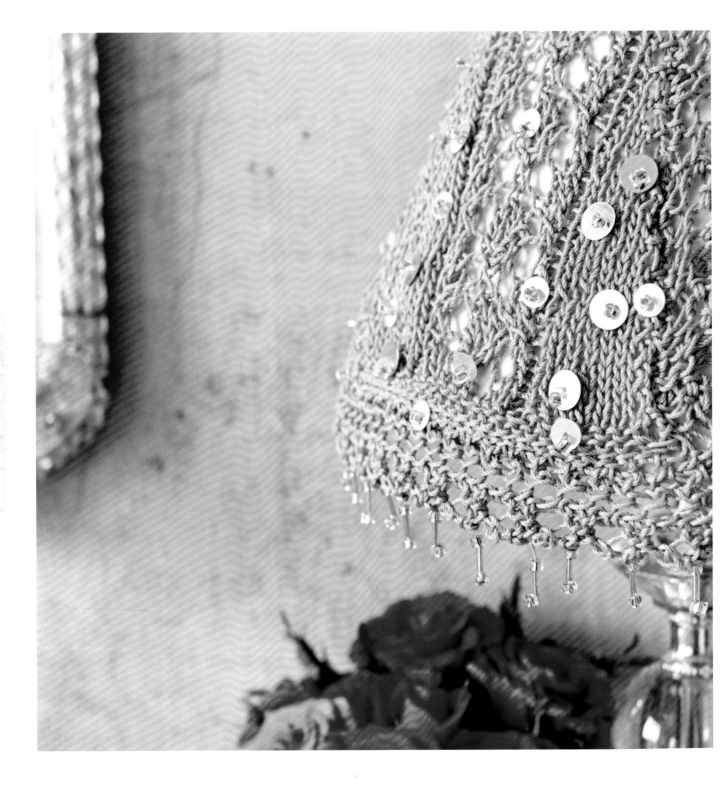

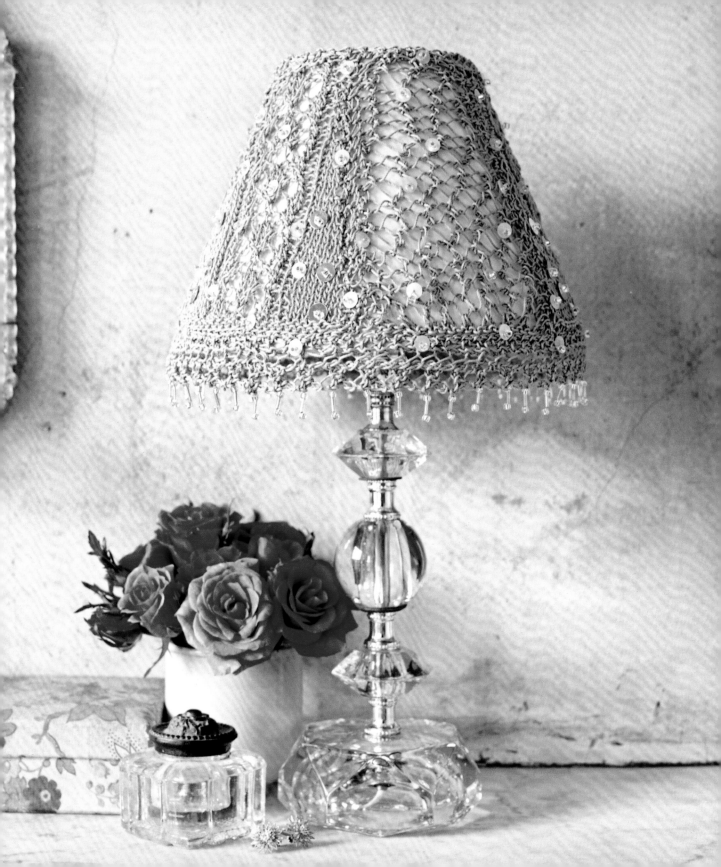

boudoir lampshade

materials

Any super-fine-weight mercerized cotton yarn, such as Yeoman
 Cannele 4ply
 1 x 245g (8¾oz) cone
Pair each of 3.25mm (US size 3), 4mm (US size 6) and 5.5mm
 (US size 9) knitting needles
Approximately 100 small (8mm) matt silver sequins
Approximately 20 medium (10mm) shiny silver sequins
Approximately 220 small (3mm) clear glass seed beads
Approximately 50 small (7mm) clear glass bugle beads
Sewing needle and sewing thread for sewing on beads
Lampshade, approximately 72cm (28½in) around lower edge,
 36cm (14¼in) around upper edge and 17cm (6¾in) tall

size

One size, approximately 17cm (6¾in) tall

tension (gauge)

Turkish stitch: 10 sts to 6cm (2½in) over pattern using 4mm
 (US size 3) needles or size necessary to obtain tension (US gauge).
Diamond stitch: 12 sts to 6cm (2½in) over pattern using 4mm
 (US size 3) needles or size necessary to obtain tension (US gauge).

To make Turkish stitch panels (make 3)

With 5.5mm (US size 9) needles, cast on 10 sts.

Work 2 rows in garter st (k every row).

Patt row 1: K2, *yfwd (US yo), sl 1, k1, psso; rep from * to last 2 sts, k2.

Rep last row 6 times more.

Next row (inc row): K into front and back of first st, k1, *yfwd (US yo), sl 1, k1, psso; rep from * to last 2 sts, k into front and back of next st, k1.

Cont in patt as set **and at the same time** inc 1 st as before at each end of 4 foll 6th rows. *20 sts.*

Work without shaping in patt for 4 rows.

Work 2 rows in garter st.

Cast off (US bind off) knitwise.

To make diamond stitch panels (make 3)

Using 4mm (US size 6) needles, cast on 11 sts.

Work 2 rows in garter st.

Row 1 (RS): P2, k2tog [k1, yfwd (US yo)] twice, k1, sl 1, k1, psso, p2.

Row 2 and every foll WS row: K2, p7, k2.

Row 3: P2, k2tog, yfwd (US yo), k3, yfwd, sl 1, k1, psso, p2.

Row 5: P2, k1, yfwd (US yo), sl 1, k1, psso, k1, k2tog, yfwd, k1, p2.

Row 7: P2, k2, yfwd (US yo), sl 1, k2tog, psso, yfwd, k2, p2.

Row 8: Rep row 2.

Rep last 8 rows to form diamond stitch patt **and at the same time** inc 1 st at each end of next row and then at each end of every foll 4th row until there are 27 sts, taking inc sts into st st.

Cont in patt until row 8 of 5th diamond stitch patt repeat is complete.

Work 2 rows in garter st.

Cast off (US bind off) knitwise.

Edging

Using 3.25mm (US size 3) needles, cast on 6 sts.

Row 1 (WS): K1, k2tog, yfwd (US yo), k2, [yfwd] twice, k1. *8 sts.*

Row 2: K1, [k1 tbl] twice into double yfwd (US double yo), k2tog, yfwd (US yo), k3.

Row 3: K1, k2tog, yfwd (US yo), k5.

Row 4: Cast off (US bind off) 2 sts, k2tog, yfwd (US yo), k3. *6 sts.*

Rep last 4 rows until work fits around lower edge of shade.

Cast off (US bind off).

Rep on upper edge of shade.

To finish

Weave in any loose yarn ends.

Pin out six panels and gently steam.

Lay panels side by side, alternating stitch patterns, and graft them together.

Grafting loosely to maintain lace effect, sew straight edge of edgings to upper and lower edges.

Sew sequins and beads randomly to main panels and stitch beads to lower edging.

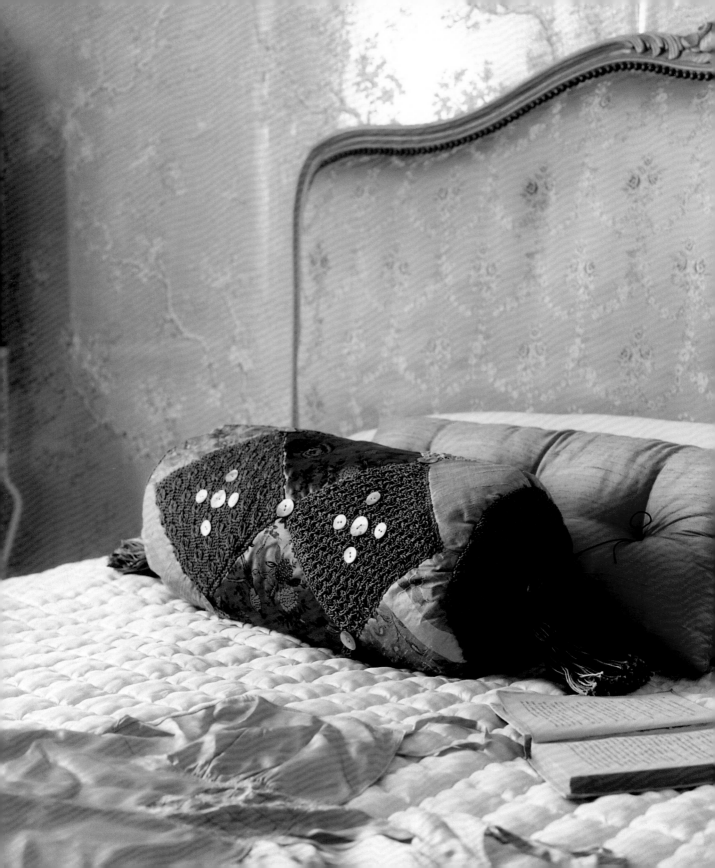

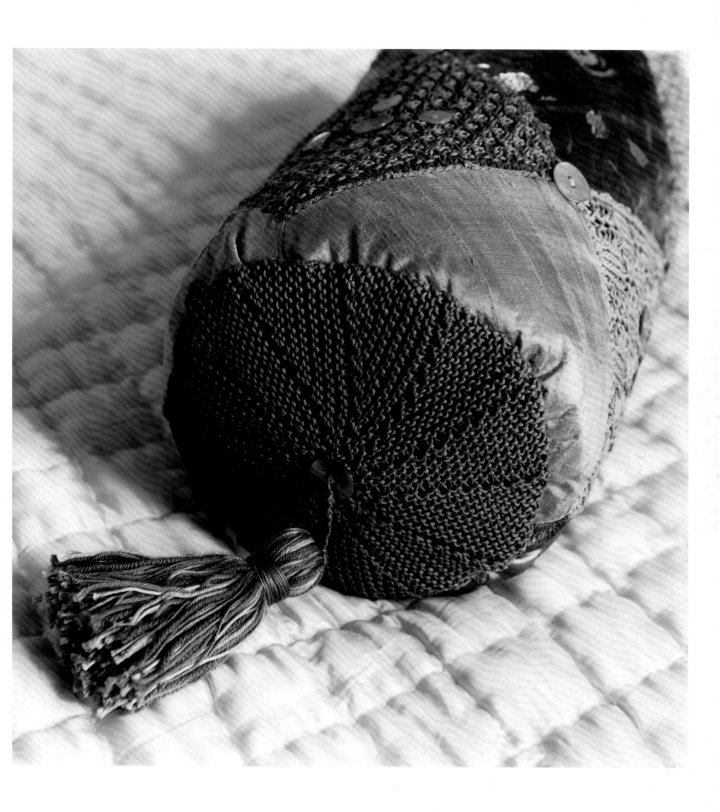

jacquard bolster

materials

Any fine-weight or super-fine-weight mercerized cotton yarns, such as
Rowan *Cotton Glacé* or Yeoman *Cannele 4ply*
A: 1 x 50g (1¾oz) ball of *Cotton Glacé* in light dusky green
B: 1 x 50g (1¾oz) ball of *Cotton Glacé* in ochre brown
C: 1 x 50g (1¾oz) ball of *Cotton Glacé* in beige
D: 5 x 50g (1¾oz) balls of *Cotton Glacé* or 1 x 245g (8¾oz) cone of
Yeoman *Cannele 4ply* in brown
E: 1 x 50g (1¾oz) ball of *Cotton Glacé* in grey
Approximately 30cm (⅓yd) in each of four fabrics:
F: Chinoiserie fabric in grey/black
G: Silk fabric in green
H: Silk jacquard in gold/aqua
I: Silk dupion in taupe
Pair of 3.25mm (US size 3) knitting needles
Bolster cushion, 45cm (18in) long x 17cm (6¾in) in diameter
17 large mother-of-pearl buttons, 2cm (¾in) in diameter
24 small mother-of-pearl buttons, 1.5cm (½in) in diameter
Microfilament sewing thread
Black fusible interfacing for backing patches
Piece of cardboard 12cm x 25cm (4¾in x 10in)

size

One size, approximately 45cm (18in) long x 17cm (6¾in) in diameter

tension (gauge)

Each knitted square measures 15cm x 15cm (6in x 6in) using 3.25mm
(US size 3) needles or size necessary to obtain tension (US gauge).

pattern note

- For the short-row shaping, when the instructions say 'turn' at the end of the row, this means that the remaining stitches are not worked. In order to avoid creating a hole when turning on a knit row, work a wrap stitch – knit as far as instructed, then slip the next stitch purlwise onto the right-hand needle, bring the yarn forward between the two needles, slip the stitch back to the left-hand needle and take the yarn to the back between the two needles, turn, and purl to the end of the next row.

special abbreviations

Cr2L = pass right needle behind first st on left needle and k 2nd st tbl, then k first st and slip both sts off left needle.

Cr2R = pass right needle in front of first st on left needle and p 2nd st, then p first st and slip both sts off left needle.

To make circular ends for bolster (make 2)
Using 3.25mm (US size 3) needles and D, cast on 20 sts.
Work in garter st and short rows as foll:
Row 1: K all sts.
Row 2: K all sts.
Row 3: K to last 2 sts, turn (see Pattern Note above).
Row 4: K.
Row 5: K to last 4 sts, turn.
Row 6: K.
Cont working in short rows as set, leaving 2 more sts unworked on every alternate knit row until there are no more sts to knit.
This completes the first segment of circle.
Start again with row 1 and cont until 12 segments have been worked to form a full circle.
Do not cast off (US bind off) sts, but join last segment to first segment by grafting one st from needle with corresponding st on cast-on edge.

To make tassels (make 2)
Wrap a generous amount of each colour yarn used around a piece of cardboard 12cm by 25cm (4¾in x 10in).
Wrap a length of yarn a few times around strands at one end of cardboard and knot, leaving long enough loose ends for stitching tassel in place.
Cut strands at other end of tassel (see page 127).
Wrap another length of yarn around tassel, approximately 2.5cm (1in) from top, linking and securing ends under wrapping.
Make a second tassel in same way.

Checks and cords square
Using 3.25mm (US size 3) needles and C, cast on 34 sts.

83

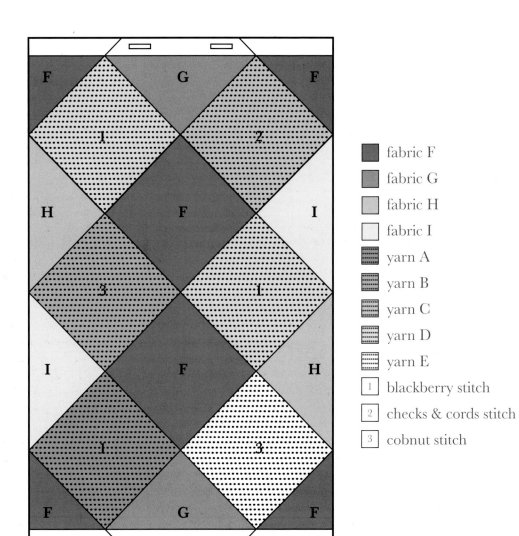

■	fabric F
■	fabric G
■	fabric H
□	fabric I
▦	yarn A
▦	yarn B
▦	yarn C
▦	yarn D
▦	yarn E
1	blackberry stitch
2	checks & cords stitch
3	cobnut stitch

Row 1 (RS): K1, *k4, p2, Cr2L, p2; rep from * to last st, k1.

Row 2: P1, *k2, Cr2R, k2, p4; rep from * to last st, p1.

Rows 3–6: Rep rows 1 and 2 twice.

Row 7: K1, *p1, Cr2L, p2, k4, p1; rep from * to last st, k1.

Row 8: P1, *k1, p4, k2, Cr2R, k1; rep from * to last st, p1.

Rows 9–12: Rep rows 7 and 8 twice.

Rep last 12 rows until square measures 15cm (6in).

Cast off (US bind off).

Blackberry stitch squares (make 1 in A and 2 in D)

Using 3.25mm (US size 3) needles, cast on 34 sts.

Row 1 (RS): K1, *[k1, yfwd (US yo), k1] into next st, p3; rep from * to last st, k1.

Row 2: P1, *p3tog, k3; rep from * to last st, p1.

Row 3: K1, *p3, [k1, yfwd (US yo), k1] into next st; rep from * to last st, k1.

Row 4: P1, *k3, p3tog; rep from * to last st, p1.

Rep last 4 rows until square measures 15cm (6in).

Cast off (US bind off).

Cobnut stitch squares (make 1 in B and 1 in E)

Using 3.25mm (US size 3) needles, cast on 32 sts.

Row 1 (RS): *P3, [k1, yfwd (US yo), k1] into next st; rep from * to end.

Rows 2 and 3: *P3, k3; rep from * to end.

Row 4: *P3tog, k3; rep from * to end.

Row 5: P.

Row 6: K.

Row 7: *P1, [k1, yfwd (US yo), k1] into next st, p2; rep from * to end.

Row 8: K2, *p3, k3; rep from * to last 4 sts, p3, k1.

Row 9: P1, *k3, p3; rep from * to last 5 sts, k3, p2.

Row 10: K2, *p3tog, k3; rep from * to last 4 sts, p3tog, k1.

Row 11: P.

Row 12: K.

Rep last 12 rows until square measures 15cm (6in).

Cast off (US bind off).

To finish

Weave in any loose yarn ends on knitted squares.

Lay squares out flat and gently steam.

Backing piece

For backing piece for bolster cover, cut a piece of fusible interfacing, 71cm by 45cm (28in x 18in).

Fabric patches

Cut a template for square fabric patches, 15cm x 15cm plus 1.5cm (6in x 6in plus ½in) all around for seam allowance.

Using template, cut the two complete squares, six half squares and four quarter squares shown on diagram opposite, allowing 5cm (2in) extra along buttonhole and button band

edges at top and bottom.

Patchwork arrangement

Iron fabric patches onto backing, then machine zigzag stitch around edges, using microfilament thread. Zigzag stitch knitted squares in place over seam allowances of fabric patches.

Button decoration

Sew one large button to centre of each of six knitted squares, then sew four small buttons around each of these as shown.

Using seven large buttons, sew one to each corner of two square fabric patches at centre of patchwork.

Bolster assembly

Turn under 5cm (2in) at top and bottom of patchwork and stitch. Make two buttonholes evenly spaced on centre patch of one end. Overlap buttonhole end over button band end and topstitch for approximately 10cm (4in) at each end to secure. Sew on two large buttons to correspond with buttonholes.

Cut out two circles of fabric, each the size of bolster end plus 1.5cm (½in) seam allowance all around. Turn patchwork cover wrong-side out and pin and stitch fabric ends in place.

Turn right-side out and hand stitch knitted bolster ends in place. Sew a tassel to centre of each end of bolster, stitching it in place through a large button.

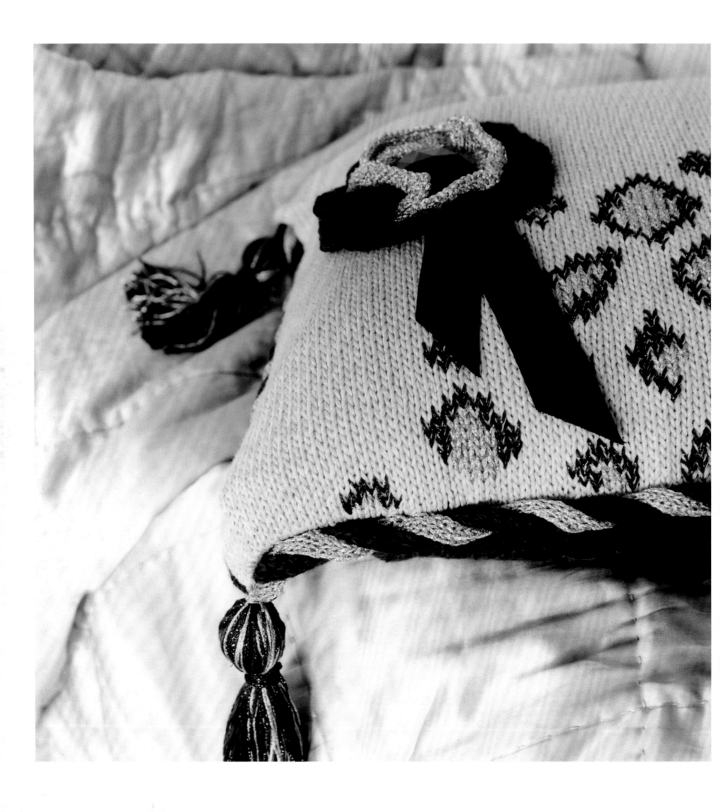

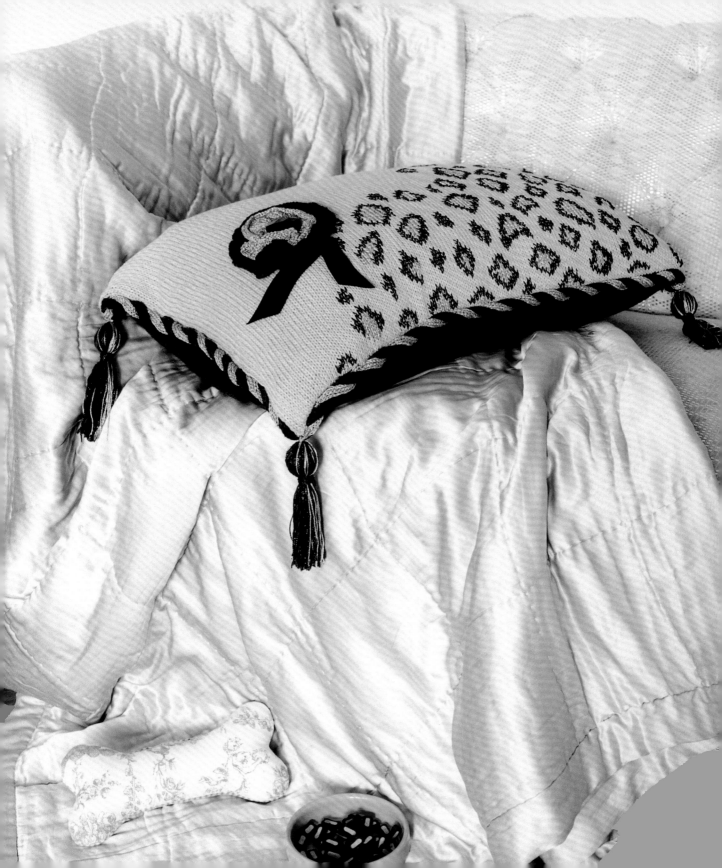

pooch cushion

materials

Any double-knitting-weight cotton yarn, such as Wendy *Supreme Luxury Cotton DK*

 A: 3 x 100g (3½oz) balls in dark brown

 B: 2 x 100g (3½oz) balls in off-white

Any super-fine-weight metallic yarn, such as Twilleys *Goldfingering*

 C: 1 x 25g (⅞oz) ball in black

 D: 2 x 25g (⅞oz) balls in white gold

 E: 1 x 25g (⅞oz) ball in bronze

Pair each of 3.25mm (US size 3) and 4mm (US size 6) knitting needles

Pair each of 3.25mm (US size 3) and 3.75mm (US size 5) double-pointed knitting needles

4 wooden beads, 2cm (¾in) in diameter, for tassels

30cm (12in) of black satin ribbon, 2.5cm (1in) wide, for rosette

Large sew-on jewel or button

Sewing needle and sewing thread for stitching rosette

3 large press fasteners (US snaps)

40cm x 60cm (16in x 24in) feather-filled cushion pad (US pillow form)

size

One size, approximately 40cm x 60cm (16in x 24in)

tension (gauge)

22 sts and 30 rows to 10cm (4in) over st st using B and 4mm (US size 6) needles or size necessary to obtain tension (US gauge).

pattern notes

- If you prefer to embroider the colour pattern onto the knitting, follow the instructions for the embroidered top.
- When working the stocking stitch (US stockinette stitch) colour pattern from the chart, read odd-numbered rows (knit rows) from right to left and even-numbered rows (purl rows) from left to right.
- Work the colour pattern using the intarsia technique, using a separate ball (or long length) of yarn for each area of colour and twisting yarns on wrong side of work where colours change to avoid holes forming.

To make cushion base pieces (make 2)

Using 4mm (US size 6) needles and A, cast on 132 sts.

Rib row 1: *K1, p1; rep from * to end.

Rep last row until work measures 3.5cm (1½in) from cast-on edge, ending with RS facing for next row. Beg with a k row, work 25cm (10in) in st st.

Cast off (US bind off).

To make cushion top

Using 4mm (US size 6) needles and B, cast on 132 sts.

Embroidered top only

Beg with a k row, work 40cm (16in) in st st.

Top with knit-in pattern only

Beg with a k row, work 2 rows in st st, ending with RS facing for next row.

Beg with a k row and chart row 1, work 75 rows following chart, ending with WS facing for next row.

Beg with a p row and using B only, cont in st st until work measures 40cm (16in) from cast-on edge.

Both versions

Cast off (US bind off).

To make edging cords (make 2)

Using a pair of 3.25mm (US size 3) double-pointed needles and one strand of D, cast on 6 sts.

Row 1 (RS): K.

Row 2 (RS): Without turning right needle, slide sts to right end of right needle and transfer this needle to left hand, take yarn across WS of work from left to right and pull tightly, then k to end.

Rep last row until work measures approximately 2m (2yds).

Slip sts onto a st holder and do not cut off yarn.

Using a pair of 3.75mm (US size 5)

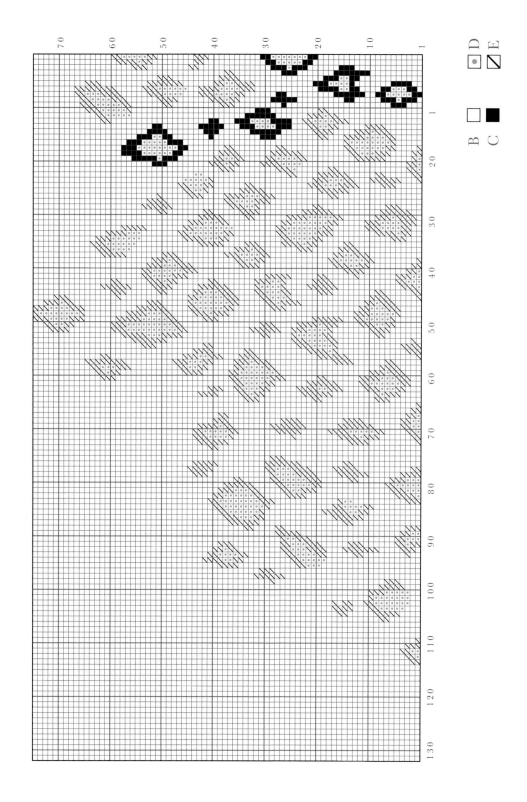

double-pointed needles and A, cast on 5 sts and make second cord in same way as first cord.

To make rosette circles (make 2)

Using 4mm (US size 6) needles and A, cast on 28 sts.
Beg with a k row, work 2 rows in st st, ending with RS facing for next row.
Shape as foll:
Row 1 (RS): *K1, k into front and back of next st; rep from * to end.
Row 2 and every foll WS row: P.
Row 3: *K2, k into front and back of next st; rep from * to end.
Row 5: *K3, k into front and back of next st; rep from * to end.
Row 7: *K4, k into front and back of next st; rep from * to end.
Row 9: *K5, k into front and back of next st; rep from * to end.
Row 11: *K6, k into front and back of next st; rep from * to end.
Row 12: Rep row 2.
Cast off (US bind off).
Using 3.25mm (US size 3) needles and one strand of D, make second rosette circle in same way.

To make tassels (make 4)

Cut a generous number of lengths of A, D and E, each approximately 30cm (12in) long.
With lengths aligned, tie a strand of D around centre.
Place a wooden bead in centre of strands and fold them around bead.
Then wrap a length of D around neck of tassel below bead. Keep winding to make a little band, then tie tightly and trim tassel.
Make three more tassels in same way.

To finish

Weave in any loose yarn ends.
Lay top and base pieces out flat and gently steam.

Embroidery

If embroidering colour pattern, follow chart using Swiss darning (US duplicate stitch) and gently steam again.

Cushion seams

Overlap two base pieces at ribbed edge to form a rectangle 60cm x 40cm (24in x 16in).
Then sew base to cushion top, using mattress stitch.

Edging cord

Twist two cords around each other and pin around edge of cushion.
Adjust cord lengths if necessary and cast off (US bind off).
Sew twisted cord in place.

Rosettes

Sew row-end edges together on each rosette circle. Then work running stitch around cast-on edge of each circle, pull to gather, and secure end.
Place circle in D on top of circle in A and join together by stitching a large button or jewel through centre.
Fold ribbon into a V-shape and sew to bottom of rosette as shown.
Sew finished rosette to cushion top as shown.

Tassels

Sew a tassel to each corner of cushion.
Sew three press fasteners (US snaps) evenly spaced to overlapped rib edges of cushion base.
Insert cushion pad (US pillow form).
Call for pup or puss!

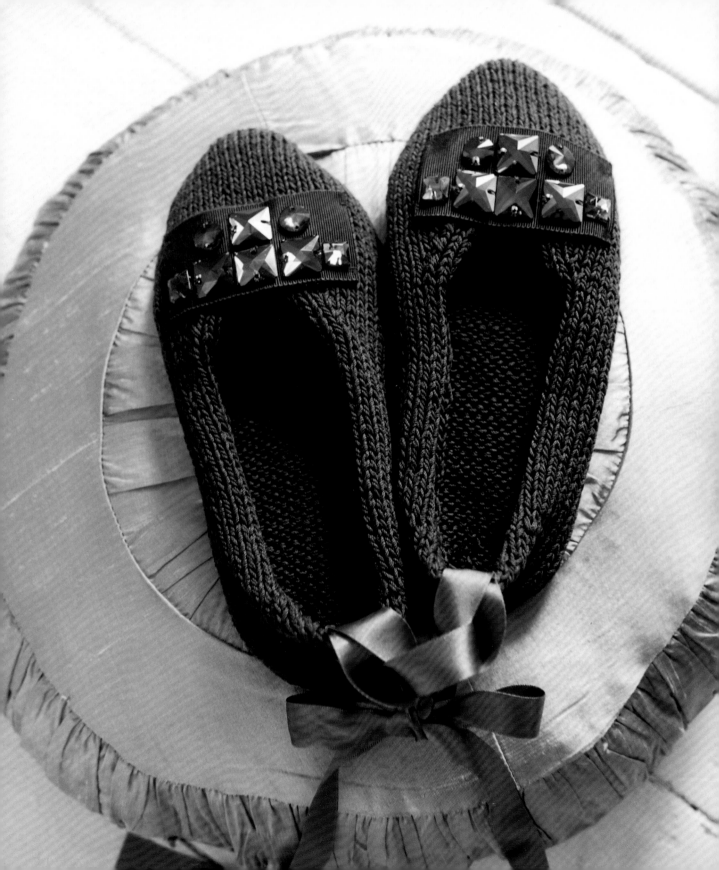

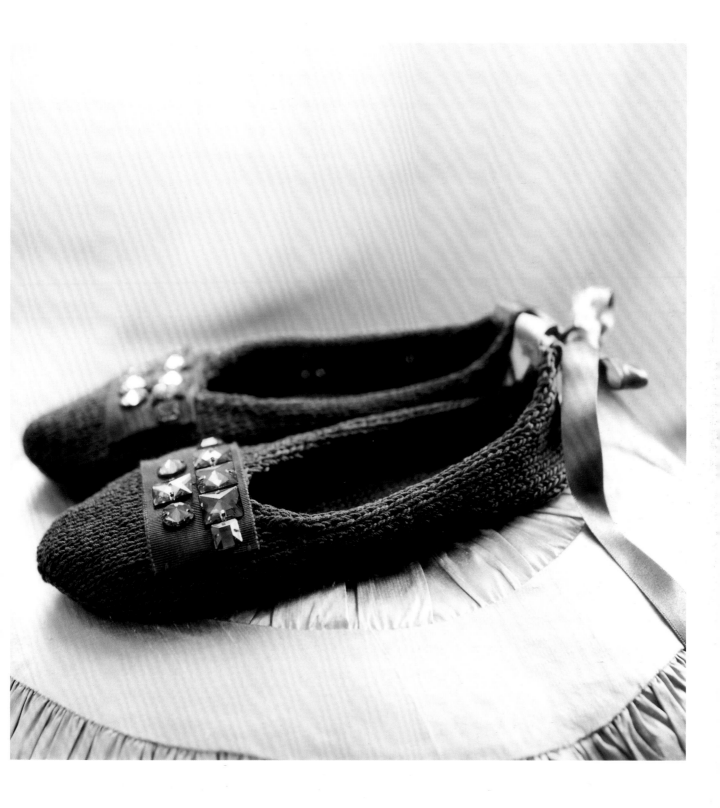

ornate slippers

materials

Any super-fine-weight mercerized cotton yarn, such as
 Yeoman *Cannele 4ply*
 1 x 245g (8¾oz) cone in aubergine
Pair of 4mm (US size 6) knitting needles
33cm (13in) of grosgrain ribbon, 4cm (1½in) wide
1m (1yd) of satin ribbon, 1.5cm (½in) wide
8 large square faceted sew-on jewels
2 small square faceted sew-on jewels
2 small round faceted sew-on jewels
Sewing needle and sewing thread for sewing on jewels

sizes

Size	small	medium	large	
Finished length	20	22	24.5	cm
	8	8¾	9½	in

Note: Slippers stretch to fit so that they fit snuggly.

tension (gauge)

22 sts and 28 rows to 10cm (4in) over st st using yarn doubled and
 4mm (US size 6) needles or size necessary to obtain tension (US
 gauge).

pattern note

• The yarn is used double throughout.

To make right sole

Using 4mm (US size 6) needles and two strands of yarn held together throughout, cast on 5 sts.

Shape heel end

Work sole in st st as foll:

Row (RS): K.

Row 2: P1, m1, p to last st, m1, p1.

Row 3: K1, m1, k to last st, m1, k1.

Rep last 2 rows once more. *13 sts.*

Work without shaping until sole measures 10cm (4in) from cast-on edge, ending with RS facing for next row.

Shape toe end

Next row (inc row) (RS): K2, m1, k to end.

Next row: P.

Rep last 2 rows 1 (3: 5) times more. *15 (17: 19) sts.*

Work without shaping until sole measures 17.5 (19 : 20.5)cm/7 (7½: 8)in from cast-on edge, ending with RS facing for next row.

Next row (RS): K2, k2tog, k to last 4 sts, k2tog tbl, k2.

Next row: P.

Rep last 2 rows until 7 sts remain. Cast off (US bind off).

To make left sole

Work as for right sole, but work toe-end inc rows as foll:

Inc row (RS): K to last 2 sts, m1, k2.

To make uppers (make 2)

Using 4mm (US size 6) needles and two strands of yarn held together throughout, cast on 6 sts.

Work upper in st st as foll:

Row 1 (WS): P.

Row 2: K2, m1, k to last 2 sts, m1, k2.

Row 3: P2, m1, p to last 2 sts, m1, p2.

Rep last 2 rows until there are 22 (26: 30) sts.

Next row: K2, m1, k to last 2 sts, m1, k2.

Next row: P.

Rep last 2 rows until there are 30 (32: 40) sts.

Work without shaping until upper measures 8 (9: 9.5)cm/3¼ (3½: 3¾)in, ending with RS facing for next row.

Shape sides

Next row (RS): K14 (15: 19) and slip these sts onto a st holder, cast off (US bind off) next 2 sts, k to end. Working on these 14 (15: 19) sts only, cont as foll:

Next row: P.

Next row: K3, k2tog, k to end.

Next row: P.

Rep last 2 rows until there are 11 (12: 16) sts.

Work without shaping until upper measures 18 (21: 23)cm/7 (8¼: 9)in from cast-on edge, ending with RS facing for next row.

Next row (RS): K2, m1, k to end.

Work without shaping for 3 rows.

Rep last 4 rows, twice more. *14 (15: 19) sts.*

Work without shaping until upper measures 21.5 (23: 24.5)cm/8½: 9: 9¾)in from cast-on edge. Cast off (US bind off).

With WS facing, rejoin yarn to sts on holder and p to end.

Next row (RS): K to last 5 sts, sl 1, k1, psso, k3.

Next row: P.

Rep last 2 rows until there are 11 (12: 16) sts.

Work without shaping until upper measures 18 (21: 23)cm/7 (8¼: 9)in from cast-on edge, ending with RS facing for next row.

Next row (RS): K to last 2 sts, m1, k2.

Work without shaping for 3 rows.

Rep last 4 rows, twice more. *14 (15: 19) sts.*

Work without shaping until upper measures 21.5 (23: 24.5)cm/8½: (9: 9¾)in. Cast off (US bind off).

To finish

Weave in any loose yarn ends.

Lay work out flat and gently steam.

Sew together cast-off (US bound-off) edges of uppers with an outside seam to form heel.

With wrong sides together, pin sole to upper, easing to fit, and sew using mattress stitch.

Decoration

Cut grosgrain ribbon in half, fold ends in to centre to make a double thickness and press. Sew jewels to grosgrain ribbons as shown and sew to uppers.

Cut two 10cm (4in) lengths of satin ribbon. Fold under ends of each piece, then fold in half widthwise to form a loop. Stitch one loop to centre back heel seam on each slipper.

95

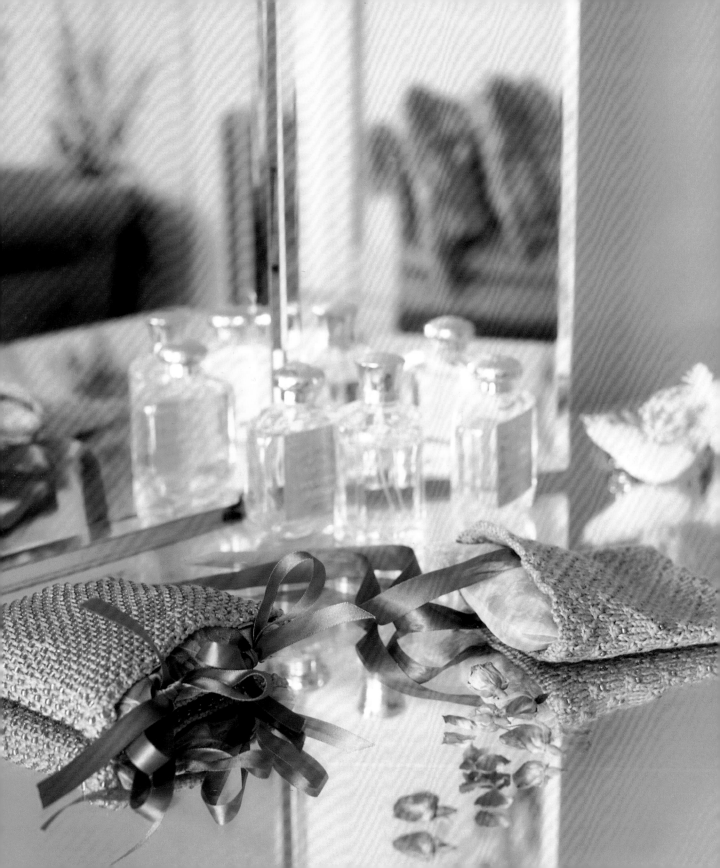

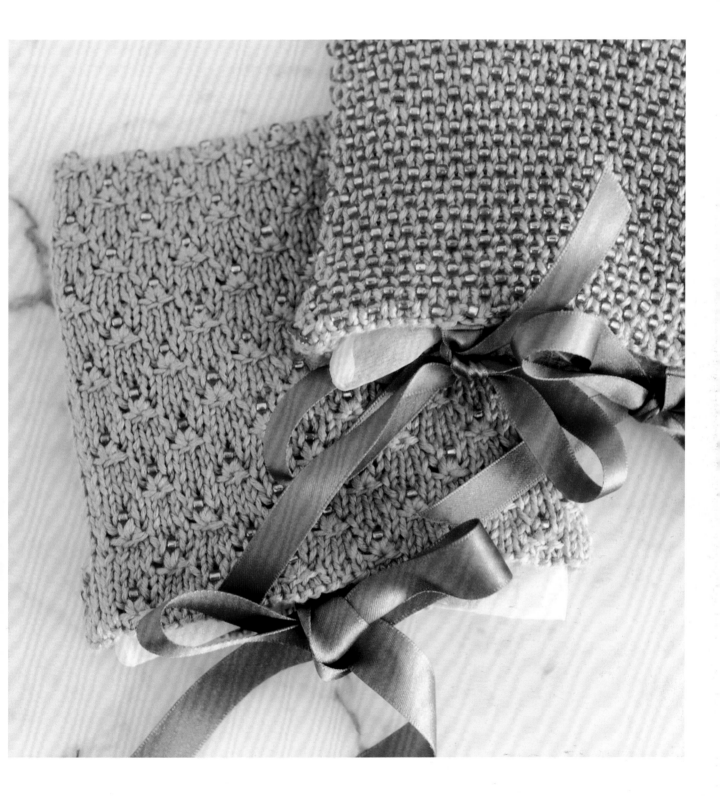

scented sachets

materials

Any double-knitting-weight silk yarn, such as Debbie Bliss
Luxury Silk DK
2 x 50g (1¾oz) balls for both bags
Approximately 1,300 beads, for scented sachet with all-over beads
Approximately 220 beads, for scented sachet with knots and beads
Pair of 3mm (US size 3) knitting needles
Small piece of organza and matching sewing thread, to make
inner bag
Lavender or rose petals to fill inner bag
Satin ribbons

size

One size, approximately 12.5cm x 12.5cm (5in x 5in)

tension (gauge)

Scented sachet with all-over beads: 28 sts and 52 rows to 10cm
(4in) over beaded st st using 3mm (US size 3) needles.
Scented sachet with knots and beads: 28 sts and 40 rows to 10cm
(4in) over beaded knot pattern using 3mm (US size 3) needles.

pattern notes

* Before starting to knit, thread the beads onto the yarn. To do this,
 thread a sewing needle that will pass through the bead with sewing
 thread, knot the ends of the thread, and put the yarn through this
 loop. Thread the beads onto the needle and slide them along onto
 the yarn until they are all threaded on.

special abbreviations

bead 1 = bring yarn to front (RS) of work between two needles, slip bead up next to st just worked and slip next st purlwise from left needle to right needle to leave bead in front of slipped st, then take yarn to back (WS) of work between two needles.

make knot = p3tog leaving sts on left needle, then k same 3 sts tog, p them tog again and slip sts off left needle.

To make scented sachet with all-over beads

Using 3mm (US size 3) needles, cast on 42 sts.

Beg with a k row, work 6 rows in st st, ending with RS facing for next row.

Next row (ridge row) (RS): P, to form foldline ridge.

Next row: P.

Now add beads where indicated as foll:

Row 1 (RS): K2, *bead 1, k1; rep from * to last 2 sts, k2.

Row 2: P.

Row 3: K3, *bead 1, k1; rep from * to last st, k1.

Row 4: P.

Rep last 4 rows until work measures 25cm (10in) from ridge row, ending with WS facing for next row.

Next row (ridge row) (WS): K, to form foldline ridge on RS.

Beg with a k row, work 6 rows in st st. Cast off (US bind off).

To make scented sachet with knots and beads

Using 3mm (US size 3) needles, cast on 42 sts.

Beg with a k row, work 6 rows in st st, ending with RS facing for next row.

Next row (ridge row) (RS): P, to form foldline ridge.

Next row: P.

Now make knots and add beads where indicated as foll:

Row 1 (RS): K1, *make knot, k3; rep from * to last 5 sts, make knot, k2.

Row 2: P.

Row 3: K2, *bead 1, k5; rep from * to last 4 sts, bead 1, k3.

Row 4: P.

Row 5: K4, *make knot, k3; rep from * to last 2 sts, k2.

Row 6: P.

Row 7: *K5, bead 1; rep from * to last 6 sts, k6.

Row 8: P.

Rep last 8 rows until work measures 25cm (10in) from ridge row, ending with WS facing for next row.

Next row (ridge row) (WS): K, to form foldline ridge on RS.

Beg with a k row, work 6 rows in st st. Cast off (US bind off).

To finish both sachets

Weave in any loose yarn ends. Lay work out flat and gently steam on WS to avoid damaging beads. Fold in half widthwise and sew both side seams.

Turn top edge to inside along ridge row and sew in place.

Sew a length of ribbon to each side of opening.

Inner bag

Cut a strip of organza 15.5cm x 29cm (6in x 11in). Fold in half widthwise and sew sides taking 1.5cm (½in) seams. Turn right-side out and fill with rose petals or lavender. Slip stitch opening closed. Insert bag into knitted cover.

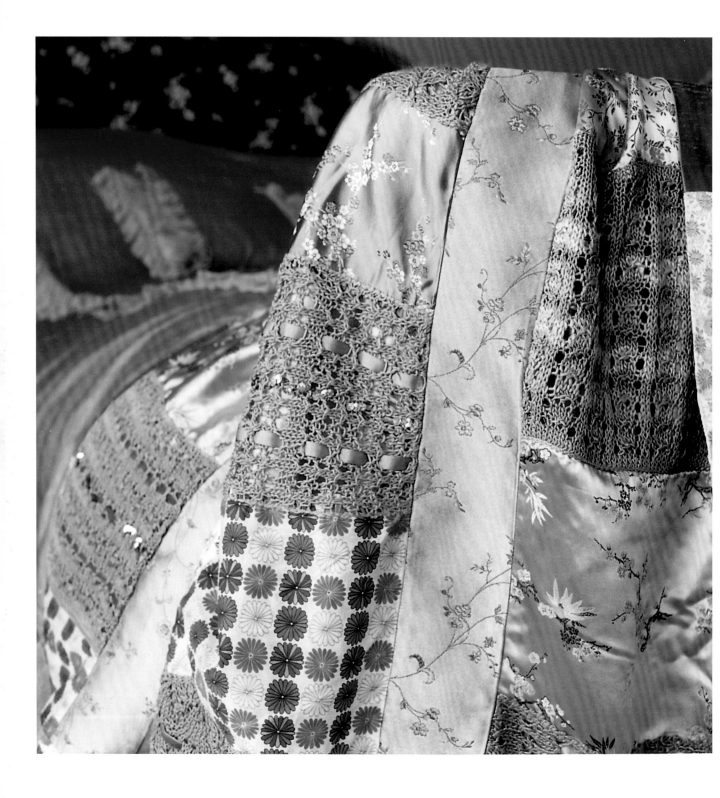

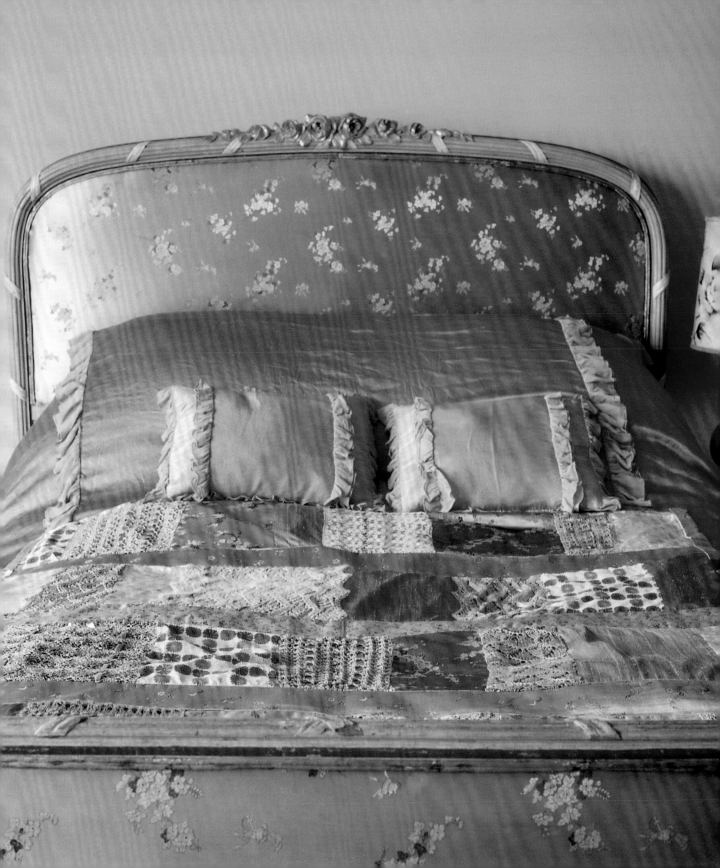

chinoiserie throw

materials

Any super-fine-weight mercerized cotton yarn, such as Yeoman *Cannele 4ply*
 Small amount in four different colours – tangerine, dusty pink,
 light pink and light sage
Any double-knitting-weight silk yarn, such as Debbie Bliss *Luxury Silk DK*
 1 x 50g (1¾oz) ball in mauve
Pair of 4mm (US size 6) knitting needles 3.25mm (US size 3) and
Assorted fabrics in five different colours (and matching thread) for
 patchwork, such as
 A: chinoiserie silk in three colourways
 B: floral print cotton lawn
 C: silk dupion
Ten 1m (1yd) lengths of assorted velvet and satin ribbons and sequins
Fusible interfacing
Microfilament sewing thread

size

One size, approximately 127cm x 127cm (50¼in x 50¼in)

pattern notes

- Make 12 assorted knitted squares using the stitch patterns on the opposite page, in a variety of yarns and colours and introducing coloured stripes as desired.
- Make each square either 24cm (9½in) long or 24cm (9½in) wide so they can be appliquéd in place either vertically or horizontally across a 24cm (9½in) panel. For vertical squares, work a tension (US gauge) swatch in the chosen stitch to determine how many stitches to cast on for a 24cm (9½in) width.

To make knit squares

Using 4mm (US size 6) needles, knit 12 squares (see Pattern Notes).

Cell stitch

Cast on a multiple of 4 sts plus 3 sts.

Row 1 (RS): K2, *yfwd (US yo), sl 1, k2tog, psso, yfwd, k1; rep from * to last st, k1.

Rows 2, 6 and 8: P.

Row 3: K1, k2 tog, yfwd (US yo), k1, *yfwd, sl 1, k2tog, psso, yfwd, k1; rep from * to last 3 sts, yfwd, sl 1, k1, psso, k1.

Rows 4 and 5: K.

Row 7: K.

Rep last 8 rows to form patt.

Van Dyke stitch

Cast on a multiple of 10 sts plus 1 st.

Row 1 (RS): K1, *yfwd (US yo), k3, sl 1, k2tog, psso, k3, yfwd, k1; rep from *.

Row 2 and every WS row: P.

Row 3: K1, *k1, yfwd (US yo), k2, sl 1, k2tog, psso, k2, yfwd, k2; rep from *.

Row 5: K1, *k2, yfwd (US yo), k1, sl 1, k2tog, psso, k1, yfwd, k3; rep from *.

Row 7: K1, *k3, yfwd (US yo), sl 1, k2tog, psso, yfwd, k4; rep from *.

Row 8: Rep row 2.

Rep last 8 rows to form patt.

Little shell pattern

Cast on a multiple of 6 sts plus 2 sts.

Row 1 (RS): K.

Rows 2 and 4: P.

Row 3: K2, *yfrn (US yo), p1, p3tog, yon (US yo), k2; rep from *.

Rep last 4 rows to form patt.

Undulating lacy rib

Cast on a multiple of 9 sts plus 2 sts.

Rows 1, 3, 5, 7 and 9: *K2, yfwd (US yo), k1, yfwd, k2, k2tog tbl, k2tog; rep from * to last 2 sts, k2.

Row 2 and every foll WS row: P.

Rows 11, 13, 15, 17 and 19: *K2, k2tog tbl, k2tog, k2, yfwd (US yo), k1, yfwd; rep from * to last 2 sts, k2.

Row 20: Rep row 2.

Rep last 20 rows to form patt.

Openwork rib

Cast on a multiple of 4 sts plus 1 st.

Row 1: K1, *k3, p1; rep from *.

Row 2: *K1, p3; rep from * to last st, p1.

Row 3: K1, *yfwd (US yo), sl 1, k2tog, psso, yfrn (US yo), p1; rep from *.

Row 4: Rep row 2.

Rep last 4 rows to form patt.

To finish

Weave in any loose yarn ends on 12 knitted squares and gently press. Thread ribbons and sequins through lace eyelets to embellish knits.

Patchwork top

Cut patches 27cm (10½in) wide from fabrics A, B and C. Iron fusible interfacing onto WS of each piece. Taking 1.5cm (½in) seams on fabric throughout, sew together patches into four panels, each 27cm (10½in) wide by 123cm (48¾in) long. Cut three strips of fabric A, each 11cm (4¼in) by 123cm (48¾in). Then stitch three narrow strips to four pieced panels, alternating the widths. Using microfilament thread, machine zigzag three knitted pieces in random positions to each of four wide panels, stretching knitting to fit if necessary and leaving 1.5cm (½in) uncovered around outer edge of top for edging seam.

Patchwork backing

From A, cut four pieces each 50cm (19¾in) square; then from C, cut two pieces each 29cm (11¼in) by 50cm (19¾in), and one strip 29cm (11¼in) by 123cm (48¾in). Iron fusible interfacing to each piece. Make two panels, each with two A squares sewn to either side of one rectangle in C.

Sew pieced panels to either side of strip in C to make a 123cm (48¾in) square.

With wrong sides together, place patchwork top on top of backing, pin and stitch around edges.

Patchwork edging

From assorted fabrics, cut 24 rectangles, each 10cm (3½in) by 25cm (9½in). Piece these rectangles together lengthwise to make four long strips of six rectangles each. Trim two strips to 123cm (48¾in) and two to 130cm (51¼in).

Press 1.5cm (½in) onto wrong side of one long edge of each strip. With right sides together, and taking 1.5cm (½in) seams, stitch unpressed edge of two shorter edging strips to top and bottom of throw. Fold these strips over onto back of throw and slip stitch pressed edge to backing along stitching line.

Repeat this on other two edges, folding under raw edges at corners.

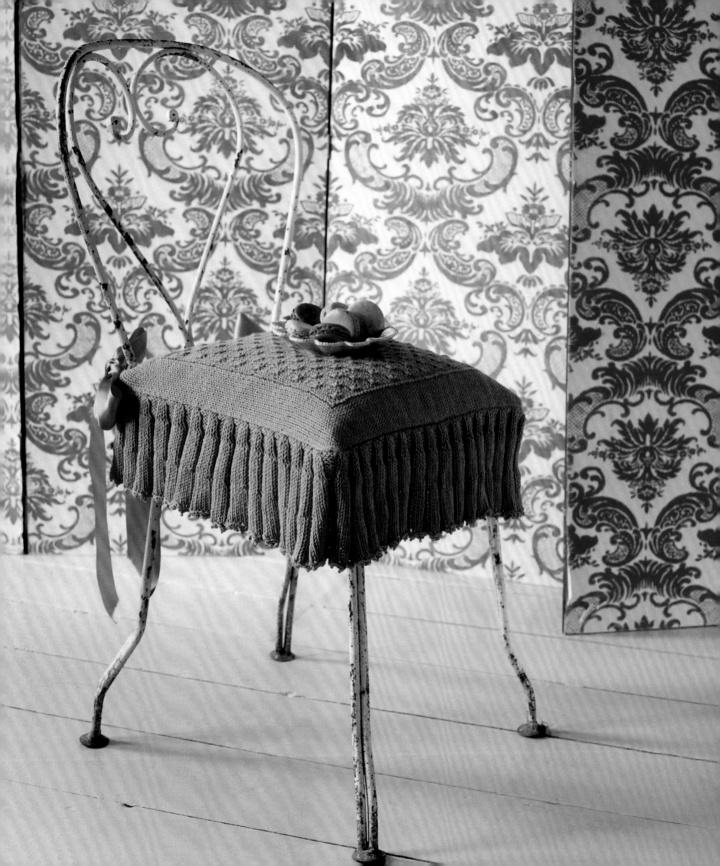

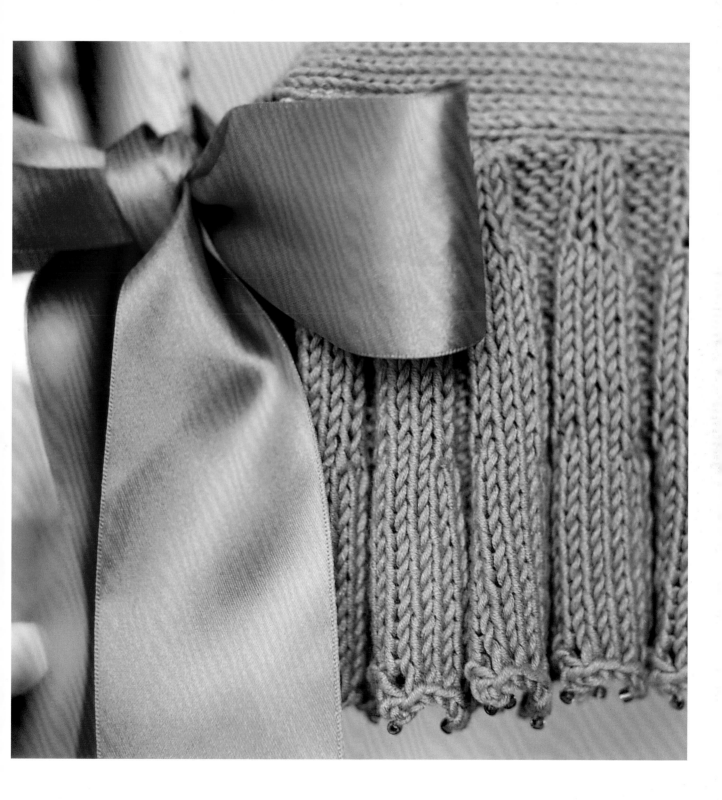

boudoir cushion

materials

Any double-knitting-weight mercerized cotton yarn, such as Wendy
Supreme Luxury Cotton DK
4 x 100g (3½oz) balls
Pair of 3.75mm (US size 5) knitting needles
3.75mm (US size 5) long circular knitting needle, for edging
35cm x 35cm (14in x 14in) feather-filled cushion pad (US pillow form)
Approximately 500 small (3mm) pink glass seed beads
Approximately 2.5m (2¾yds) of pink satin ribbon, 5cm (2in) wide

size

One size, 35cm x 35cm (14in x 14in)

tension (gauge)

22 sts and 30 rows to 10cm (4in) over st st using 3.75mm (US size 5)
needles or size necessary to obtain tension (US gauge).

special abbreviations

make knot = p3tog leaving sts on left needle, then k same 3 sts tog,
p them tog again and slip sts off left needle.

knot pattern

Row 1 (RS): K.
Row 2 and every foll WS row: P.
Row 3: K1, * make knot, k3; rep from * to last 4 sts, make knot, k1.
Row 5: K.
Row 7: K4, * make knot, k3; rep from * to last st, k1.
Row 8: P.
Rep last 8 rows to form knot patt.

To make cushion top

Using 3.75mm (US size 5) needles, cast on 77 sts.

Beg with a k row, work 15 rows in st st, ending with WS facing for next row.

Next row (WS): P11, k55, p11.

Next row (RS): K11, p1, work row 1 of knot patt over next 53 sts, p1, k11.

Next row: P11, k1, work row 2 of knot patt over next 53 sts, k1, p11.

Cont with sts and knot patt as set until work measures 30cm (12in) from cast-on edge, ending with RS facing for next row.

Next row (RS): K11, p55, k11.

Beg with a p row, work 15 rows in st st.

Cast off (US bind off).

To make cushion base

Using 3.75mm (US size 5) needles, cast on 77 sts.

Beg with a k row, work in st st for 35cm (14in).

Cast off (US bind off).

To make edging

With RS of work facing and using 3.75mm (US size 5) needles, pick up and k 79 sts along cast-off (US bound-off) edge of cushion top (back edge of cushion top).

Row 1 (WS): K4, *p1, k4; rep from * to end.

Row 2: P4, *m1, k1, m1, p4; rep from * to end.

Rows 3, 5, and 7: K4, *p3, k4; rep from * to end.

Rows 4 and 6: P4, *k3, p4; rep from * to end.

Row 8: P4, *[k1, m1 twice, k1, p4; rep from * to end.

Row 9: K4, *p5, k4; rep from * to end.

Row 10: P4, *k5, p4; rep from * to end.

Rows 11–18: Rep rows 9 and 10 four times.

Row 19: Rep row 9.

Row 20: P4, *k1, m1, k3, m1, k1, p4; rep from * to end.

Row 21: K4, *p7, k4; rep from * to end.

Row 22: P4, *k7, p4; rep from * to end.

Rows 23–30: Rep rows 21 and 22 four times.

Row 31: Rep row 21.

Work simple picot cast-off (US bind-off) as foll:

Next row: Cast off (US bind off) 4 sts, * slip st on right needle back onto left needle, k twice into this st, cast off (US bind off) 4 sts; rep from * to end.

Work edging around remaining three sides of cushion as foll:

With RS of cushion top facing and using 3.75 (US size 5) circular needle, pick up and k 78 sts along one side edge of cushion, 78 sts along cast-on edge and 78 sts along remaining side edge of cushion. *234 sts.*

Work 31-row edging patt and picot cast-off on these sts.

To finish

Weave in any loose yarn ends.

Lay work out flat and gently steam.

Sew cushion base to top along three sides, using mattress stitch.

Insert cushion pad (US pillow form) and sew final seam.

Cut ribbon into four pieces. Fold under one end of each piece to neaten and stitch a pair at each side of opening at back of cushion, under edging. Tie in a large bow.

Stitch a small glass bead to each point of picot edge.

tea-party tea cozy

materials

3m (3¼yds) of tulle fabric, 70cm (27½in) wide, cut into a continuous
 strip (see Pattern Note below)
Pair of 9mm (US size 13) knitting needles
50cm (½yd) of chinoiserie fabric, 70-cm (27½-in) wide, for lining
Elastic thread
50cm (½yd) of organza ribbon, 4cm (1½in) wide

size

One size, approximately 43cm (17in) in circumference and 23cm
 (9in) tall

tension (gauge)

12 sts and 20 rows to 10cm (4in) over garter stitch using 9mm
 (US size 13) needles or size necessary to obtain tension (US gauge).

pattern note

- To cut the tulle into a continuous strip of 'yarn', start by laying it
 out flat. Working from right to left, cut the tulle 2.5cm (1in) from the
 bottom edge to within 2cm (¾in) of the left edge. Then cut from left
 to right 2.5cm (1in) away from the first cut, again leaving 2cm (¾in)
 uncut at the right edge. Continue in this way, rolling the strip into a
 ball as you work.

To make tea cozy pieces (make 2)

Using 9mm (US size 13) needles, cast on 26 sts.
Work in garter st (k every row) for 23cm (9in).
Cast off (US bind off).

To finish

Using knitted pieces as templates, cut two pieces of lining fabric, allowing 1.5cm (½in) extra all around for hems. Turn under 1.5cm (½in) around edge of each lining piece and sew lining to knitted pieces.

With wrong sides together, sew together the knitted pieces along the side row-end edges to form a tube, leaving openings for spout and handle.

Run a double line of elastic thread through tulle knitting only, approximately 5cm (2in) down from top, and gently gather up.

Make a floppy bow with organza ribbon and sew to tea cozy on gathered neck.

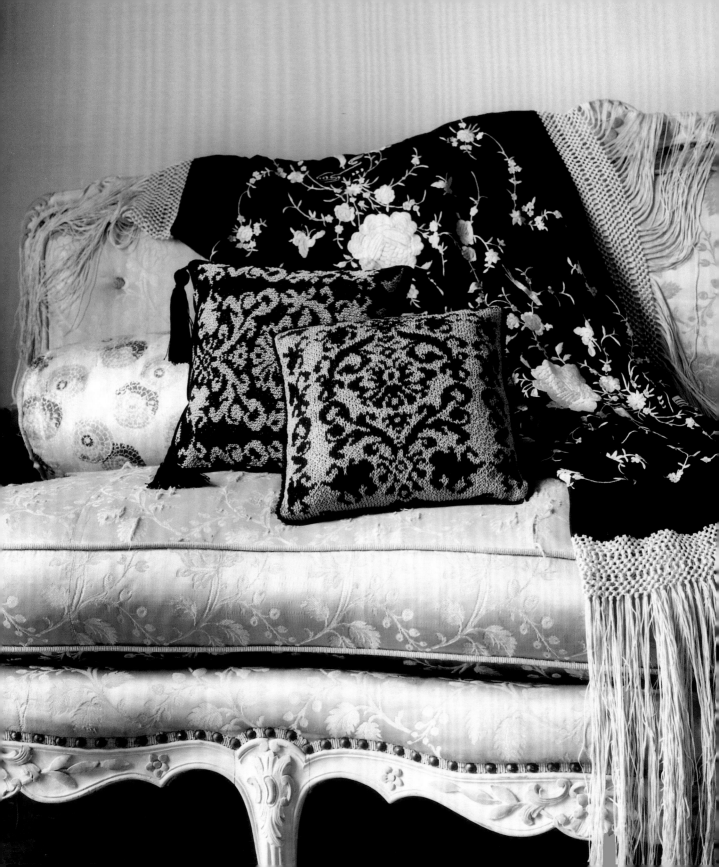

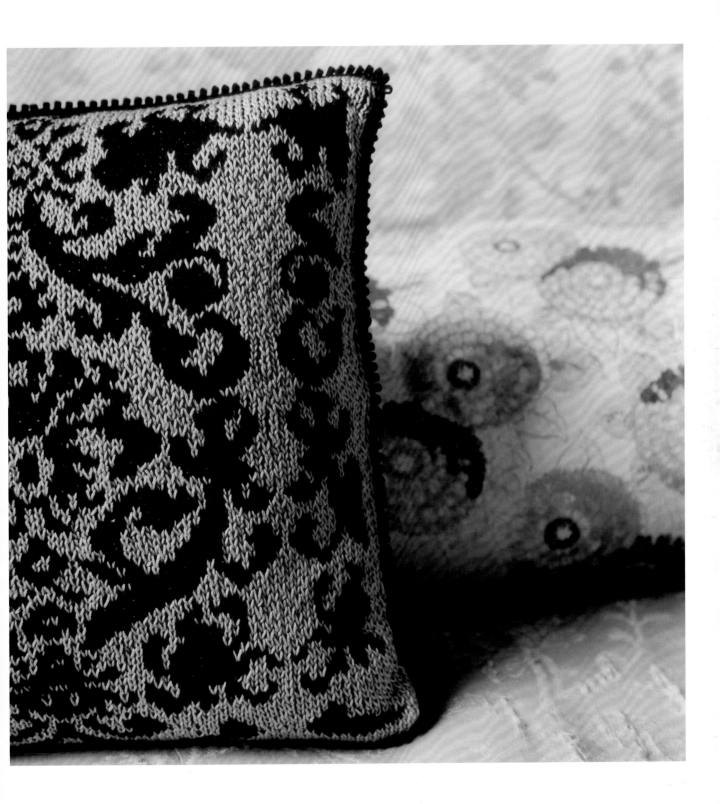

jacquard cushion

materials

Any super-fine-weight mercerized cotton yarn, such as
 Yeoman *Cannele 4ply*
 A: 1 x 245g (8¾oz) cone in black
 B: 1 x 245g (8¾oz) in turquoise
Pair of 3.25mm (US size 3) knitting needles
Approximately 50cm (½yd) of black velvet fabric and matching
 sewing thread, for back of cover
30cm x 30cm (12in x 12in) feather-filled cushion pad
 (US pillow form)
1.3m (1½yds) of braid trimming for edging (optional)

size

One size, approximately 30cm x 30cm (12in x 12in)

tension (gauge)

29 sts and 36 rows to 10cm (4in) over pattern using 3.25mm
 (US size 3) needles or size necessary to obtain tension (US gauge).

pattern notes

• For the reverse colourway, use A for B and B for A. The yarn
 amount specified is enough for both cushions (US pillows).
• When working the stocking stitch (US stockinette stitch) colour
 pattern from the chart, read odd-numbered rows (knit rows)
 from right to left and even-numbered rows (purl rows) from left
 to right.
• Work the colour pattern using the stranding (Fair Isle) technique,
 stranding the yarn not in use loosely across the back of the work.
 Do not carry the yarn over more than three stitches at a time, but
 weave it under and over the colour being worked.

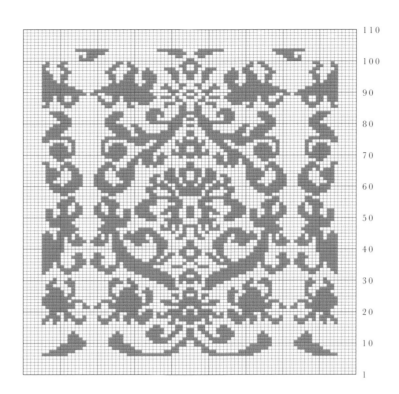

To make cover front
Using 3.25mm (US size 3) needles
and B, cast on 90 sts.
Beg with a k row and chart row 1,
work 110 rows following chart.
Cast off (US bind off).

To finish
Weave in any loose yarn ends.
Lay work out flat and gently steam.
Cover back
For cover back, cut two pieces of
fabric, each 27cm x 33cm (10½in
x 13in).

Along one long edge of each piece
fold 1.5cm (½in) to wrong side
twice and stitch in place to form a
double hem.
Lay knitting right-side up and place
both back pieces wrong-side up on
top, so that raw edges extend 1.5cm
(½in) past edges of knitting and
hemmed edges overlap at centre.
Pin and stitch around all sides,
taking a 1.5cm (½in) seam on
fabric and stitching close to edge on
knitting.
Turn right-side out.

Tassels (optional)
Using a piece of cardboard 10cm
(4in) square and A, make four
tassels as for tassel on page 127, but
tying tassels 2cm (¾in) from top.
Sew one tassel to each corner
of cushion, or sew braid trim
around edge.
Insert cushion pad (US pillow
form).

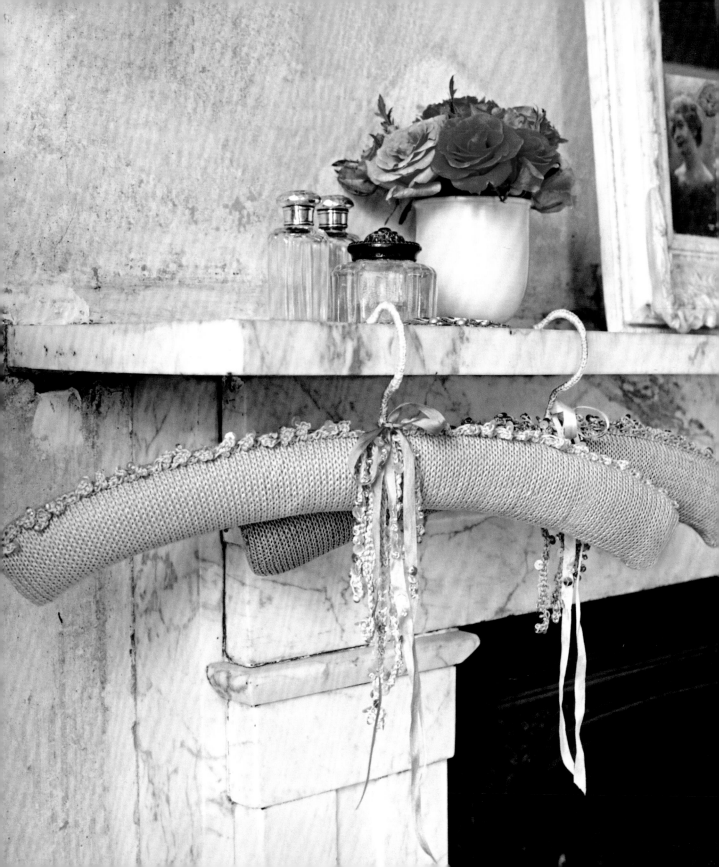

dress hanger

materials

Any super-fine-weight mercerized cotton yarn, such as
 Yeoman *Cannele 4ply*
 1 x 245g (8¾oz) cone
Approximately 5m (5½yds) of ribbon, 7mm (¼in) wide
Two pairs of 3.25mm (US size 3) knitting needles
Approximately 100 small (3mm) green or pink glass seed beads
Approximately 100 small (5mm) green or pink glass bugle beads
Approximately 100 small (5mm) shiny green or pink sequins
Standard-size padded and covered coat-hanger, approximately
 43cm (17in) long x 13cm (5in) around
Sewing needle and sewing thread, to sew on extra beads and sequins

size

One size, to fit standard coat-hanger

tension (gauge)

29 sts and 32 rows to 10cm (4in) over st st using 3.25mm (US size 3)
 needles or size necessary to obtain tension (US gauge).

To make hanger cover

Using 3.25mm (US size 3) needles, cast on 124 sts.

Back of cover

Beg with a k row, work 19 rows in st st, ending with WS facing for next row.

Cut yarn leaving a long end, leave these sts on needle and set aside.

Front of cover

Thread approximately 60 beads and sequins onto yarn.

Using 3.25mm (US size 3) needles and yarn threaded with beads and sequins, cast on 124 sts.

Pushing beads and sequins along yarn to use for picot cast-off (US bind-off) and beg with a k row, work 20 rows in st st, ending with RS facing for next row.

Do not cut yarn.

Join back and front

Join back and front of cover as foll:
Hold two needles with back and front on them in your left hand, the back behind the front with WS together and needle points facing to right, then with a third needle k to end of row, working 1 st from front needle tog with same st from needle behind. *124 sts.*

Picot cast-off (US bind-off)

Remembering to transfer st on right needle to left needle after each cast-off (US bind-off), work picot cast-off (US bind-off) as foll:
[Cast on 3 sts (onto left needle), insert bead/sequin, cast off (US bind off) next 6 sts] 19 times.
Cast on 26 sts, placing bead/sequin on each of last 4 sts, cast off (US bind off) next 28 sts.
Cast on 33 sts, placing bead/sequin on each of last 4 sts, cast off (US bind off) next 35 sts.
Cast on 44 sts, placing bead/sequin on each of last 4 sts, cast off (US bind off) next 46 sts.
Cast on 40 sts, placing bead/sequin on each of last 4 sts, cast off (US bind off) next 42 sts.
Cast on 20 sts, placing bead/sequin on each of last 4 sts, cast off (US bind off) next 22 sts.
[Cast on 3 sts, insert bead/sequin, cast off (US bind off) next 6 sts] 19 times.
Fasten off.

To finish

Weave in any loose yarn ends.
Lay work out flat and gently steam.
Sew seam on knitted cover, leaving one short end open.
Remove hook and push hanger into cover.
Sew short end closed.
Screw hook back into hanger, gently pushing through knitting.

Embellishments

Cover hook with satin ribbon by wrapping around hook in blanket-stitch fashion and secure with small sewing stitches.
Tie ribbon around neck of hook and tie in a bow. Sew a few sequins onto ribbon.
Embellish long tendrils randomly with beads and sequins to create pretty dangling shapes.

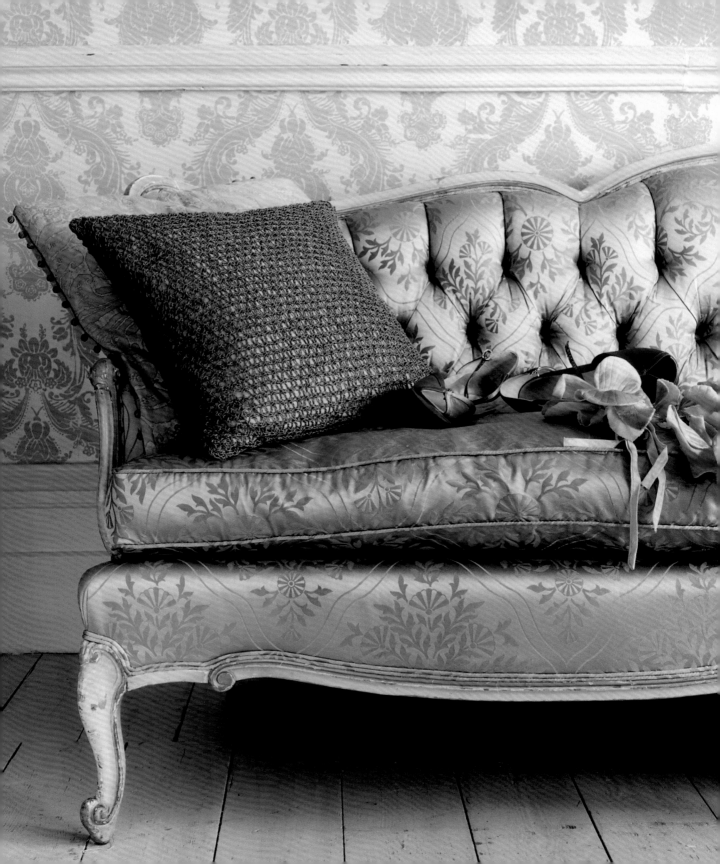

knot stitch cushion

materials

Any super-fine-weight mercerized cotton yarn, such as
 Yeoman *Cannele 4ply*
 1 x 245g (8¾oz) cone
Pair of 5mm (US size 8) knitting needles
45cm x 45cm (18in x 18in) feather-filled cushion pad
 (US pillow form)
50cm (¾yd) of silk fabric to cover cushion pad
 (US pillow form)

size

One size, approximately 45cm x 45cm (18in x 18in)

tension (gauge)

17 sts to 10cm (4in) over knot stitch pattern using 5mm (US size 8)
 needles or size necessary to obtain tension (US gauge).

To make cover front

Using 5mm (US size 8) needles, cast on 77 sts.

Beg with a k row, work 2 rows in st st, ending with RS facing for next row.

Beg knot stitch patt as foll:

Row 1 (RS): K3, *yfwd (US yo), sl 1, k2tog, psso, yfwd, k1; rep from * to last 2 sts, k2.

Row 2: P.

Row 3: K2, k2tog, yfwd (US yo), k1, *yfwd, sl 1, k2tog, psso, yfwd, k1; rep from * to last 4 sts, yfwd, sl 1, k1, psso, k2.

Row 4: P.

Rep last 4 rows until work measures 44cm (17¾in) from cast-on edge, ending with RS facing for next row. Beg with a k row, work 2 rows in st st.

Cast off (US bind off).

To make cover back

Work cover back exactly as for cover front.

To finish

Weave in any loose yarn ends. Lay work out flat and gently steam.

Cushion pad (US pillow form) covering

Cut two pieces of fabric 48cm (19in) square.

With right sides together, stitch around three sides, taking a 1.5cm (½in) seam. Turn right-side out. Insert cushion pad (US pillow form) and slip stitch opening closed.

Knitted cover

With wrong sides facing, sew three seams of cushion (US pillow) cover, using mattress stitch.

Insert cushion pad (US pillow form) and sew last seam.

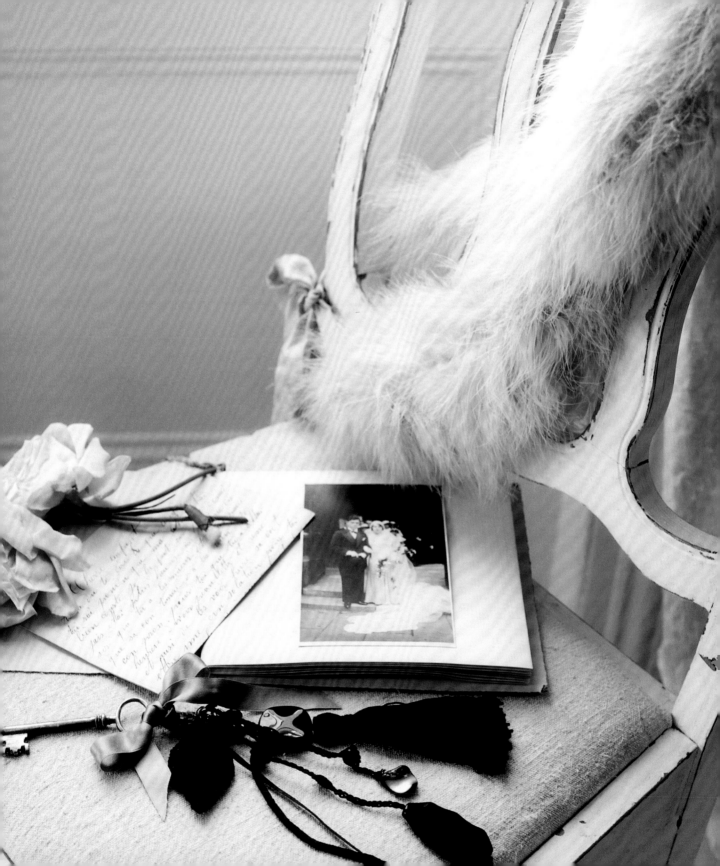

key fob

materials

Small amount of any super-fine-weight mercerized cotton yarn, such
 as Yeoman *Cannele 4ply*
Pair of 2.75mm (US size 2) knitting needles
1 small-size (15mm) natural irregular black bead
1 medium-size (30mm) natural irregular black bead
1 large-size (50mm) natural irregular black bead
1 small-size (15mm) natural stone bead
20cm (8in) of a strand of black sequins
20cm (8in) of very narrow black satin ribbon
50cm (½yd) of taupe satin ribbon, 1cm (½in) wide
Snap hook

To make leaf shapes (make 2)
Using 2.75mm (US size 2) needles,
cast on 3 sts
Row 1 (RS): K.
Row 2 and every foll WS row: P.
Row 3: [K1, m1] twice, k1.
Row 5: K2, m1, k1, m1, k2.
Row 7: K3, m1, k1, m1, k3.
Row 9: K4, m1, k1, m1, k4.
Row 11: K5, m1, k1, m1, k5. *13 sts.*
Row 13: Sl 1, k1, psso, k to last 2
sts, k2tog.

Row 15: Rep row 13.
Row 17: Rep row 13.
Row 19: Rep row 13.
Row 21: Rep row 13. *3 sts.*
Row 23: Sl 1, k2tog, psso and
fasten off.
Make second leaf shape in same
way.

I-cord with bobbles (make 2)
Using 2.75mm (US size 2) needles,
cast on 1 st, leaving a long yarn end

(to secure cord to snap hook).
Work this st in garter st (k every
row) until cord measures 2cm (¾in).
Next row (bobble row) [K into
front and back of st] twice, k into
front of st again. *5 sts.*
K 1 row.
Next row P5tog. *1 st rem.*
Cont as set, working a bobble
as before at random intervals
between rows of garter st until
cord measures approximately

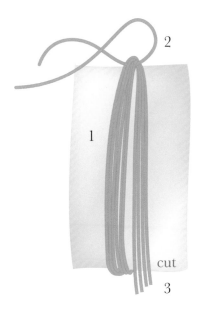

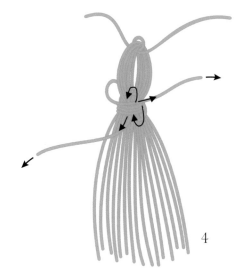

7.5cm (3in) from cast-on edge. Fasten off, leaving a long yarn end (to go through bead).
Make a second cord in same way approximately 11cm (4¼in) long.

To make tassel
Cut a piece of cardboard 13cm (5in) long (or length of tassel required) and wrap a generous amount of yarn around it.
Wrap a separate length of yarn a few times around strands at one end of cardboard and knot, leaving long enough loose ends for stitching tassel in place.

Cut strands at other end of tassel. Wrap another length of yarn around tassel, approximately 1.5cm (½in) from top (to form a 'neck'), linking and securing ends under wrapping.

To finish
Thread large bead onto longest length of I-cord and attach this cord to snap hook by folding over top and securing with a small stitch. Thread smaller natural stone onto shorter length of I-cord and attach this cord to snap hook in same way. Next, attach lengths of sequins and

narrow satin ribbon to snap hook in same way as cords.
Thread end at top of tassel through medium bead, then through other natural stone. Attach tassel to snap hook with a knot and secure with a small stitch.
Sew two leaf shapes together around edges, fold top over snap hook and secure with a few small stitches.
Finally thread silk ribbon through the snap hook and tie in a bow.

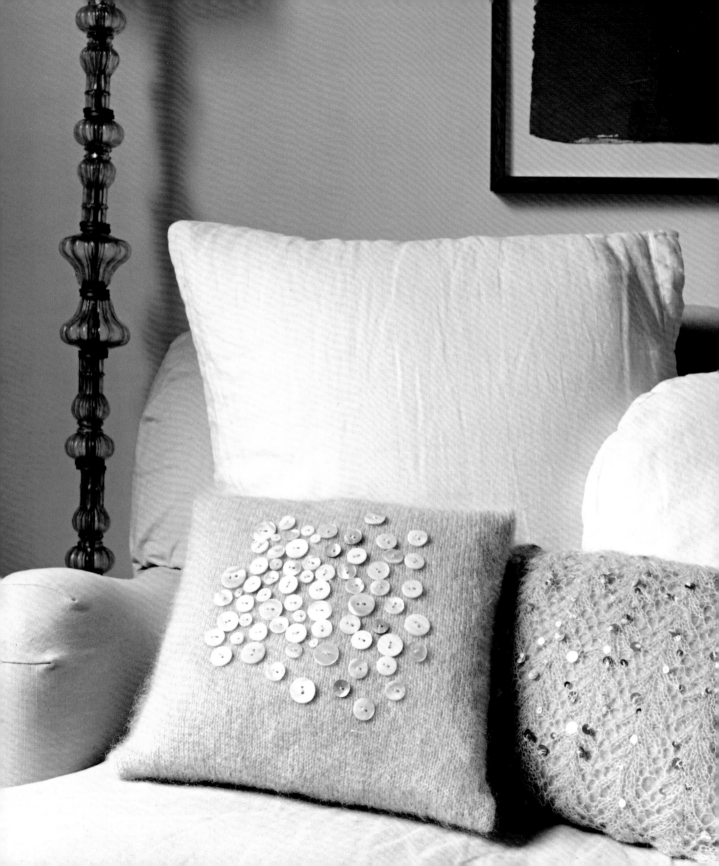

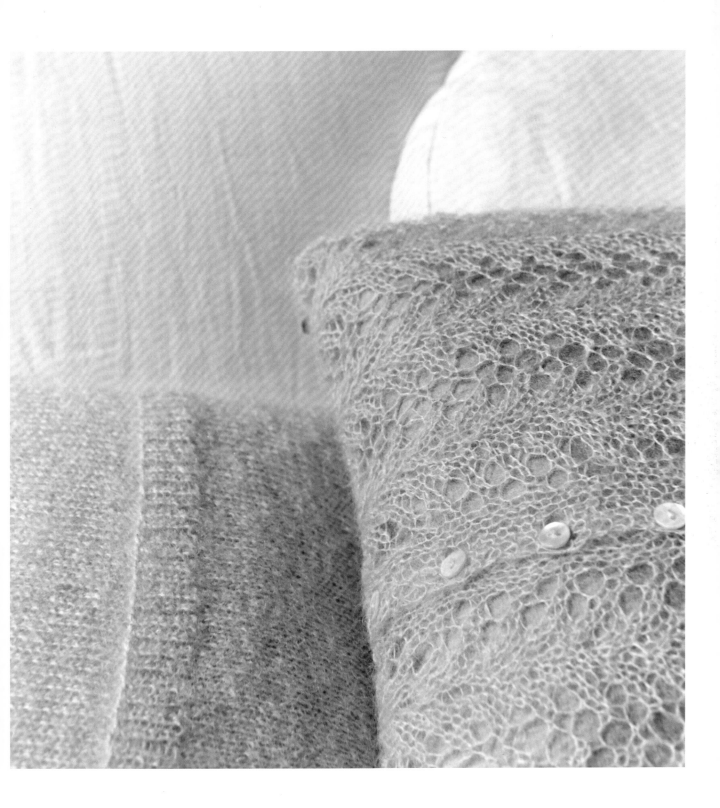

pearl button and lace sequin cushions

materials

pearl button cushion

Any fine-weight mohair-blend yarn, such as Rowan *Kidsilk Haze*
 4 x 25g (⅞oz) balls
Pair of 3.75mm (US size 5) knitting needles
Approximately 70 mother-of-pearl buttons in assorted sizes

lace sequin cushion

Any fine-weight 4ply mohair-blend yarn, such as Rowan *Kidsilk Haze*
 2 x 25g (⅞oz) balls
Pair of 5mm (US size 8) knitting needles
Approximately 100 small (5mm) and medium (10mm) shiny silver sequins
7 small mother-of-pearl buttons
50cm (35½in) of 90cm (19¾in) wide silk fabric and matching sewing thread

both cushions

Feather-filled cushion pad (US pillow form) to fit finished cover

size

Pearl button cushion: One size, approximately 40cm x 40cm (16in x 16in)
Lace sequin cushion: One size, approximately 40cm x 30cm (16in x 12in)

tension (gauge)

Pearl button cushion: 22 sts and 30 rows to 10cm (4in) over st st using yarn doubled and 3.75mm (US size 5) needles or size necessary to obtain tension (US gauge).
Lace sequin cushion: 19 sts and 24 rows to 10cm (4in) over stitch pattern using 5mm (US size 8) needles or size necessary to obtain tension (US gauge).

lace stitch pattern

Row 1 (WS): K3, p to last 3 sts, k3.
Row 2: K5, *yfwd (US yo), k2, sl 1, k1, psso, k2tog, k2, yfwd, k1; rep from * to last 4 sts, k4.
Row 3: K3, p to last 3 sts, k3.
Row 4: K4, *yfwd (US yo), k2, sl 1, k1, psso, k2tog, k2, yfwd, k1; rep from * to last 5 sts, k5.
Rep last 4 rows to form lace stitch patt.

To make button version

Using 3.75mm (US size 5) needles and two strands of yarn held together throughout, cast on 81 sts.
Row 1 (RS): *K2, p1; rep from * to end.
Row 2: *K1, p2; rep from * to end.
Rep last 2 rib rows until work measures 2.5cm (1in), ending with RS facing for next row.
Beg with a k row, work in st st until work measures 87.5cm (34½in) from cast-on edge, ending with RS facing for next row.
Work in rib as for cast-on edge for 2.5cm (1in).
Cast off (US bind off) in rib.

To make lace sequin version

Using 5mm needles (US size 8), cast on 153 sts.

Work 2cm (¾in) in lace stitch patt, ending with RS facing for next row.
Next row (buttonhole row): K1, yfwd (US yo), k2tog, patt to end.
Cont in patt and work 6 more buttonholes approximately 4cm (1½in) apart **and at the same time** cont until work measures 30cm (12in) from cast-on edge, ending with WS facing for next row.
Cast off (US bind off).

To finish both versions

Weave in any loose yarn ends.
Lay work out flat and gently steam.
Button cushion (US pillow)
Fold edges into centre, overlapping by 5cm (2in).
Sew side seams with mattress stitch, working through all layers.
Scatter buttons randomly over cushion front and sew in place.
Insert cushion pad (US pillow form).
Lace cushion (US pillow)
Fold edges into centre, overlapping by width of garter stitch borders.
Sew side seams with mattress stitch, working through all layers.
Scatter sequins randomly over cushion front and sew in place.
Sew on buttons to match buttonholes.
For fabric cushion pad (US pillow form) cover, cut two pieces of silk fabric, each 43cm (17in) square.
With right sides of fabric together, stitch around three sides, taking a 1.5cm (½in) seam. Turn right-side out.
Insert cushion pad (US pillow form), slip stitch seam closed and insert in lace cover.

classic
for her

cable scarf

materials

Any aran-weight wool yarn, such as Erika Knight *Vintage Wool*,
 Rowan *Super Fine Merino Aran* or Erika Knight for John Lewis *Aran*
 4 x 50g (1¾oz) balls of *Vintage Wool* or *Super Fine Merino Aran* or
 3 x 100g (3oz) balls of *Aran*
Pair of 4.5mm (US size 7) knitting needles
Cable needle
2 stitch holders

size

One size, approximately 106.5cm (42in) long

tension (gauge)

19 sts and 25 rows to 10cm (4in) over st st using 4.5mm (US size 7)
 needles or whatever size necessary to obtain tension (US gauge).

special abbreviations

C6B (cable 6 back) = slip next 3 sts onto cn and hold at back of work,
 k3, then k3 from cn.
C6F (cable 6 front) = slip next 3 sts onto cn and hold at front of work,
 k3, then k3 from cn.

cables

upwards cable (worked over 12 sts)
Row 1 (RS): K.
Row 2: P.
Row 3: C6B, C6F.
Row 4: P.
Rows 5–8: Rep rows 1 and 2 twice.
Rep last 8 rows to form cable.

downwards cable (worked over 12 sts)
Row 1 (RS): K.
Row 2: P.
Row 3: C6F, C6B.
Row 4: P.
Rows 5–8: Rep rows 1 and 2 twice.
Rep last 8 rows to form cable.

To make scarf
Using 4.5mm (US size 7) needles, cast on 50 sts.
Rib row 1 (RS): *K2, p1; rep from * to last 2 sts, k2.
Rib row 2: P2, *k1, p2; rep from * to end.
Rep last 2 rows twice.
Beg upwards cable patt as foll:
Next row (RS): [K1, p1] 3 times, k13, p1, work row 1 of upwards cable over next 12 sts, [p1, k1] 9 times.
Next row: [P1, k1] 9 times, work row 2 of upwards cable over next 12 sts, k1, p13, [k1, p1] 3 times.
Keeping rib and upwards cable pattern correct as set, cont in patt **and at the same time** working dec 3 sts in from edge, dec 1 st by working p2tog at end of next row and then at same edge on every foll 6th row until 38 sts rem, ending with WS facing for next row.
Next row (WS): [P1, k1] 3 times, p26, [k1, p1] 3 times.
Next row (RS): [K1, p1] 3 times, k26, [p1, k1] 3 times.
Cont in st st as now set, with 6-st rib border at each edge, until scarf measures 78.5cm (31in) from cast-on edge, ending with RS facing for next row.
Beg shaping slit in scarf as foll:
Next row (RS): Rib 6, k12, p1, k2tog, k11, rib 6.
Next row: Rib 6, p12, then turn, leaving rem sts on a holder.
Work 18 rows in patt as set on these 18 sts.
Cut off yarn and leave sts on a holder.
With WS facing, rejoin yarn to rem 19 sts left on first holder and work as foll:
Next row (WS): K1, work row 2 of downwards cable over next 12 sts, rib 6.
Next row: Rib 3, inc 1 in next st, rib 2, work row 3 of downwards cable over next 12 sts, p1.
Keeping downwards cable and rib sts correct as set, work 17 rows **and at the same time** inc 1 st at same edge of every foll 6th row.
Both sides of slit have now been completed.
Next row (RS): Rib 3, inc 1 in next st, rib 5, work row 5 of downwards cable over next 12 sts, p1, k into front and back of first st on holder, k next 11 sts from holder and then rib 6 from holder. *42 sts.*
Next row: Rib 6, p13, k1, p12, rib to end.
Cont as set, inc 1 st as set on same edge of every 6th row until there are 50 sts on needle.
Work 1 row (row 6 of downwards cable), ending with RS facing for next row.
Work 6 rows rib as for other end of scarf.
Cast off (US bind off) in rib.

To finish
Weave in any loose yarn ends. Gently steam to enhance the yarn, avoiding 'pressing' cable design. Pass end of scarf through slit to keep in place when worn.

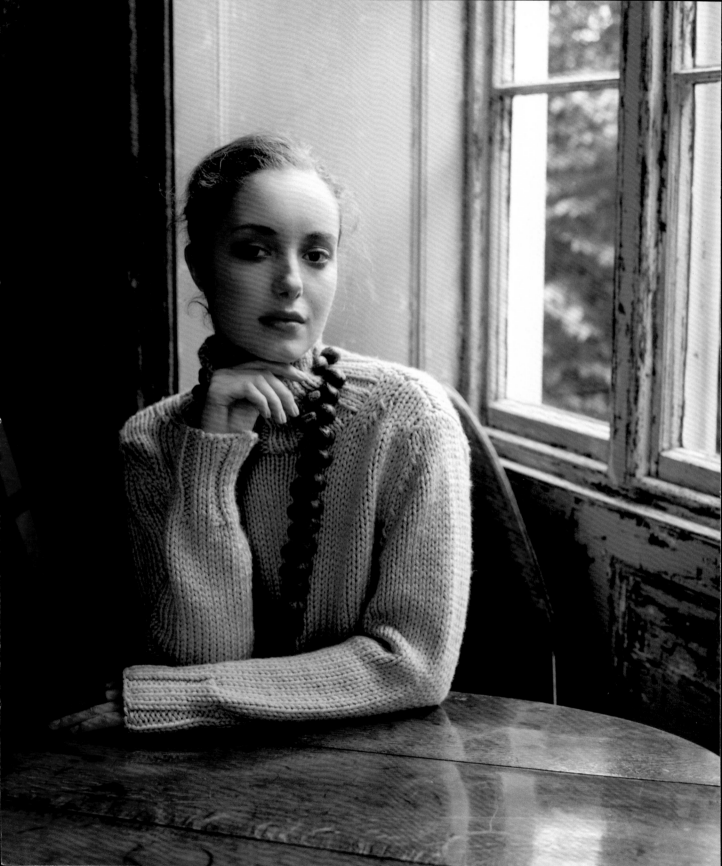

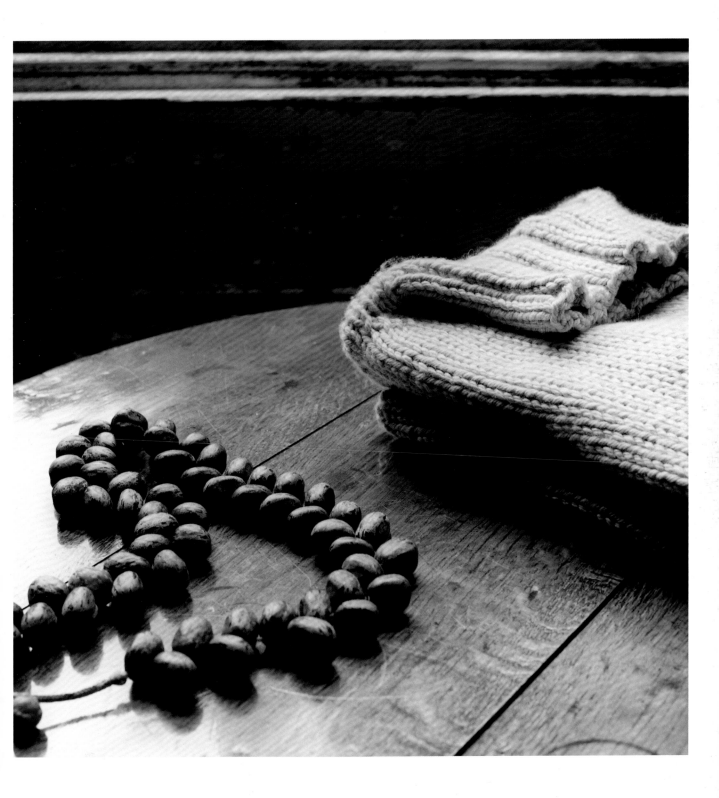

casual sweater

materials

Any super-chunky/bulky-weight wool yarn, such as Erika Knight for
 John Lewis *Super Chunky* or Erika Knight *Maxi Wool*
 8 (9: 10: 11: 12: 13) x 100g (3½oz) balls
Pair each of 7mm (US size 10½) and 7.5mm (US size 11) knitting
 needles

sizes

to fit bust	81	86	91	97	102	107	cm
	32	34	36	38	40	42	in

knitted measurements

around bust	86	91	97	102	107	112	cm
	34	36	38	40	42	44	in
length	53	57	60	62	65	67	cm
	21	22½	23½	24½	25½	26½	in
sleeve seam	42	42	43	43	44.5	46	cm
	16½	16½	17	17	17½	18	in

tension (gauge)

12 sts and 17 rows to 10cm (4in) over st st using 7.5mm (using size 11)
 needles or whatever size necessary to obtain tension (US gauge).

pattern note

- After ribbing, work increases and decreases three stitches inside the
 edges to create a fully fashioned detail. Work the decreases through
 the back of loops as foll:
 On a k row: K3, k2tog, k to last 5 sts, k2tog tbl, k3.
 On a p row: P3, p2tog tbl, p to last 5 sts, p2tog, p3.

Back

Using 7mm (US size 10½) needles, cast on 53 (58: 58: 63: 68: 68) sts.

Rib row 1 (RS): *K3, p2; rep from * to last 3 sts, k3.

Rib row 2: *P3, k2; rep from * to last 3 sts, p3.

Rep last 2 rows until back measures 5.5 (5.5: 5.5: 5.5: 8.5: 8.5)cm/ 2¼ (2¼: 2¼: 2¼: 3¼: 3¼)in, ending with WS facing for next row.

Next row (WS): Rib as set, inc 1 st at end of row on 1st and 6th sizes, dec 1 st at end of row on 2nd size, inc 1 st at each end of row on 3rd size and dec 1 st at each end of row on 5th size.

54 (57: 60: 63: 66: 69) sts.

Change to 7.5mm (US size 11)

needles and beg with a k row, work in st st, dec 1 st at each end of 5th row and every foll 6th row until 46 (49: 52: 55: 58: 61) sts rem.

Cont in st st throughout, work 11 (13: 13: 13: 15: 15) rows without shaping, ending with RS facing for next row.

Inc 1 st at each end of next row and every foll 8th row until there are 52 (55: 58: 61: 64: 67) sts.

Work without shaping until back measures 35 (38: 39.5: 40.5: 42: 43)cm/14 (15: 15½: 16: 16½: 17)in from cast-on edge, ending with RS facing for next row.

Shape armholes

Cast off (US bind off) 3sts at beg of next 2 rows.

46 (49: 52: 55: 58: 61) sts.

Dec 1 st at each end of next and foll 3 (3: 3: 3: 4: 5) alt rows.

38 (41: 44: 47: 48: 49) sts.

Work without shaping until armhole measures 18 (19: 20.5: 21.5: 23: 24)cm/7 (7½: 8: 8½: 9: 9½)in, ending with RS facing for next row.

Shape shoulders and neck

Next row (RS): Cast off (US bind off) 4 (4: 4: 6: 6: 6) sts, work until there are 7 (8: 9: 8: 9: 9) sts on right-hand needle, then turn, leaving rem sts unworked.

Cast off (US bind off) 3 sts at beg of next row.

Cast off (US bind off) rem 4 (5: 6: 5: 6: 6) sts.

With RS facing, rejoin yarn to rem sts

and cast off (US bind off) centre 16 (17: 18: 19: 18: 19) sts, then complete to match first side, reversing all shaping.

Front

Work as for back until there are 10 (10: 10: 10: 12: 12) rows fewer worked than back to start of shoulder shaping, ending with RS facing for next row.

Shape neck

Next row (RS): K15 (16: 17: 19: 19: 19), then turn, leaving rem sts on a holder.

Work each side separately.

Cast off (US bind off) 3 sts at beg of next row.

12 (13: 14: 16: 16: 16) sts.

Dec 1 st at neck edge on next 3 rows

and then on foll 1 (1: 1: 2: 1: 1) alt rows. *8 (9: 10: 11: 12: 12) sts.*

Work without shaping for 3 (3: 3: 1: 5: 5) rows, ending with RS facing for next row.

Shape shoulders

Cast off (US bind off) 4 (4: 4: 6: 6: 6) sts at beg of next row.

Work withoug shaping for 1 row.

Cast off (US bind off) rem 4 (5: 6: 5: 6: 6) sts.

With RS facing, rejoin yarn to rem sts and cast off (US bind off) centre 8 (9: 10: 9: 10: 11) sts, then complete to match first side, reversing all shaping.

Sleeves

Using 7mm (US size 10½) needles, cast on 30 (30: 30: 35: 35: 35) sts.

Rib row 1 (RS): *K3, p2; rep from * to end.

Rib row 2: *K2, p3; rep from * to end.

Rep last 2 rows until rib measures 10 (10: 10: 10: 12.5: 12.5)cm/4 (4: 4: 4: 5: 5)in from cast-on edge, ending with WS facing for next row.

Next row (WS): Rib as set, inc 3 sts across row on 3rd size, and inc 1 st at end of row on 5th and 6th sizes.

30 (30: 33: 35: 36: 36) sts.

Change to 7.5mm (US size 11) needles and beg with a k row, work in st st, inc 1 st at each end of 5th row and every foll 8th row until there are 40 (42: 45: 45: 46: 48) sts.

Cont in st st throughout, work without shaping until sleeve measures

42 (42: 43: 43: 44.5: 46)cm/
16½ (16½: 17: 17: 17½: 18)in from
cast-on edge, ending with RS facing
for next row.

Shape cap
Cast off (US bind off) 3 (3: 3: 3: 3: 3)
sts at beg of next 2 rows.
Dec 1 st at each end of next row and
every foll alt row until 26 (28: 29: 29:
30: 32) sts rem.
Dec 1 st at each end of foll 4th row.
24 (26: 27: 27: 28: 30) sts.
Work without shaping for 3 rows.
Dec 1 st at each end of next row and
foll alt row, then on foll 3 rows.
Cast off (US bind off) 3 sts at beg of
next 2 rows.
Cast off (US bind off) rem 8 (10: 11:
11: 12: 14) sts.

Collar
Sew right shoulder seam.
Using 7mm (US size 10½) needles
and with RS facing, pick up and k
14 (14: 13: 13: 16: 16) sts down left
side of front neck, 8 (9: 10: 9: 10:
11) sts across centre front, 14 (14:
13: 13: 16: 16) sts up right side of
front neck, and 22 (23: 24: 25: 24: 25)
sts across back neck. *58 (60: 60:
60: 66: 68) sts.*

1st and 6th sizes only
Next row: K2, p3, k into front and
back of next st, [p3, k2] twice, p3,
k into front and back of next st, p3,
*k2, p3; rep from * to end.
60 (–: –: –: –: 70) sts.

5th size only
Next row: K2tog, k1, *p3, k2; rep

from * to last 3 sts, p3.
– (–: –: –: 65: –) sts.

All sizes
Next row: *K3, p2; rep from *
to end.
Work 10cm (4in) in rib as set.
Cast off (US bind off) in rib.

To finish
Weave in any loose yarn ends.
Lay work out flat and gently steam to
enhance the yarn.
Sew collar and shoulder seam.
Sew sleeve heads into armholes.
Sew side and sleeve seams.

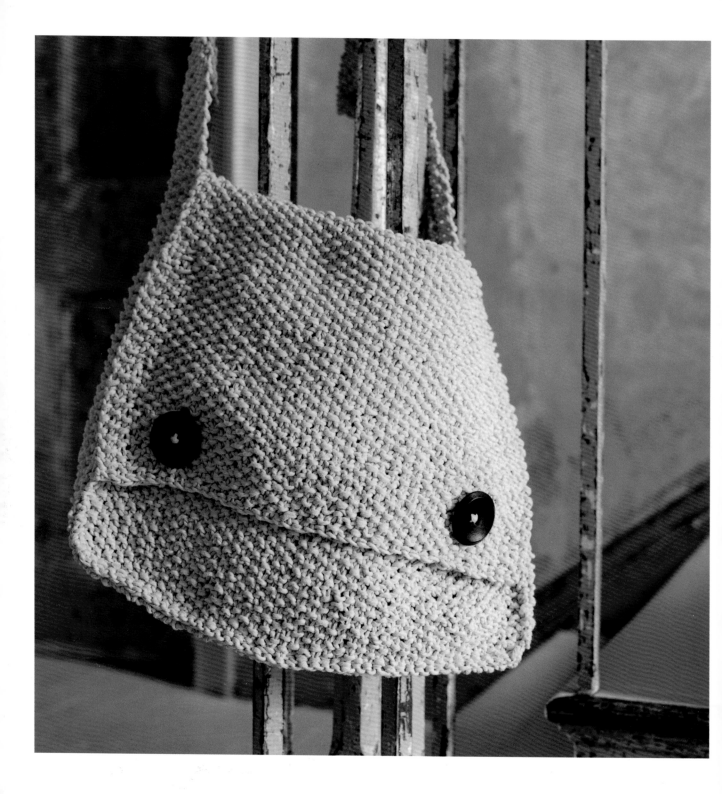

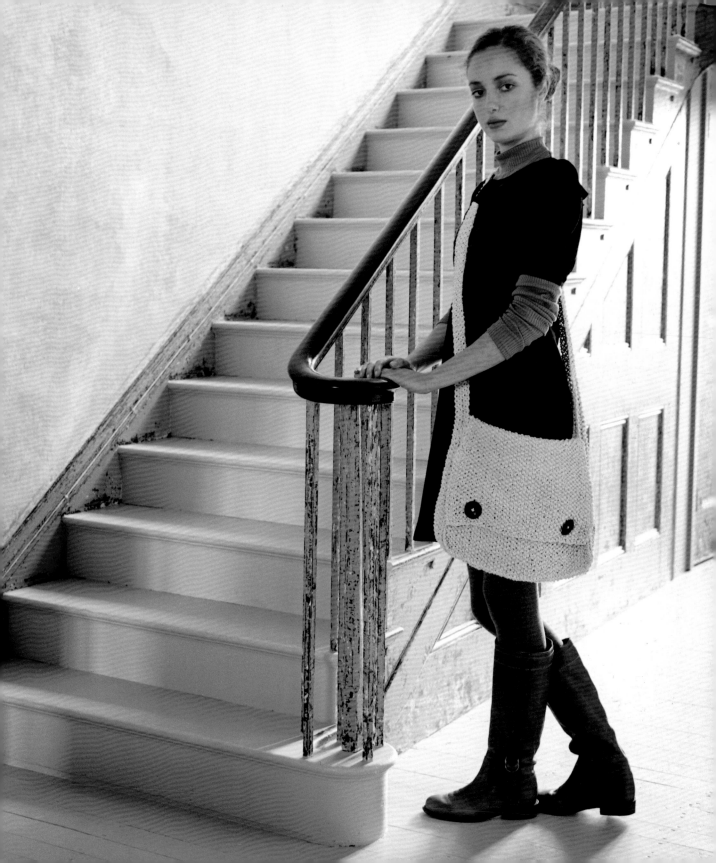

messenger bag

materials

Any medium-weight, natural-coloured cotton parcel string or kitchen
 twine (from hardware or stationery stores)
 9 x 80m (88yd) balls
Pair of 4.5mm (US size 7) knitting needles
Piece of leather, approximately 7.5cm x 13cm (3in x 5in), for handle
2 large buttons, 2 medium-size buttons and 2 large press studs (snaps)

size

One size, approximately 33cm x 26.5cm (13in x 10½in)

tension (gauge)

14 sts and 24 rows to 10cm (4in) over moss st (US seed st) using
 4.5mm (US size 7) needles or whatever size necessary to obtain
 tension (gauge).

Back

Using 4.5mm (US size 7) needles, cast on 47 sts.

Row 1: K1, *p1, k1; rep from * to end.

Rep last row to form moss st (US seed st) and keeping moss st (US seed st) patt correct as set throughout, work 64 rows, dec 1 st at each end of rows 21 and 42.
*43 sts.***

Mark each end of last row to mark foldline of front flap.

Work 55 rows, inc 1 st at each end of row 21. *45 sts.*

Cast off (US bind off) in moss st (US seed st).

Front

Work as for back to **.

Cast off (US bind off) in moss st (US seed st).

Straps (make 2)

Using 4.5mm (US size 7) needles, cast on 17 sts.

Working in moss st (US seed st) as for back and keeping patt correct as set throughout, work 39 rows.

Mark each end of last row to mark bottom corner of bag.

Dec 1 st at each end of every foll 16th row until 11 sts rem.

Work without shaping for 16 rows.

Mark each end of last row to mark corner of bag.

Work 113 rows, dec 1 st at each end of row 20. *9 sts.*

Cast off (US bind off) in moss st (US seed st).

To finish

Weave in any loose yarn ends.

Working all seams as external seams, sew cast-on edges of straps together to form centre bottom of gusset of bag.

Sew front and back to strap between markers, allowing flap to fold to front.

Sew large buttons to front flap and press studs (US snaps) underneath.

Sew one medium-size button to each strap end.

Trim leather to width of strap and cut a buttonhole at each end.

Button leather strip onto straps.

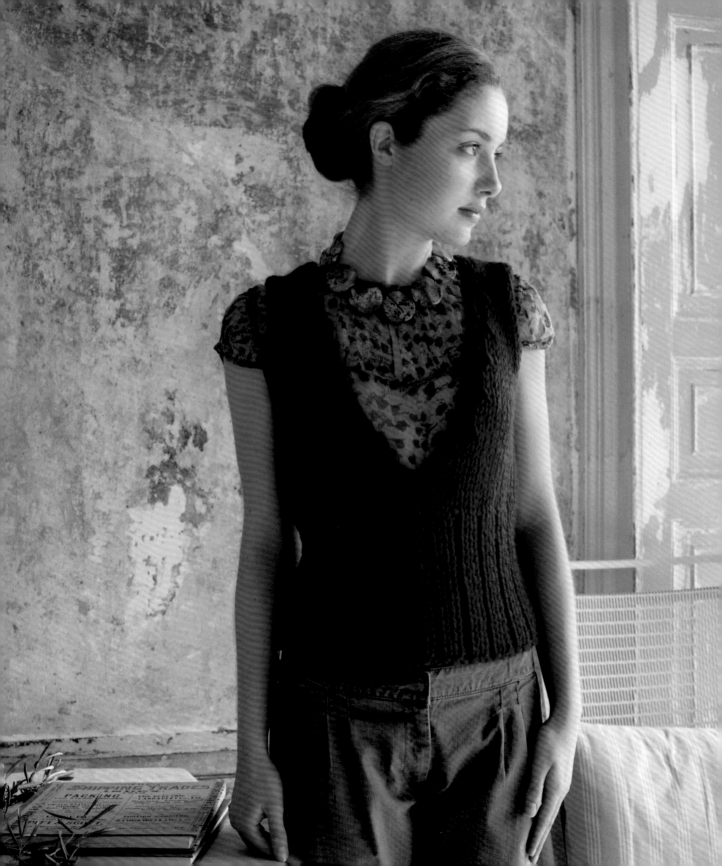

tank top

materials

Any super-chunky/bulky-weight wool yarn, such as Erika Knight
 Maxi Wool
 3 (3: 3: 4: 4: 5) x 100g (3½oz) balls
Pair each of 10mm (US size 15) and 12mm (US size 17) knitting
 needles

sizes

to fit bust	81	86	91	97	102	107	cm
	32	34	36	38	40	42	in

knitted measurements

around bust	81	86	91	97	102	107	cm
	32	34	36	38	40	42	in
length	44.5	47	49.5	52	54	57	cm
	17½	18½	19½	20½	21½	22½	in

tension (gauge)

8 sts and 12 rows to 10cm (4in) over st st using 12mm (US size 17)
 needles or whatever size necessary to obtain tension (US gauge).

pattern note

• To create a fully fashioned detail along the armhole and neckline,
 work increases and decreases two or three stitches inside the edges
 as instructed.

Back

Using 10mm (US size 15) needles, cast on 33 (33: 36: 39: 39: 42) sts.

Rib row 1 (RS): *K2, p1; rep from * to end.

Rib row 2: *K1, p2; rep from * to end.

Rep last 2 rows until back measures 15 (17: 17: 18: 18: 19)cm/6 (6½: 6½: 7: 7: 7½)in from cast-on edge, ending with WS facing for next row.

Next row (WS): Rib as set, dec 1 st at beg of row on 1st and 4th sizes, and inc 1 st at beg of row on 2nd and 5th sizes.

*32 (34: 36: 38: 40: 42) sts.***

Change to 12mm (US size 17) needles and beg with a k row, work in st st until back measures 27.5 (29: 30.5: 32: 32: 34)cm/11 (11½: 12: 12½: 13: 13½)in from cast-on edge, ending with RS facing for next row.

Shape armhole

Cont in st st throughout, cast off (US bind off) 2 sts at beg of next 2 rows. *28 (30: 32: 34: 36: 38) sts.*

Next row (RS): K2, k2tog, k to last 4 sts, k2tog tbl, k2.

Next row: P.

Rep last 2 rows once more.

24 (26: 28: 30: 32: 34) sts.

Work without shaping until armhole measures 17 (18: 19: 20: 22: 23)cm/ 6½ (7: 7½: 8: 8½: 9)in, ending with RS facing for next row.

Shape shoulders and neck

Next row (RS): Cast off (US bind off) 4 (4: 4: 4: 5: 5) sts, k until there are 4 (4: 5: 5: 5: 5) sts on right-hand needle, then turn.

Cast off (US bind off) rem 4 (4: 5: 5: 5: 5) sts.

With RS facing, rejoin yarn to rem sts and cast off (US bind off) centre 8 (10: 10: 12: 12: 14) sts, then k to end.

Complete to match first side, reversing all shaping.

Front

Work as for back to **.

Change to 12mm (US size 17) needles and beg with a k row, work 4 (4: 4: 6: 6: 6) rows in st st.

Next row (RS): K16 (17: 18: 19: 20: 21), then turn, leaving rem sts on a holder.

Shape neck

Next row (WS): K1, p1, k1, p .to end.

Next row: K to last 3 sts, p1, k1, p1.

Next row: K1, p1, k1, p to end.

Rep last 2 rows once more.

Next row (dec row) (RS): K to last 5 sts, k2tog tbl, p1, k1, p1.

Cont in st st with 3-st rib border, dec 1 st inside 3-st rib border as set on every foll 4th row **and at the same time** when front measures same as back to armhole, shape armhole as for back.

Cont dec at neck edge on every 4th row until 8 (8: 9: 9: 10: 10) sts rem.

Work without shaping until armhole measures same as back to shoulder, ending with RS facing for next row.

Shape shoulder

Cast off (US bind off) 4 (4: 4: 4: 5: 5) sts at beg of next row.

Cast off (US bind off) rem 4 (4: 5: 5: 5: 5) sts.

With RS facing, rejoin yarn to rem sts and complete to match first side, reversing all shaping.

To finish

Weave in any loose yarn ends.

Lay work out flat and gently steam.

Sew shoulder seams with a flat seam.

Sew side seams.

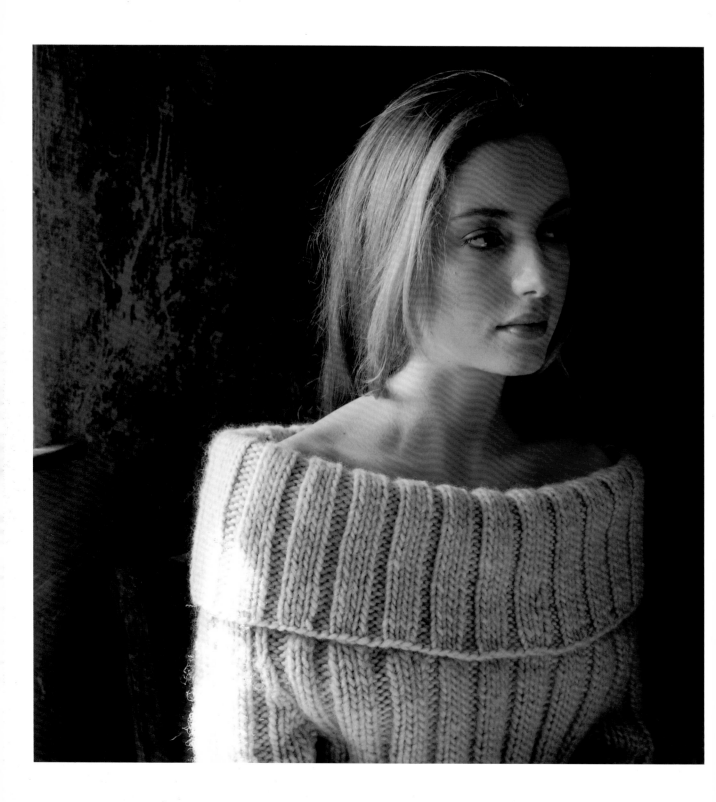

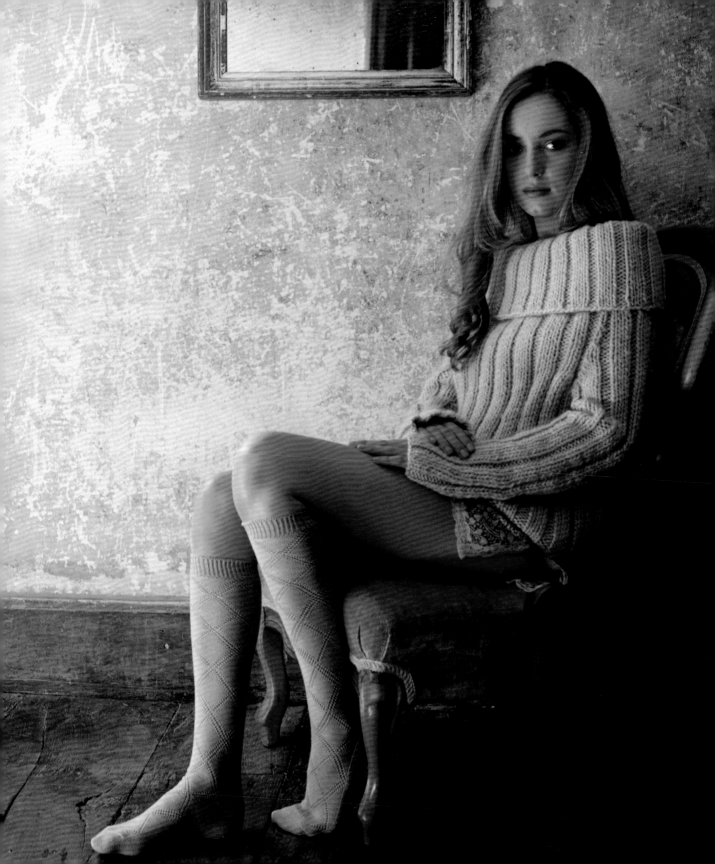

bardot sweater

materials

Any super-chunky/bulky-weight wool yarn, such as Quince & Co *Puffin*
 9 (10: 10: 11: 12: 12) x 100g (3½oz) balls
Pair each of 9mm (US size 13) and 10mm (US size 15) knitting needles

sizes

to fit bust	81	86	91	97	102	107	cm
	32	34	36	38	40	42	in

knitted measurements

aroundl bust	91.5	99	107	114.5	122	127	cm
	36	39	42	45	48	50	in
length	47	49.5	52	54	57	59.5	cm
	18½	19½	20½	21½	22½	23½	in
sleeve seam	44.5	44.5	47	47	49.5	49.5	cm
	17½	17½	18½	18½	19½	19½	in

tension (gauge)

14 sts and 14 rows to 10cm (4in) over rib using 10mm (US size 15)
 needles or whatever size necessary to obtain tension (US gauge).

pattern note

• To create a fully fashioned detail, work decreases two stitches in from
 edge if desired.

Back

Using 9mm (US size 13) needles, cast on 63 (68: 73: 78: 83: 88) sts.

Row 1 (RS): *K3, p2; rep from * to last 3 sts, k3.

Row 2: *P3, k2; rep from * to last 3 sts, p3.

Rep last 2 rows 3 times more.

Change to 10mm (US size 15) needles and cont in rib as set until back measures 30.5 (32: 33: 34.5: 36: 37)cm/12 (12½: 13: 13½: 14: 14½)in from cast-on edge, ending with RS facing for next row.

Shape raglan armhole

Keeping rib patt correct as set throughout, cast off (US bind off) 3 sts at beg of next 2 rows.
57 (62: 67: 72: 77: 82) sts.

Dec 1 st at each end of next 5 rows, then on foll alt row.
45 (50: 55: 60: 65: 70) sts.

Work without shaping until back measures 47 (49.5: 52: 54: 57: 59.5)cm/18½ (19½: 20½: 21½: 22½: 23½)in from cast-on edge, ending with RS facing for next row.

Cast off (US bind off) in rib.

Front

Work as for back until 4 (4: 4: 6: 6: 6) rows fewer have been worked before cast off (US bind off).

Next row (RS): Work 14 (16: 18: 20: 22: 24) sts, then turn, leaving rem sts on a holder.

Cast off (US bind off) 2 sts at beg of next row and foll alt row.
10 (12: 14: 16: 18: 20) sts.

Work without shaping for 0 (0: 0: 2: 2: 2) rows.

Cast off (US bind off) in rib.

With RS facing, rejoin yarn to rem sts and cast off (US bind off) centre 17 (18: 19: 20: 21: 22) sts, then work to end.

Complete to match first side, reversing all shaping.

Sleeves (make 2)

Using 9mm (US size 13) needles, cast on 33 (33: 38: 38: 43: 43) sts.

Work 8 rows in rib as for back.

Change to 10mm (US size 15) needles and keeping rib correct as set throughout, inc 1 st at each end of next row and every foll 12th row until there are 43 (43: 48: 48: 53: 53) sts, work extra sts into rib.

Work without shaping until sleeve measures 44.5 (44.5: 47: 47: 49.5: 49.5)cm/17½ (17½: 18½: 18½: 19½: 19½)in from cast-on edge, ending with RS facing for next row.

Shape raglan armhole

Cast off (US bind off) 3 sts at beg of next 2 rows. *37 (37: 42: 42: 47: 47) sts.*

Dec 1 st at each end of next 2 rows, then on next and foll 3 (3: 4: 4: 4: 4) alt rows, then on foll 4th row 2 (2: 2: 3: 3) times.

21 (21: 24: 24: 27: 27) sts.

Work without shaping for 3 (3: 5: 7: 7: 9) rows.

Cast off (US bind off) in rib.

To finish

Sew both front and right back raglan seams.

Collar

Using 9mm (US size 13) needles and with RS facing, pick up and k 19 (19: 22: 22: 25: 25) sts across top of left sleeve, 14 (14: 15: 15: 16: 16) sts down left front neck, 17 (18: 19: 20: 21: 22) sts across centre front neck, 14 (14: 15: 15: 16: 16) sts up right front neck, 19 (19: 22: 22: 25: 25) sts across top of right sleeve, and 44 (48: 54: 58: 64: 68) sts across back neck.

127 (132: 147: 152: 167: 172) sts.

Row 1: *K3, p2; rep from * to last 2 sts, k2.

Row 2: P2, *k2, p3; rep from * to end.

Rep last 2 rows until collar measures 15cm (6in), then change to 10mm (US size 15) needles and work 15cm (6in) more.

Cast off (US bind off) in rib.

Sew raglan and collar seam, reversing seam for last 15cm (6in) of collar.

Sew sleeve and side seams.

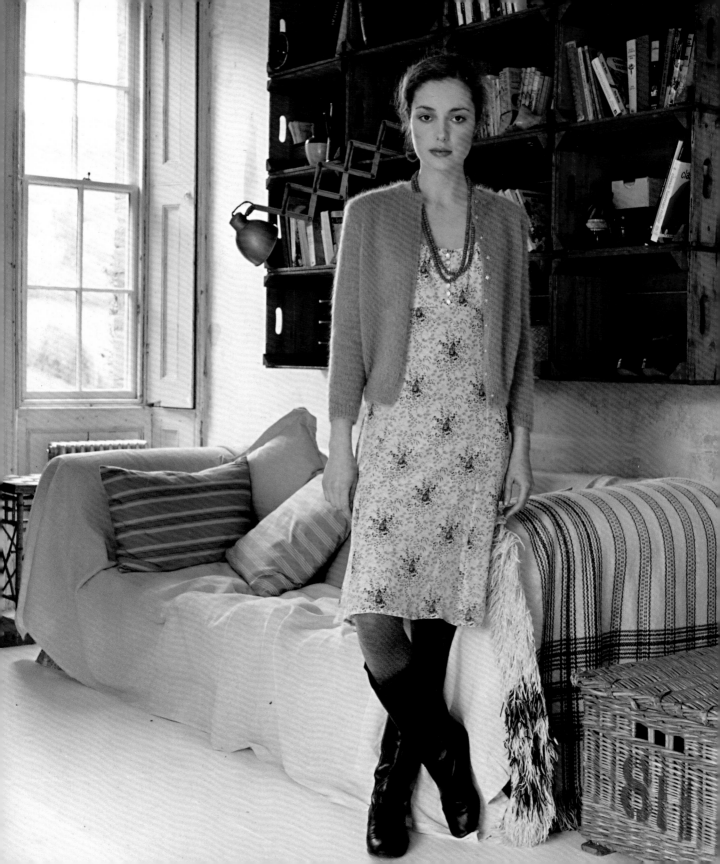

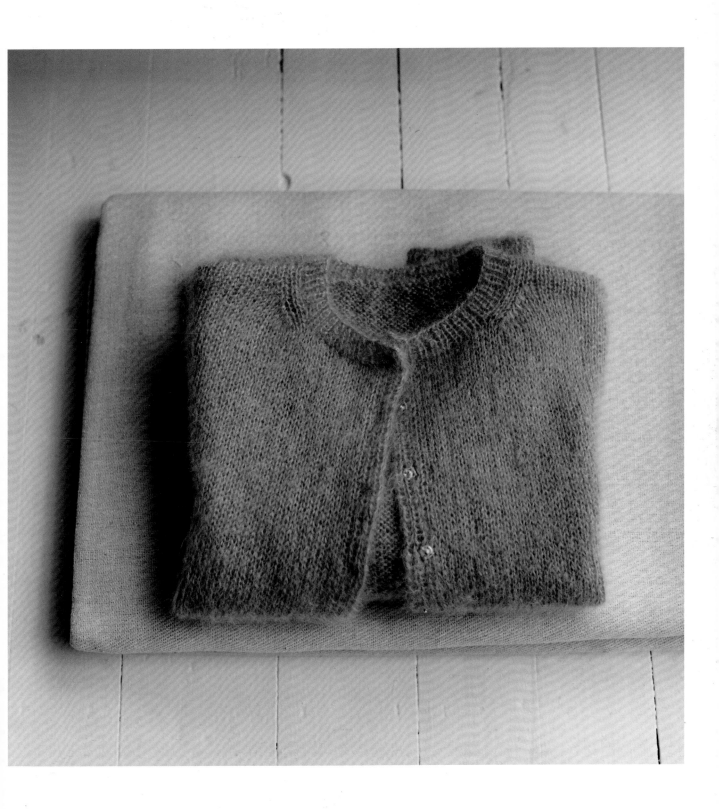

kelly cardigan

materials

Any fine-weight mohair yarn, such as Rowan *Kidsilk Haze*
 6 (6: 8: 8: 10: 10) x 25g (⅞oz) balls
Pair each of 3mm (US size 3) and 3.75mm (US size 5) knitting needles
9 press studs (US snaps)

sizes

to fit bust	81	86	91	97	102	107	cm
	32	34	36	38	40	42	in

knitted measurements

actual bust	86	92	97	103	108	114	cm
	34	36	38	40½	42½	45	in
length	47	48	49	50	51	52	cm
	18½	19	19½	19½	20	20½	in
sleeve seam	36	36	37	37	37	38	cm
	14	14	14½	14½	14½	15	in

tension (gauge)

22 sts and 30 rows to 10cm (4in) over st st using yarn doubled and
 3.75mm (US size 5) needles or whatever size necessary to obtain
 tension (US gauge).

pattern notes

- Remember to use two strands of the yarn held together throughout.
- To create a fully fashioned detail, work increases and decreases
 three sts inside the edges as instructed.
- Work the front k1, p1 rib buttonbands integrally with each front to
 give a neater finish and to avoid having to sew it on.

Back

Using 3mm (US size 3) needles and two strands of yarn held together throughout, cast on 87 (95: 101: 107: 113: 119) sts.

Rib row 1 (RS): *P1, k1; rep from * to last st, p1.

Rib row 2: *K1, p1; rep from * to last st, k1

Rep last 2 rows until back measures 5cm (2in) from cast-on edge, ending with RS facing for next row.

Change to 3.75mm (US size 5) needles.

Next row (RS): K3, m1, k to last 3 sts, m1, k3.

Cont in st st throughout, inc 1 st in same way at each end of every foll 20th row until there are 95 (101: 107: 113: 119: 125) sts.

Work without shaping until back measures 29 (30: 30: 31: 31: 32)cm/11½ (12: 12: 12: 12: 12½)in from cast-on edge, ending with RS facing for next row.

Shape armholes

Cast off (US bind off) 4 (5: 5: 6: 6: 7) sts at beg of next 2 rows and 3 sts at beg of foll 2 rows.

81 (85: 91: 95: 101: 105) sts.

Next row (RS): K3, k2tog, k to last 5 sts, k2tog tbl, k3.

Next row: P3, p2tog tbl, p to last 5 sts, p2tog tbl, p3.

Dec 1 st in same way at each end of next 1 (1: 3: 3: 5: 5) rows and then on foll 0 (1: 1: 2: 2: 3) alt rows and then on foll 4th row.

73 (75: 77: 79: 81: 83) sts.

Work without shaping until armhole measures 18 (18: 19: 19: 20: 20)cm/7 (7: 7½: 7½: 8: 8)in, ending with RS facing for next row.

Shape shoulders and neck

Cast off (US bind off) 7 (7: 7: 7: 8: 8) sts at beg of next 2 rows.

59 (61: 63: 65: 65: 67) sts.

Next row (RS): Cast off (US bind off) 7 (7: 7: 7: 8: 8) sts, k until there are 10 (10: 11: 11: 10: 11) sts on right-hand needle, then turn, leaving rem sts on a holder.

Work this side first.

Cast off (US bind off) 3 sts at beg of next row.

Cast off (US bind off) rem 7 (7: 8: 8: 7: 8) sts.

With RS facing, rejoin yarn to rem sts and cast off (US bind off) centre

25 (27: 27: 29: 29: 29) sts, then k
to end.
Complete to match first side,
reversing all shaping.

Left front
Using 3mm (US size 3) needles
and two strands of yarn held
together throughout, cast on 53 (55:
59: 61: 65: 67) sts.
Rep 2 rib rows as for back until front
measures 5cm (2in) from cast-on
edge, ending with RS facing for next
row and inc 0 (1: 0: 1: 0: 1) st at end
(side-seam edge) of last row.
53 (56: 59: 62: 65: 68) sts.
Change to 3.75mm (US size 5) needles.
Next row (RS): K3, m1, k to last
5 sts, [p1, k1] twice, p1.
Cont in st st throughout, with 5-st rib
border as set, inc 1 st at side-seam
edge on every foll 20th row until there
are 56 (59: 62: 65: 68: 71) sts.

Work without shaping until front
measures 29 (30: 30: 31: 31: 32)cm/
11½ (12: 12: 12: 12: 12½)in from
cast-on edge, ending with RS facing
for next row.
Shape armhole
Cast off (US bind off) 4 (5: 5: 6: 6: 7)
sts at beg of next row and 3 sts at beg
of foll alt row.
49 (51: 54: 56: 59: 61) sts.
Work without shaping for 1 row.
Working all armhole decreases as set
for back, dec 1 st at armhole edge of
next 3 (3: 5: 5: 7: 7) rows, then on
foll 0 (1: 1: 2: 2: 3) alt rows, then on foll
4th row. *45 (46: 47: 48: 49: 50) sts.*
Work without shaping until 11 (11:
11: 11: 11: 13) rows fewer have been
worked than for back to start of
shoulder shaping, ending with WS
facing for next row.
Shape neck
Next row (WS): Rib first 5 sts

and leave on a holder, cast off (US
bind off) next 8 (9: 9: 10: 10: 11) sts,
p to end.
Cast off (US bind off) 4 sts at beg of
foll alt row.
28 (28: 29: 29: 30: 30) sts.
Working decreases as before, dec 1 st
at neck edge on next 7 rows, then on
foll 0 (0: 0: 0: 0: 1) alt rows.
21 (21: 22: 22: 23: 24) sts.
Work without shaping for 1 row,
ending with RS facing for next row.
Shape shoulder
Cast off (US bind off) 7 (7: 7: 7: 8: 8)
sts at beg of next and foll alt row.
Work without shaping for 1 row.
Cast off (US bind off) rem 7 (7: 8: 8:
7: 8) sts.

Right front
Work as for left front, reversing all
shaping and working 1 extra row
before start of armhole shaping.

Sleeves (make 2)

Using 3mm (US size 3) needles and two strands of yarn held together throughout, cast on 53 (53: 55: 57: 57: 59) sts.

Work 3cm (1¼in) in k1, p1 rib.

Change to 3.75mm (US size 5) needles.

Beg with a k row, work in st st throughout, inc 1 st at each end of 7th row and every foll 12th (10th: 10th: 8th: 8th: 10th) row until there are 69 (67: 67: 69: 61: 79) sts.

2nd, 3rd, 4th and 5th sizes only

Inc 1 st at each end of every foll – (12th: 12th: 12th: 10th: –) row until there are – (71: 73: 75: 77: –) sts.

All sizes

69 (71: 73: 75: 77: 79) sts.

Work without shaping until sleeve measures 36 (36: 37: 37: 37: 38)cm/ 14 (14: 14½: 14½: 14½: 15)in from cast-on edge, ending with RS facing for next row.

Shape cap

Cast off (US bind off) 4 (5: 5: 6: 6: 7) sts at beg of next 2 rows and 3 sts at beg of foll 2 rows.

55 (55: 57: 57: 59: 59) sts.

Dec 1 st at each end of next 3 rows and foll 2 alt rows, then on every foll 4th row until 35 (35: 37: 37: 39: 39) sts rem.

Work without shaping for 1 row, ending with RS facing for next row.

Dec 1 st at each end of next and every foll alt rows until 29 sts rem, then on foll row, ending with RS facing for next row. *27 sts.*

Cast off (US bind off) 3 sts at beg of next 4 rows.

Cast off (US bind off) rem 15 sts.

To finish

Weave in any loose yarn ends.

Steam garment gently.

Sew shoulder seams.

Sew sleeve heads to armholes.

Sew sleeve and side seams.

Neckband

Using 3mm (US size 3) needles and two strands of yarn held together throughout, and with RS facing, rib 5 from right front holder, pick up k 18 (19: 19: 21: 21: 21) sts up right front neck, 31 (33: 33: 35: 35: 35) sts across back neck, and 18 (19: 19: 21: 21: 21) sts down left front neck, then rib 5 from holder.

77 (81: 81: 87: 87: 87) sts.

Work 2.5cm (1in) in k1, p1 rib as set by front bands.

Cast off (bind off) in rib.

Sew press studs (US snaps), evenly spaced, to inside of front bands, including neckband.

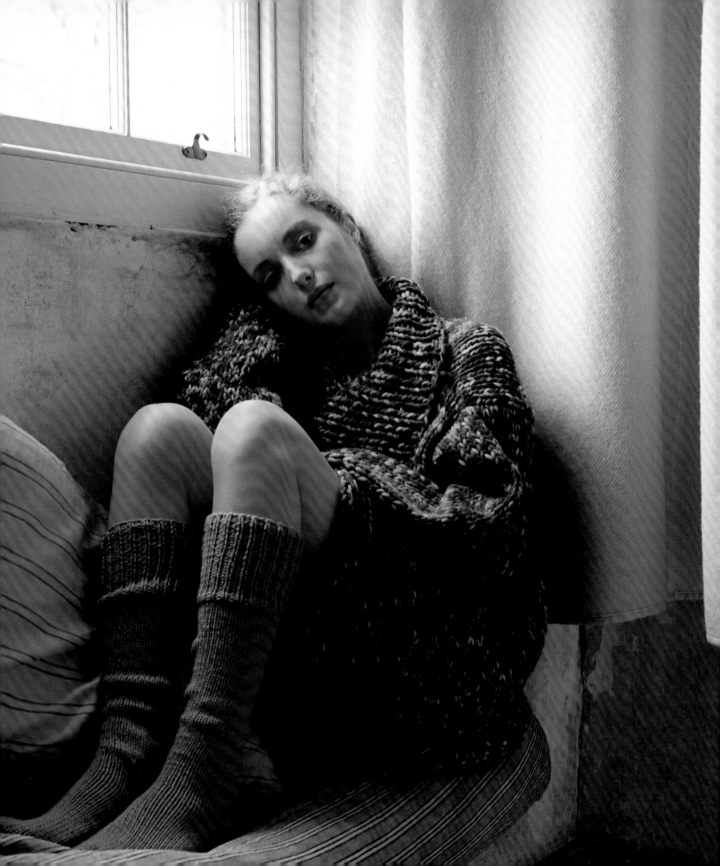

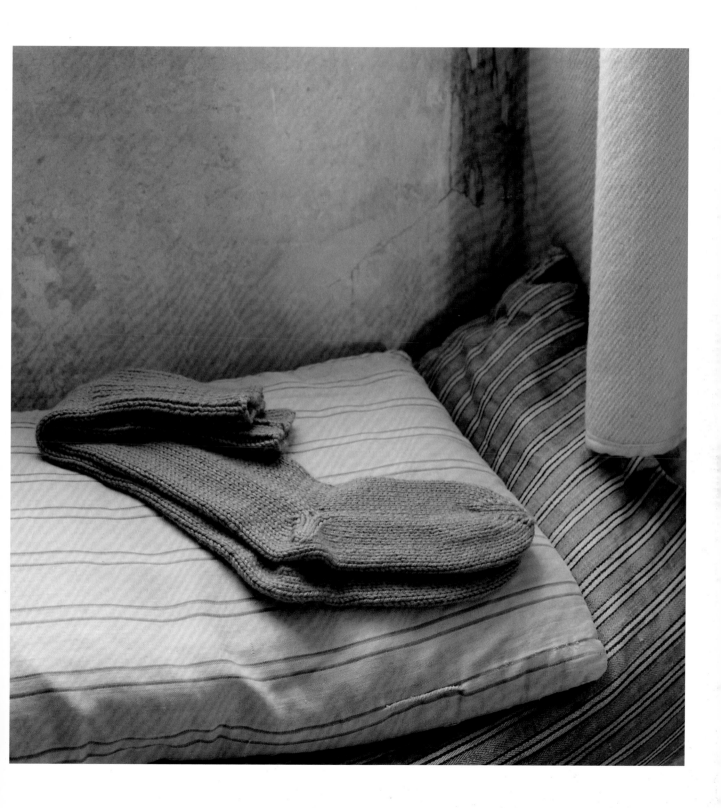

slouch socks

materials

Any aran-weight wool yarn, such as Erika Knight *Vintage Wool*,
 Rowan *Superfine Merino Aran* or Erika Knight for John Lewis *Aran*
 3 (4) x 50g (1¾oz) balls of *Vintage Wool* or *Superfine Merino Aran*
 or 2(3) x 100g (3½oz) balls of *Aran*
Pair each of 4.5mm (US size 7) and 5mm (US size 8) knitting needles

size

One size, to fit woman's average-size foot (the length of the foot
 can be lengthened or shortened by working more or fewer rows
 where indicated)

tension (gauge)

19 sts and 25 rows to 10cm (4in) over st st using 4.5mm (US size 7)
 needles or whatever size necessary to obtain tension (US gauge).
18 sts and 24 rows to 10cm (4in) over st st using 5mm (US size 8)
 needles or whatever size necessary to obtain tension (US gauge).

pattern note

• Knit the long socks shown in the photograph, or follow the
 alternative instructions for the short socks.

short socks

Right sock

Using 5mm (US size 8) needles, cast on 40 sts.

Work 6.5cm (2½in) in k1, p1 rib.

Change to 4.5mm (US size 7) needles and cont in rib as set until rib measures 12.5cm (5in).

Beg with a k row, work in st st until sock measures 19.5cm (7¾in) from cast-on edge, ending with RS facing for next row.

Shape heel

Next row (RS): K2, k2tog, k12, k2tog tbl, k2, then turn, leaving rem 20 sts on a holder.

Next row: P.

Next row: K2, k2tog, k to last 4 sts, k2tog tbl, k2.

Next row: P.

Rep last 2 rows until 8 sts rem.

Next row (RS): K2, m1, k to last 2 sts, m1, k2.

Next row: P.

Rep last 2 rows until there are 20 sts on needle.

Next row: K 20 sts on needle, then k 20 sts from holder. *40 sts.*

Work without shaping for 12.5cm (5in), ending with RS facing for next row.

Note: Adjust length of sock here by working more or fewer rows without shaping.

Shape toe

Next row (RS): K2, k2tog, k12, k2tog tbl, k2, then turn, leaving rem 20 sts on a holder.

Next row: P.

Next row: K2, k2tog, k to last 4 sts, k2tog tbl, k2.

Next row: P.

Rep last 2 rows once more. *14 sts.*

Dec 1 st at each end of next 3 rows as set. *8 sts.*

P 1 row.

Cast off (US bind off).

With RS facing, rejoin yarn to rem 20 sts on holder and complete to match first side.

Left sock

Using 5mm (US size 8) needles, cast on 40 sts and work 6.5cm (2½in) in k1, p1 rib.

Change to 4.5mm (US size 7) needles and cont in rib as set until rib measures 12.5cm (5in).

Beg with a k row, work in st st until sock measures 19.5cm (7¾in) from cast-on edge, ending with WS facing for next row.

Next row: P20, then turn, leaving rem sts on a holder.

Shape heel

Next row: K2, k2tog, k12, k2tog tbl, k2.

Next row: P.

Next row: K2, k2tog, k to last 4 sts,

k2tog tbl, k2.

Next row: P.

Rep last 2 rows until 8 sts rem.

Next row (RS): K2, m1, k to last 2 sts, m1, k2.

Next row: P.

Next row: K2, m1, k to last 2 sts, m1, k2.

Rep last 2 rows until there are 20 sts on needle.

Next row: P 20 sts on needle, then p 20 sts from holder. *40 sts.*

Work without shaping for 12.5cm (5in), ending with RS facing for next row.

Note: Adjust length of sock here by working more or fewer rows without shaping.

Shape toe

Next row (RS): K2, k2tog, k12, k2tog tbl, k2, then turn, leaving rem 20 sts on a holder.

Next row: P.

Next row: K2, k2tog, k to last 4 sts, k2tog tbl, k2.

Next row: P.

Rep last 2 rows once more. *14 sts.*

Dec 1 st at each end of next 3 rows as set. *8 sts.*

P 1 row.

Cast off (US bind off).

With RS facing, rejoin yarn to rem 20 sts on holder and complete to match first side.

long socks

Right sock

Using 5mm (US size 8) needles, cast on 46 sts.

Work 12.5cm (5in) in k1, p1 rib. Change to 4.5mm (US size 7) needles and beg with a k row, work in st st, dec 1 st each end of 19th row and every foll 20th row until 40 sts rem. Work without shaping until sock measures 38cm (15in) from cast-on edge, ending with RS facing for next row.

Shape heel

Next row: K2, k2tog, k12, k2tog tbl, k2, then turn, leaving rem 20 sts on a holder.

Next row: P.

Next row: K2, k2tog, k to last 4 sts, k2tog tbl, k2.

Next row: P.

Rep last 2 rows until 8 sts rem.

Next row (RS): K2, m1, k to last 2 sts, m1, k2.

Next row: P.

Rep last 2 rows until there are 20 sts on needle.

Next row (RS): K 20 sts on needle, then k 20 sts from holder. *40 sts.*

Work without shaping for 12.5cm (5in), ending with RS facing for next row.

Note: Adjust length of sock here by working more or fewer rows without shaping.

Shape toe

Next row: K2, k2tog, k12, k2tog tbl, k2, then turn, leaving rem 20 sts on a holder.

Next row: P.

Next row: K2, k2tog, k to last 4 sts, k2tog tbl, k2.

Next row: P.

Rep last 2 rows once more. *14 sts.*

Dec 1 st at each end of next 3 rows as set. *8 sts.* P 1 row.

Cast off (US bind off).

With RS facing, rejoin yarn to rem 20 sts on holder and complete to match first side.

Left sock

Using 5mm (US size 8) needles, cast on 46 sts.

Work 12.5cm (5in) in k1, p1 rib. Change to 4.5mm (US size 7) needles

and beg with a k row, work in st st, dec 1 st at each end of 19th row and every foll 20th row until 40 sts rem. Work without shaping until sock measures 38cm (15in) from cast-on edge, ending with WS facing for next row.

Next row (WS): P20, then turn, leaving rem sts on a holder.

Shape heel

Next row: K2, k2tog, k12, k2tog tbl, k 2.

Next row: P.

Next row: K2, k2tog, k to last 4 sts, k2tog tbl, k2.

Next row: P.

Rep last 2 rows until 8 sts rem.

Next row (RS): K2, m1, k to last 2 sts, m1, k2.

Next row: P.

Next row: K2, m1, k to last 2 sts, m1, k2.

Rep last 2 rows until there are 20 sts on needle.

Next row: P 20 sts on needle, then p 20 sts from holder. *40 sts.*

Work without shaping for 12.5cm (5in), ending with RS facing for next row.

Note: Adjust length of sock here by working more or fewer rows without shaping.

Shape toe

Next row: K2, k2tog, k12, k2tog tbl, k2, then turn, leaving rem 20 sts on a holder.

Next row: P.

Next row: K2, k2tog, k to last 4 sts, k2tog tbl, k 2.

Next row: P.

Rep last 2 rows once more. *14 sts.*

Dec 1 st at each end of next 3 rows as set. *8 sts.*

P 1 row.

Cast off (US bind off).

With RS facing, rejoin yarn to rem 20 sts on holder and complete to match first side.

To finish

Weave in any loose yarn ends.

Lay work out flat and gently steam to enhance yarn.

Sew two heel seams first.

Sew side seam, starting at toe with an invisible seam and reversing seam on turnover part of rib.

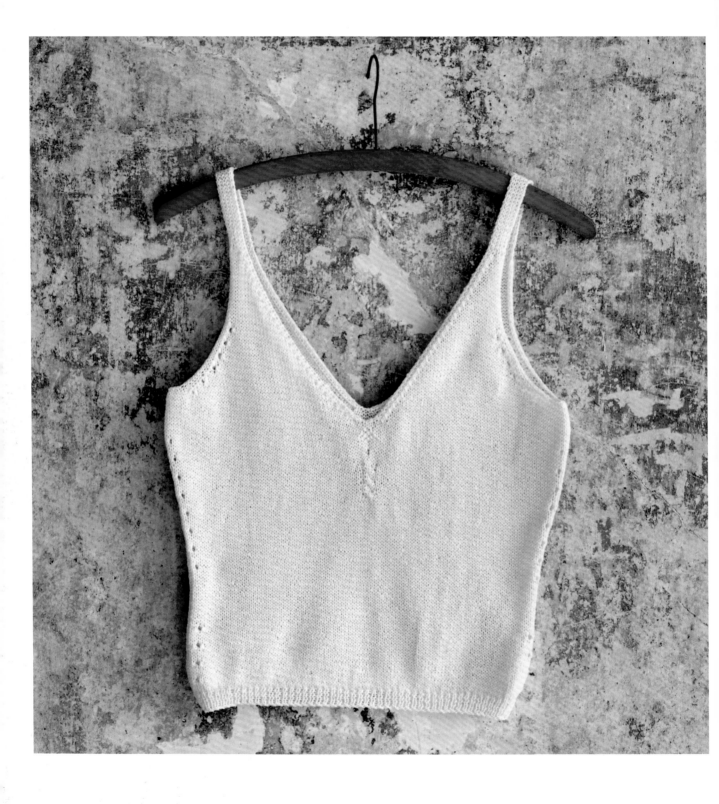

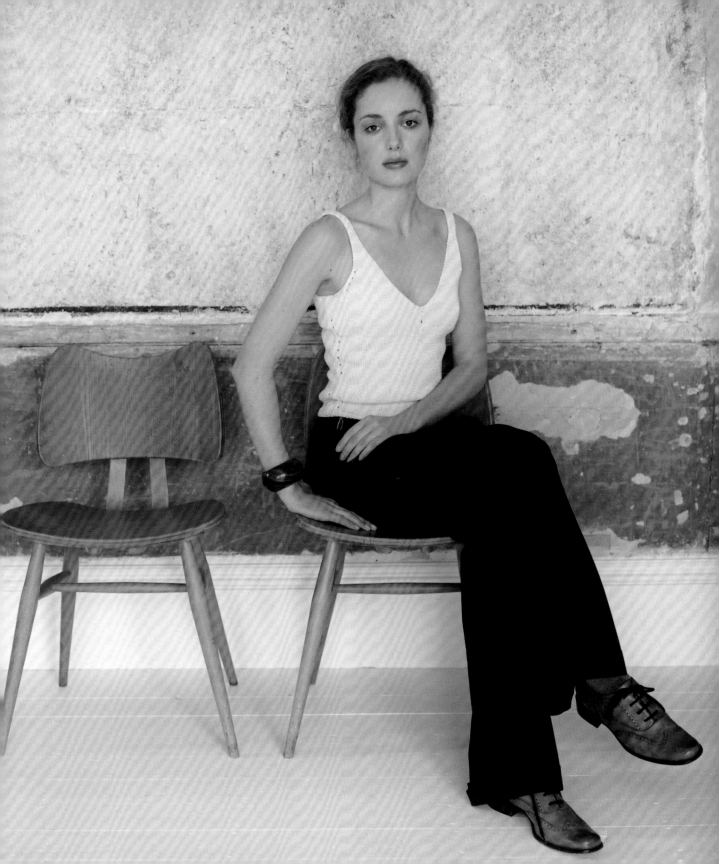

camisole

materials

Any super-fine-weight mercerized cotton yarn, such as Yeoman
Cannele 4ply
2 x 245g (8¾oz) cones or 1275 (1360: 1445: 1530: 1615: 1700)m/
1395 (1488: 1580: 1673: 1766: 1860)yds
Pair each of 3mm (US size 2) and 3.25mm (US size 3) knitting needles
Cable needle (cn)

sizes

to fit bust	81	86	91	97	102	107	cm
	32	34	36	38	40	42	in

knitted measurements

around bust	81	86	91	97	102	107	cm
	32	34	36	38	40	42	in
length	46	48	51	53	56	58.5	cm
	18	19	20	21	22	23	in

tension (gauge)

29 sts and 36 rows to 10cm (4in) over st st using 3.25mm (US size 3)
needles or whatever size necessary to obtain tension (US gauge).

special abbreviations

C4F (cable 4 front) = slip next 2 sts onto cn and leave at front of
work, k2, then k2 from cn.
dec 1 st with an eyelet at each end of row = k3, k2tog, yfwd (US
yo), k2tog, k to last 7 sts, k2tog tbl, yfwd, k2tog tbl, k3.
inc 1 st with an eyelet at each end of row = k3, yfwd (US yo), k to
last 3 sts, yfwd, k3.

Back

Using 3mm (US size 2) needles, cast on 108 (114: 120: 126: 132: 138) sts. Work 2cm (¾in) in k1, p1 rib. Change to 3.25mm (US size 3) needles and beg with a k row, work in st st, dec 1 st with an eyelet at each end of 5th row (see Special Abbreviations) and every foll 6th row until 100 (106: 112: 118: 124: 130) sts rem.

Work without shaping for 19 (19: 21: 21: 23: 23) rows, ending with RS facing for next row.

Cont in st st throughout, inc 1 st with an eyelet at each end of next row (see Special Abbreviations) and every foll 6th (6th: 6th: 8th: 8th: 8th) row until there are 116 (122: 128: 134: 140: 146) sts.

Work without shaping until back measures 25.5 (26.5: 28.5: 30: 30.5: 32)cm/10 (10½: 11: 11½: 12: 12½)in from cast-on edge, ending with RS facing for next row.

Divide for neck

**Working each side separately, divide for neck as foll:

Next row (RS): K55 (58: 61: 64: 67: 70), p1, k1, p1, then turn, leaving rem 58 (61: 64: 67: 70: 73) sts on a holder.

Next row: K1, p1, k1, p to end.

Next row (dec row): K to last 5 sts, k2tog tbl, p1, k1, p1.

***Keeping neck rib border as set, cont to dec 1 st as set at neck edge on every alt row **and at the same time** when back measures 28 (29: 31: 32.5: 33: 34.5)cm/ 11 (11½: 12: 12½: 13: 13½)in from cast-on edge, ending with RS facing, shape armhole as foll:

Shape armhole

Cast off (US bind off) 5 sts at beg of next row.

Work without shaping for 1 row.

Dec 1 st at armhole edge on next 9 rows, then on foll 7 alt rows, using an eyelet decrease on first of these decreases and every foll 4th row. Cont dec as set at neck edge only on alt rows until 10 (10: 10: 10: 12: 12) sts rem.

Work without shaping, ribbing across all sts as set, until armhole measures 18 (19: 20: 21.5: 23: 24)cm/7 (7½: 8: 8½: 9: 9½)in. Cast off (US bind off) in rib.

With RS facing. re yarn to sts on holder and cont as foll:

Next row: P1, k1, p1, k to end of row.

Next row: P to last 3 sts, k1, p1, k1.

Next row (dec row): P1, k1, p1, k2tog, k to end.

Complete to match first side from ***, reversing all shaping.

Front

Work as for back **and at the same time** 24 rows before start of neck shaping, place a marker at centre of sts and cont with side increases as set, work as foll:

Row 1: K to 3 sts before marker, p1, C4F, p1, k to end.

Row 2: P to 3 sts before marker, k1, p4, k1, p to end.

Row 3: K to 3 sts before marker, p1, k4, p1, k to end.

Row 4: Rep row 2.

Rep rows 1–4 once more, then rows 1 and 2 again.

Row 11: K.

Row 12: P.

Row 13: K to marker, yfwd (US yo), k to end.

Row 14: P, move marker to centre st.

Row 15: K.

Row 16: P.

Row 17: K to marker, p1, k to end.

Row 18: P to 1 st before marker, k1, p1, k1, p to end.

Row 19: K to 2 sts before marker, [p1, k1] twice, p1, k to end.

Row 20: P to 1 st before marker, k1, p1, k1, p to end.

Row 21: K to marker, p1, k to end.

Row 22: P.

Row 23: K.

Row 24: P58 (61: 64: 67: 70: 73), p2tog, p to end of row.
116 (122: 128: 134: 140: 146) sts.
Complete as for back from **.

To finish

Weave in any loose yarn ends. Gently steam and press pieces under a damp cloth. Sew shoulder seams with a flat seam. Sew side seams.

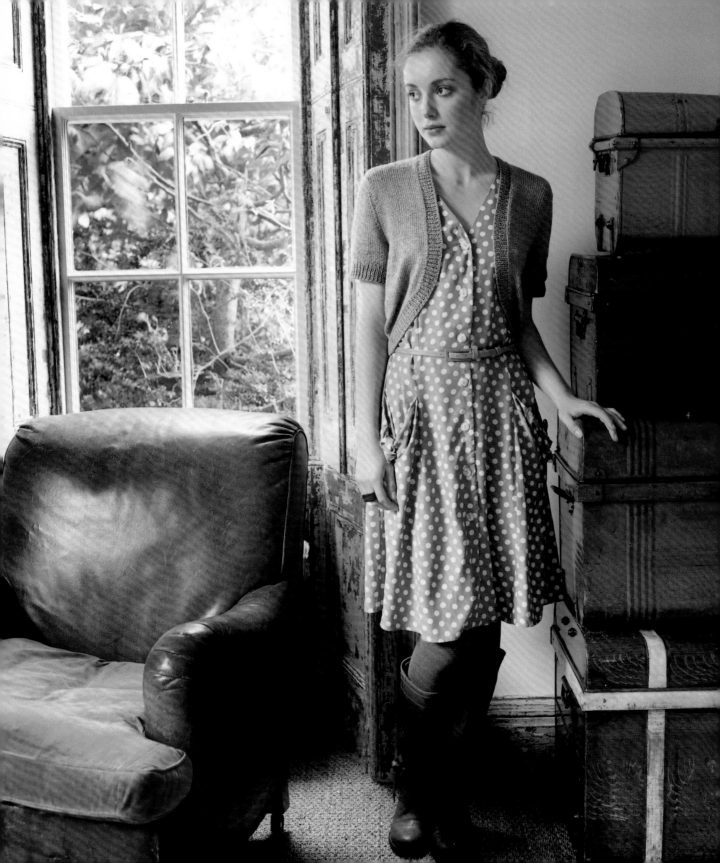

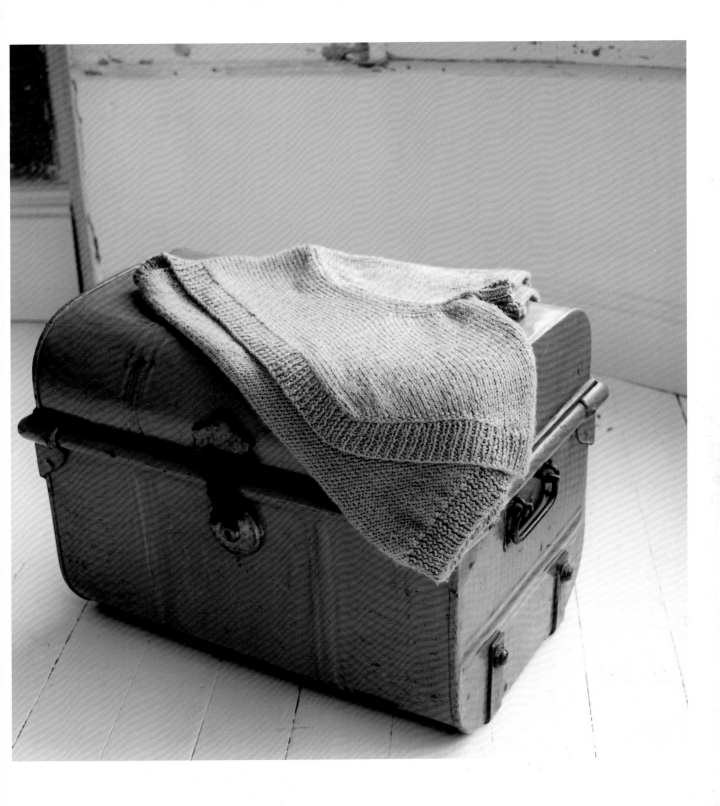

silk shrug

materials

Any double-knitting-weight silk yarn, such as Debbie Bliss *Luxury Silk DK*
 or Rowan *Truesilk*
 8 (8: 8: 9: 9: 10) x 50g (1¾oz) balls of *Luxury Silk DK* or
 5 (5: 5: 6: 6: 7) x 50g (1¾oz) balls of *Truesilk*
Pair each of 3.25mm (US size 3) and 3.75mm (US size 5) knitting needles
3.25mm (US size 3) long circular knitting needle

sizes

to fit bust	81	86	91	97	102	107	cm
	32	34	36	38	40	42	in

knitted measurements

around bust	85	88	92	95	98	102	cm
	34	35	36½	38	39½	40½	in
length	33	35.5	37	38	39	41	cm
	13	14	14½	15	15½	16	in

tension (gauge)

24 sts and 34 rows to 10cm (4in) over st st using 3.75mm (US size 5)
 needles or whatever size necessary to obtain tension (US gauge).

pattern note

• To create a fully fashioned detail, work increases and decreases three
 stitches inside the edges as explained in Pattern Note on page 140.

Back
Using 3.25mm (US size 3) needles, cast on 90 (94: 98: 102: 106: 110) sts. Work 3.5cm (1½in) in k1, p1 rib. Change to 3.75mm (US size 5) needles and beg with a k row, work in st st, inc 1 st at each end of 9th row and every foll 6th row until there are 102 (106: 110: 114: 118: 122) sts.

Cont in st st throughout, work without shaping for 9 (13: 13: 15: 17: 17) rows.
Shape armhole
Cast off (US bind off) 4 (4: 5: 5: 6: 6)

174

sts at beg of next 2 rows.

Dec 1 st at each end of next 9 rows. *76 (80: 82: 86: 88: 92) sts.*

Work without shaping for 45 (49: 53: 57: 57: 61) rows.

Shape shoulders

Cast off (US bind off) 12 (13: 13: 13: 13: 14) sts at beg of next 2 rows and 13 (13: 13: 14: 14: 14) sts at beg of foll 2 rows.

Cast off (US bind off) rem 26 (28: 30: 32: 34: 36) sts.

Right front

Using 3.75mm (US size 5) needles, cast on 7 (9: 11: 13: 15: 17) sts.

Row 1 (RS): K.

Row 2: P to last 3 sts, p into front and back of next st, p2.

Row 3: K1, k into front and back of next st, k to end.

Rows 4–7: Rep rows 2 and 3 twice.

Row 8: Rep row 2.

Row 9: K1, k into front and back of next st, k to last 3 sts, k into front and back of next st, k2.

Row 10: Rep row 2.

Row 11: Rep row 3.

Row 12: Rep row 2.

Row 13: Rep row 3.

Row 14: Rep row 2.

Rep rows 9–14 twice.

Rep rows 9–11 once.

Cont in st st throughout, work 20 (24: 24: 26: 28: 28) rows, inc 1 st at end of 4th and 10th rows as set, ending with WS facing for next row.

41 (43: 45: 47: 49: 51) sts.

Shape armhole

****Cast off (US bind off) 5 (6: 7: 8: 8: 8) sts at beg of next row.

Dec 1 st at armhole edge on next 11 (11: 12: 12: 15: 15) rows. *25 (26: 26: 27: 27: 28) sts.*

Work without shaping until armhole matches back to shoulder shaping, ending with WS facing for next row.

Shape shoulder

Cast off (US bind off) 12 (13: 13: 13: 14: 14) sts at beg of next row.

Work 1 row.

Cast off (US bind off) rem 13 (13: 13: 14: 14: 14) sts.****

Left front

Using 3.75mm (US size 5) needles, cast on 7 (9: 11: 13: 15: 17) sts.

Row 1 (RS): K.

Row 2: P1, p into front and back of next st, p to end.

Row 3: K to last 3 sts, k into front and back of next st, k2.

Rows 4–7: Rep rows 2 and 3 twice.

Row 8: Rep row 2.

Row 9: K1, k into front and back of next st, k to last 3 sts, k into front and back of next st, k2.

Row 10: Rep row 2.

Row 11: Rep row 3.

Row 12: Rep row 2.

Row 13: Rep row 3.

Row 14: Rep row 2.

Rep rows 9–14 twice.

Rep rows 9–11 once.

Cont in st st throughout, work 19 (23: 23: 25: 27: 27) rows, inc 1 st at beg of 4th and 10th rows as set, ending with RS facing for next row.

41 (43: 45: 47: 49: 51) sts.

Shape armhole and shoulder

Complete as for right front from ** to **.

Sleeves (make 2)

Using 3.25mm (US size 3) needles, cast on 72 (76: 80: 84: 88: 92) sts.

Work 3.5cm (1½in) in k1, p1 rib.

Change to 3.75mm (US size 5) needles and beg with a k row, work in st st, shaping sleeve cap as foll:

Dec 1 st each end of next 5 rows. *62 (66: 70: 74: 78: 82) sts.*

Dec 1 st at each end of every foll alt row until 28 (30: 32: 34: 36: 38) sts rem.

Work 1 row.

Dec 1 st at each end of next 4 rows.

Cast off (US bind off) 3 sts at beg of next 4 rows.

Cast off (US bind off) rem 8 (10: 12: 14: 16: 18) sts.

To finish

Weave in any loose yarn ends.

Lay work out flat and gently steam.

Sew both shoulder seams.

Front bands

Using 3.25mm (US size 3) circular needle and with RS of right front facing, rejoin yarn at side edge and pick up and k 112 (118: 124: 130: 136: 142) sts up right front, 26 (28: 30: 32: 34: 36) sts across back neck, and 112 (118: 124: 130: 136: 142) sts down left front.

250 (264: 278: 292: 306: 320) sts.

Working in rows rather than rounds, work 3.5cm (1½in) in k1, p1 rib.

Cast off (US bind off) in rib.

Sew sleeve heads into armholes with an invisible seam.

Sew side seams with an invisible seam.

gloves

materials

Any double-knitting-weight wool-cotton yarn, such as Rowan *Wool Cotton*
 3 x 50g (1¾oz) balls
Pair each of 3mm (US size 2) and 3.25mm (US size 3) knitting needles

size

One size, to fit woman's average-size hand

tension (gauge)

25 sts and 34 rows to 10cm (4in) over st st using 3.25mm (US size 3)
 needles or whatever size necessary to obtain tension (gauge).

pattern note

• As an alternative, instructions are given for fingerless gloves as well.

gloves

Right glove
Using 3mm (US size 2) needles, cast on 44 sts.
Work 8cm (3¼in) in k1, p1 rib.
Change to 3.25mm (US size 3) needles and beg with a k row, work 8 rows in st st.**
Shape thumb
Row 1 (RS): K21, p1, k into front and back of next st, k1, k into front and back of next st, p1, k18. *46 sts.*
Row 2: P18, k1, p5, k1, p21.
Row 3: K21, p1, k5, p1, k18.
Row 4: Rep row 2.
Row 5: K21, p1, k into front and back of next st, k3, k into front and back of next st, p1, k18. *48 sts.*
Cont to inc 1 st at each side of thumb gusset on every 4th row until there are 56 sts, keeping p st at either side to define shaping.
Work 1 row without shaping.
Next row: K37, turn, cast on 2 sts.
Next row: P16, turn, cast on 2 sts.
***Work 16 rows on these 18 sts.
Next row: K1, [k2, k2tog] 4 times, k1.
Next row: P.
Next row: [K2tog] 5 times, k4. *9 sts.*
Cut off yarn leaving a long end, thread through rem sts, gather tightly, secure firmly, then sew thumb seam, using mattress stitch for all seams for invisible finish.
With right-hand needle, rejoin yarn and pick up and k 4 sts at base of thumb, then k to end of row. *46 sts.*
Work 11 rows.
Shape first finger
Next row: K29, turn, cast on 1 st.
Next row: P13, turn, cast on 1 st.
Work 22 rows on these 14 sts.
Next row: K1, [k2, k2tog] 3 times, k1.
Next row: P.
Next row: K2, [k2tog] 4 times, k1. *7 sts.*
Cut off yarn leaving a long end, thread through rem sts, gather tightly, secure firmly, then sew finger seam.

Shape second finger

With right-hand needle, rejoin yarn and pick up and k 2 sts at base of first finger, then k6, turn, cast on 1 st.
Next row: P15, turn, cast on 1 st.
Work 26 rows on these 16 sts.
Next row: K2, [k2tog, k2] 3 times, k2.
Next row: P.
Next row: K1, [k2tog] 6 times. *7 sts.*
Complete as for first finger.

Shape third finger

With right-hand needle, rejoin yarn and pick up and k 2 sts at base of 2nd finger, then k6, turn, cast on 1 st.
Next row: P15, turn, cast on 1 st.
Work 22 rows on these 16 sts.
Complete as for second finger.

Shape fourth finger

With right-hand needle, rejoin yarn and pick up and k 2 sts at base of 3rd finger, then k5.
Work 19 rows on these 12 sts.
Next row: K2, [k2, k2tog] twice, k2.
Next row: P.
Next row: [K2tog] 5 times. *5 sts.*
Complete as for second finger and sew down side seam to wrist.***

Left glove

Work as for right glove to **.
Shape thumb
Row 1 (RS): K18, p1, k into front and back of next st, k1, k into front and back of next st, p1, k21. *46 sts.*
Row 2: P21, k1, p5, k1, p18.
Row 3: K18, p1, k5, p1, k21.
Row 4: Rep row 2.
Row 5: K18, p1, k into front and back of next st, k3, k into front and back of next st, p1, k21. *48 sts.*
Cont to inc 1 st at each side of

thumb gusset on every 4th row until there are 56 sts, keeping p st at either side to define shaping.
Work 1 row without shaping.
Next row: K34, turn, cast on 2 sts.
Next row: P16, turn, cast on 2 sts.
Complete as for right glove, working from *** to ***.

To finish

Steam glove gently to enhance yarn.

fingerless gloves

Right fingerless glove

Using 3mm (US size 2) needles, cast on 44 sts.
Work 5.5cm (2¼in) in k1, p1 rib.
Change to 3.25mm (US size 3) needles and cont in rib as set until work measures 14cm (5½in) from cast-on edge, ending with RS facing for next row.**
Shape thumb gusset
Row 1 (RS): K21, p1, k into front and back of next st, k1, k into front and back of next st, p1, k18. *46 sts.*
Row 2: P18, k1, p5, k1, p21.
Row 3: K21, p1, k5, p1, k18.
Row 4: Rep row 2.
Row 5: K21, p1, k into front and back of next st, k3, k into front and back of next st, p1, k18. *48 sts.*
Cont to inc 1 st each side of thumb gusset on every 4th row until there are 56 sts, keeping p st at either side to define shaping.
Work without shaping for 1 row.
Next row: K37, turn, cast on 2 sts.
Next row: P16, turn, cast on 2 sts.
***Work 4 rows st st, then 4 rows of

k1, p1 rib on these 18 sts.
Cast off (US bind off) in rib.
Cut off yarn leaving a long end and sew thumb seam.
With right-hand needle, rejoin yarn and pick up and k 4 sts at base of thumb, then k to end of row. *46 sts.*
Work 9 rows in st st.
Work 4 rows in k1, p1 rib.
Cast off (US bind off) in rib.
Cut off yarn leaving a long end to sew side seam.***

Left fingerless glove

Work as for right fingerless glove to **.

Shape thumb gusset
Row 1 (RS): K18, p1, k into front and back of next st, k1, k into front and back of next st, p1, k21. *46 sts.*
Row 2: P21, k1, p5, k1, p18.
Row 3: K18, p1, k5, p1, k21.
Row 4: Rep row 2.
Row 5: K18, p1, k into front and back of next st, k3, k into front and back of next st, p1, k21. *48 sts.*
Cont to inc 1 st at each side of thumb gusset on every 4th row until there are 56 sts, keeping p st at either side to define shaping.
Work 1 row without shaping.
Next row: K34, turn, cast on 2 sts.
Next row: P16, turn, cast on 2 sts.
Complete as for right fingerless glove, working from *** to ***.

To finish

Steam gloves gently to enhance yarn. Sew side seam with mattress stitch for invisible finish.

deep-v sweater

materials

Any double-knitting-weight wool-cotton yarn, such as Rowan *Wool Cotton*
 9 (10: 10: 11: 11: 12) x 50g (1¾oz) balls
Pair each of 3mm (US size 3) and 3.75mm (US size 5) knitting needles

sizes

to fit bust	81	86	91	97	102	107	cm
	32	34	36	38	40	42	in

knitted measurements

around bust	86	92	97	103	108	114	cm
	34	36	38	40½	42½	45	in
length	56	58	58	61	61	63.5	cm
	22	23	23	24	24	25	in
sleeve seam	44.5	46	46	47	47	48	cm
	17½	18	18	18½	18½	19	in

tension (gauge)

22 sts and 30 rows to 10cm (4in) over st st using 3.75mm (US size 5) needles
 or whatever size necessary to obtain tension (gauge).

pattern notes

- To create a fully fashioned detail, work increases and decreases three stitches inside the edges as explained in Pattern Note on page 140.
- For neckband, pick up and k one st for every st and 3 sts for every 4 rows.

Back

Using 3mm (US size 3) needles, cast on 96 (102: 108: 114: 120: 126) sts. Work 7cm (3¾in) in k1, p1 rib. Change to 3.75mm (US size 5) needles and beg with a k row, work in st st, dec 1 st at each end of 9th (11th: 11th: 13th: 13th: 15th) row and every foll 12th row until 90 (96: 102: 108: 114: 120) sts rem. Cont in st st throughout, work without shaping for 19 (21: 21: 23: 23: 25) rows, ending with RS facing for next row.

Inc 1 st at each end of next row and every foll 12th row until there are 96 (102: 108: 114: 120: 126) sts. Work without shaping until back

182

measures 38 (39: 38: 40: 39: 40.5)cm/
14¾ (15½: 15: 15¾: 15½: 16)in
from cast-on edge, ending with RS
facing for next row.

Shape armhole
Cast off (US bind off) 5 sts at beg
of next 2 rows. *86 (92: 98: 104:
110: 116) sts.*
Dec 1 st at each end of next 5 rows.
76 (82: 88: 94: 100: 106) sts.
Dec 1 st at each end of next 3 alt rows.
70 (76: 82: 88: 94: 100) sts.
Work without shaping until armhole
measures 18 (19: 20: 21: 22: 23)cm/
7¼ (7½: 8: 8¼: 8½: 9)in, ending
with RS facing for next row.

Shape shoulders and neck
Next row (RS): Cast off (US bind
off) 8 (9: 10: 11: 12: 13) sts, k until
there are 13 (14: 15: 17: 18: 19) sts
on right-hand needle, then turn,
leaving rem sts on a holder.
Cast off (US bind off) 4 (4: 4: 5: 5: 5)
sts at beg of next row.
Cast off (US bind off) rem 9 (10: 11:
12: 13: 14) sts.
With RS of work facing, rejoin yarn
to rem sts and cast off (US bind off)
28 (30: 32: 32: 34: 36) sts, then k to
end of row.
Complete to match first side,
reversing all shaping.

Front
Work as for back, but when work
measures 22.5 (23.5: 23.5: 24.5:
24.5: 25)cm/8¾ (9¼: 9¼: 9¾: 9¾:
10)in from cast-on edge, ending
with RS facing for next row, divide
for neck as foll:
Next row: K to centre of row, then

turn, leaving rem sts on a holder.
Work side and armhole shaping
as for back **and at the same
time** working each side of neck
separately, shape neck as foll:
P 1 row.
Next row: K to last 5 sts, k2tog
tbl, k3.
Dec 1 st at neck edge on every foll
4th row 13 times more, then on
every foll 6th row 5 times.
17 (19: 21: 23: 25: 27) sts.
Work without shaping until front
matches back to shoulder shaping,
ending with RS facing for next row.

Shape shoulders
Cast off (US bind off) 8 (9: 10: 11:
12: 13) sts at beg of next row.
P 1 row and cast off (US bind off)
rem 9 (10: 11: 12: 13: 14) sts.
With RS facing, rejoin yarn to rem
sts and k to end.
P 1 row.
Next row: K3, k2tog, k to end.
Complete to match first side,
reversing all shaping.

Sleeves (make 2)
Using 3mm (US size 3) needles, cast
on 60 (60: 62: 62: 64: 64) sts.
Work 7cm (2¾in) in k1, p1 rib.
Change to 3.75mm (US size 5)
needles and beg with a k row, work
in st st, inc 1 st at each end of 11th
row and every foll 12th row until 76
(76: 78: 78: 80: 80) sts.
Work without shaping until sleeve
measures 44.5 (46: 46: 47: 47:
48)cm/17½ (18: 18: 18½: 18½:
19)in from cast-on edge, ending
with RS facing for next row.

Shape cap
Cast off (US bind off) 5 sts at beg of
next 2 rows. *66 (66: 68: 68: 70: 70) sts.*
Dec 1 st at each end of next 5 rows,
then on every foll alt row until 24
sts rem.
Dec 1 st at each end of next 5 rows.
Cast off (US bind off) rem 14 sts.

To finish
Weave in any loose yarn ends.
Gently steam to enhance the yarn.
Sew right shoulder seam.
Neckband
Using 3mm (US size 3) needles and
with RS facing, pick up and k 75
(77: 77: 81: 81: 85) sts down left side
of neck, place a marker on needle,
pick up and k 75 (77: 77: 81: 81: 85)
sts up right side of neck, and 36 (38:
38: 42: 44: 46) sts across back neck.
186 (192: 192: 204: 206: 216) sts.
Work in k1, p1 rib as foll:
Row 1 (WS): Beg with k1, work in
k1, p1 rib over first 111 (115: 115:
123: 125: 131) sts (ending with k1),
slip marker to right-hand needle, beg
with k1, work in k1, p1 rib to end.
Row 2: Rib as set to 2 sts before
marker, k2tog tbl, slip marker to
right-hand needle, k2tog, rib to end.
Row 3: Rib as set to 2 sts before
marker, p2tog, slip marker to right-
hand needle, p2tog tbl, rib to end.
Rep last 2 rows until neckband
measures 2.5cm (1in).
Cast off (US bind off) in rib.
Sew left shoulder seam.
Using an invisible seam, sew sleeve
heads to armholes, then sew side
and sleeve seams.

classic turtleneck

materials

Any double-knitting-weight wool yarn, such as Erika Knight *British Blue Wool* or
Rowan *Superfine Merino*
22 (22: 24: 24: 26: 26) x 25g (⅞oz) balls of *British Blue Wool* or
11 (11: 12: 12: 13: 13) x 50g (1¾oz) balls of *Superfine Merino*
Pair each of 3.75mm (US size 5) and 4mm (US size 6) knitting needles
3.75mm (US size 5) circular knitting needle, for collar

sizes

to fit bust	81	86	91	97	102	107	cm
	32	34	36	38	40	42	in

knitted measurements

around bust	86	92	97	103	108	114	cm
	34	36	38	40½	42½	45	in
length	56	58	58	61	61	63.5	cm
	22	23	23	24	24	25	in
sleeve seam	44.5	46	46	47	47	48	cm
	17½	18	18	18½	18½	19	in

tension (gauge)

22 sts and 30 rows to 10cm (4in) over st st using 4mm (US size 6) needles
or whatever size necessary to obtain tension (US gauge).

pattern notes

- When making a folded, knitted-on hem, cast on with a size larger needle (i.e., use a 4mm or US size 6) as it makes it easier to see the sts when joining loops for the hem. For a neater finished edge, when working the hem turning row (the foldline), you can use a size smaller needle (i.e., use 3.25mm or US size 3) .
- To create a fully fashioned detail, work increases and decreases three stitches inside the edges. Work the decreases through the back of loops as foll:
 On a k row: K3, k2tog, k to last 5 sts, k2tog tbl, k3.
 On a p row: P3, p2tog tbl, p to last 5 sts, p2tog, p3.

Back

With 3.75mm (US size 5) needles, cast on 64 (70: 76: 82: 88: 94) sts.

Work 6cm (2¼in) in st st, ending with RS facing for next row.

Next row (RS): P to make hem fold. Change to 4mm (US size 6) needles and beg with p row, work 6cm (2¼in) in st st, ending with RS facing for next row.

Next row (RS): To make hem, k tog 1 st from needle and 1 loop from cast-on edge all across row.

Next row: P.**

Next row: K0 (3: 6: 9: 12: 15), *k into front and back of next st, k1; rep from * to last 0 (3: 6: 9: 12: 15) sts, k 0 (3: 6: 9: 12: 15).

96 (102: 108: 114: 120: 126) sts.

Cont in st st throughout, work until back measures 38 (39: 38: 40: 39: 40.5) cm/14¾ (15½: 15: 15¾: 15½: 16)in from hem foldline row, ending with RS facing for next row.

Shape armholes

Cast off (US bind off) 5 sts at beg of next 2 rows. *86 (92: 98: 104: 110: 116) sts.*

Dec 1 st at each end of next 5 rows. *76 (82: 88: 94: 100: 106) sts.*

Dec 1 st at each end of next 3 alt rows. *70 (76: 82: 88: 94: 100) sts.*

Work without shaping until armhole measures 18 (19: 20: 21: 22: 23)cm/ 7¼ (7½: 8: 8¼: 8½: 9)in, ending with RS facing for next row.

Shape shoulders and neck

Next row (RS): Cast off (US bind off) 8 (9: 10: 11: 12: 13) sts, k until there are 13 (14: 16: 17: 18: 19) sts on right-hand needle, then turn, leaving rem sts on a holder.

Cast off (US bind off) 4 (4: 5: 5: 5: 6) sts at beg of next row.

Cast off (US bind off) rem 9 (10: 11: 12: 13: 14) sts.

With RS facing, slip centre 28 (30: 30: 32: 34: 36) sts onto a holder, then rejoin yarn to rem sts and complete to match first side, reversing all shaping.

Front

Work as for back until 12 (12: 14: 14: 14: 16) rows fewer have been worked to start of shoulder shaping, ending with RS facing for next row.

Shape neck

Next row: K25 (27: 30: 32: 34: 37), then turn, leaving rem sts on a holder.

Cast off (US bind off) 4 (4: 4: 5: 5: 5) sts at beg of next row.

21 (23: 26: 27: 29: 32) sts.

Dec 1 st at neck edge on next 3 rows, then on foll alt rows until 17 (19: 21: 23: 25: 27) sts rem.

Work without shaping for 5 rows, ending with RS facing for next row.

Shape shoulder

Cast off (US bind off) 8 (9: 10: 11: 12: 13) sts at beg of next row.

Work 1 row.

Cast off (US bind off) rem 9 (10: 11: 12: 13: 14) sts.

With RS facing, slip centre 20 (22: 22: 24: 26: 26) sts onto a holder and rejoin yarn to rem sts, then k to end.

Complete to match first side, reversing all shaping and working 1 extra row before shoulder shaping.

Sleeves (make 2)

Using 3.75mm (US size 5) needles, cast on 35 (38: 41: 44: 47: 50) sts.

Work hem as for back to **.

Next row (RS): K into front and back of every st across row.

70 (76: 82: 88: 94: 100) sts.

Cont in st st throughout, work until sleeve measures 44.5 (46: 46: 47: 47: 48)cm/17½ (18: 18: 18½: 18½: 19)in from hem foldline row, ending with RS facing for next row.

Shape cap

Cast off (US bind off) 5 sts at beg of next 2 rows. *60 (66: 72: 78: 84: 90) sts.*

Dec 1 st at each end of next 5 rows. *50 (56: 62: 68: 74: 80) sts.*

Dec 1 st at each end of every foll alt row until 20 (24: 26: 32: 36: 40) sts rem, then at each end of next 3 (5: 5: 7: 7: 9) rows.

Cast off (US bind off) rem 14 (14: 16: 18: 22: 22) sts.

To finish

Weave in any loose yarn ends.
Lay work out flat and steam gently.
Sew shoulder seams.

Collar

Using 3.75mm (US size 5) circular needle and with RS facing, pick up and k 16 (16: 19: 19: 19: 20) sts down left front neck, 20 (22: 22: 24: 26: 26) sts from holder, 16 (16: 19: 19: 19: 20) sts up right front neck, 4 (4: 5: 5: 5: 5) sts down right back neck, 28 (30: 30: 32: 34: 36) sts from holder, and 4 (4: 5: 5: 5: 5) sts up left back neck.

88 (92: 100: 104: 108: 112) sts.

Work in k2, p2 rib for 9cm (3½in).

Change to 4mm (US size 6) needles and work further 9cm (3½in) as set.

Cast off (US bind off) in rib.

Sew sleeve seams. Sew side seams.
Set in sleeves and sew in place.
Sew roll-neck collar seam, reversing seam half way so it will not show when turned over.

glamour
for her

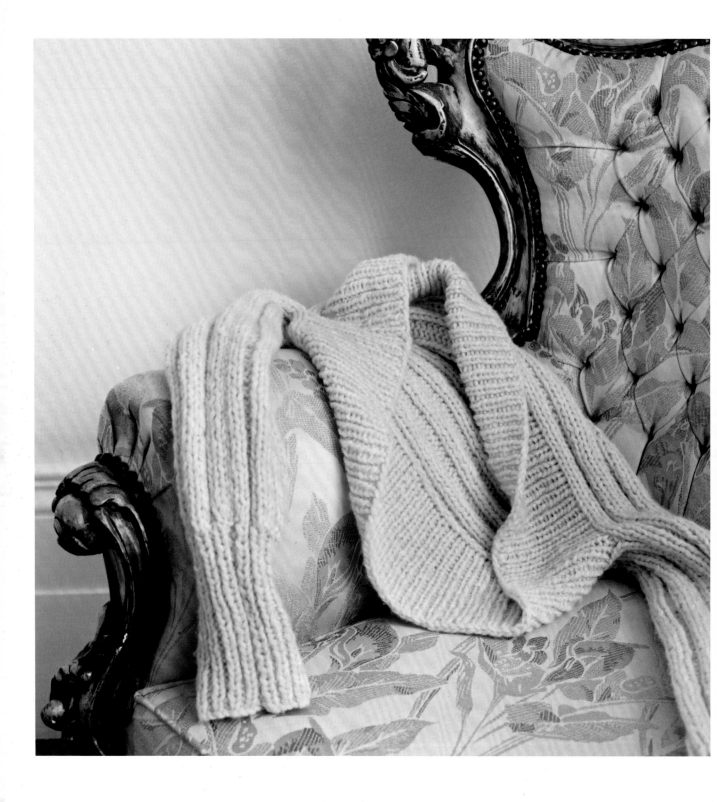

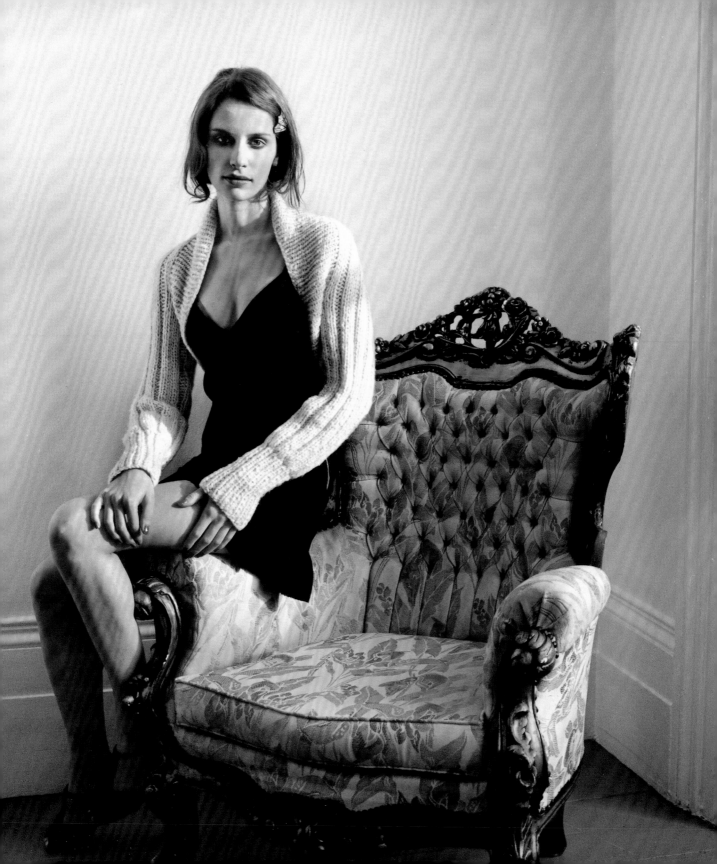

ribbed shrug

materials

Any medium-weight wool yarn, such as Rowan *Lima*
 10 (10: 11) x 50g (1¾oz) balls
Pair each of 7mm (US size 10½) and 8mm (US size 11) knitting needles
7mm (US size 10½) long circular knitting needle

sizes

to fit bust				
	81–86	91–97	102–107	cm
	32–34	36–38	40–42	in

knitted measurements

length	45	47	49	cm
	17¾	18½	19¼	in
cuff to cuff	152	157	162	cm
	59¾	61¾	63¾	in

tension (gauge)

12 sts and 16 rows to 10cm (4in) over st st using yarn doubled
 and 8mm (US size 11) needles or whatever size necessary to
 obtain tension (US gauge).

To make shrug

Shrug is made in one piece from cuff to cuff.

Using 7mm (US size 10½) needles and two strands of yarn held together throughout, cast on 32 (36: 40) sts.

Rib row 1: *K1, p1; rep from * to end.

Rep last row until shrug measures 15cm (6in) from cast-on edge.

1st size only

Next row: *K1, p into front and back of next st; rep from * to end.

2nd size only

Next row: *K1, p into front and back of next st; rep from * to last 2 sts, k1, p1.

3rd size only

Next row: K1, p1, *k1, p into front and back of next st; rep from * to last 2 sts, k1, p1.

All sizes

Stitch count is now – *48 (53: 58) sts.*
Change to 8mm (US size 11)

needles and work in rib patt as foll:

Row 1 (RS): *K3, p2; rep from * to last 3 sts, k3.

Row 2: *P3, k2; rep from * to last 3 sts, p3.

Rep these 2 rows until shrug measures 137 (142: 147)cm/55¾ (55¾: 57¾)in from cast-on edge, ending with RS facing for next row.
Change to 7mm (US size 10½) needles.

1st size only

Next row (RS): *K1, k2tog; rep from * to end.

2nd size only

Next row (RS): *K1, k2tog; rep from * to last 2 sts, k2.

3rd size only

Next row (RS): K2, *k1, k2tog; rep from * to last 2 sts, k2.

All sizes

Stitch count is now – *32 (36: 40) sts.*
Work 15cm (6in) in k1, p1 rib.
Cast off (US bind off) in rib.

To finish

Place markers at both sides of work 53cm (21in) in from each cuff.
Fold work in half lengthwise and sew cuff and sleeve seam to markers, leaving centre 46 (51: 56)cm/ 17¾ (19¾: 21¾)in unsewn.
Using 7mm (US size 10½) circular needle and two strands of yarn held together throughout and with RS facing, pick up and k 150 (162: 180) sts evenly around opening.
Working in rounds, work 12cm (4½in) in k1, p1 rib.
Cast off (US bind off) in rib.
Weave in any loose yarn ends.

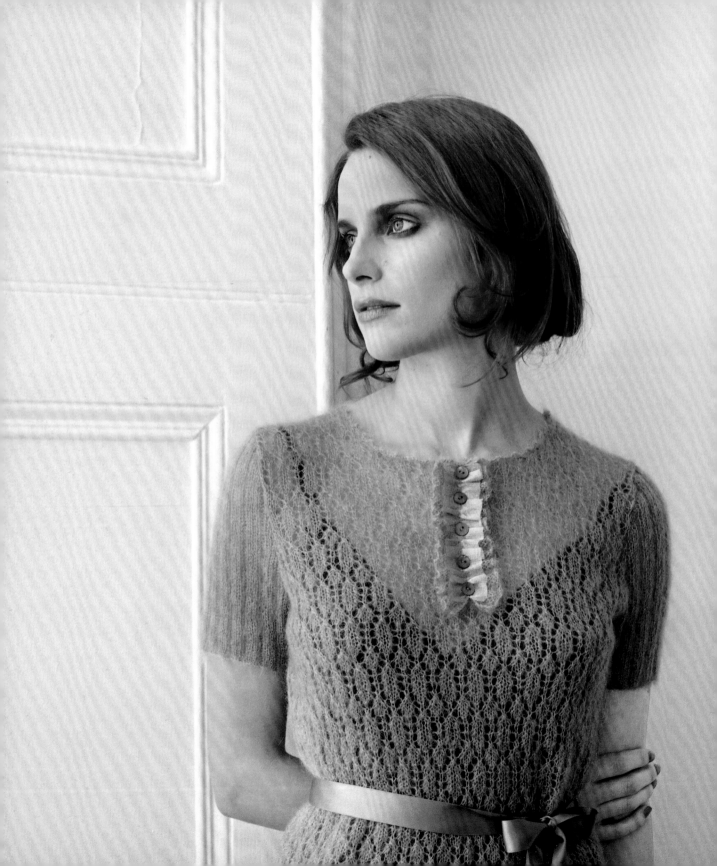

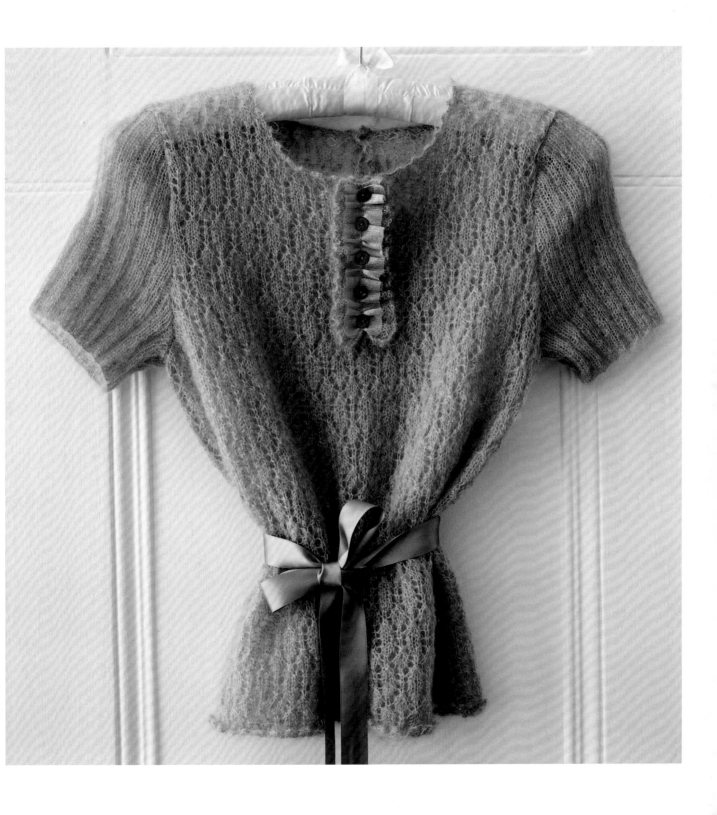

lacy tea top

materials

Any fine-weight mohair yarn, such as Rowan *Kidsilk Haze*
 3 (3: 4: 4: 5: 5) x 25g (⅞oz) balls
Pair each of 3mm (US size 2) and 3.25mm (US size 3) knitting needles
3.25mm (US size 3) long circular knitting needle
Six small buttons, approximately 12mm (½in) in diameter
Scrap of organza fabric, approximately 20cm x 4cm (8in x 1½in)
1.8m (2yds) of matching satin ribbon, 2.5cm (1in) wide, for tie

sizes

to fit bust	81	86	91	97	102	107	cm
	32	34	36	38	40	42	in

knitted measurements

around bust	81	86	91	97	102	107	cm
	32	34	36	38	40	42	in
length	51	53	53	56	56	59	cm
	20	21	21	22	22	23	in
sleeve seam	6	7	7	7	9	9	cm
	2¾	2¾	2¾	2½	3½	3½	in

tension (gauge)

25 sts and 32 rows to 10cm (4in) over lace patt using 3.25mm
 (US size 3) needles or whatever size necessary to obtain tension
 (US gauge).

special abbreviations

skp = slip 1 stitch, knit 1 stitch, pass slipped stitch over stitch just
 worked and off right-hand needle.
sk2p = slip 1 stitch, knit 2 stitches together, pass slipped stitch over
 stitch just worked and off right-hand needle.

lace pattern

Row 1 and all odd-numbered rows (WS): P.

Rows 2, 4 and 6 (RS): K1, *yon (US yo), skp, k1, k2tog, yon, k1; rep from * to end.

Row 8: K2, *yon (US yo), sk2p, yon, k3; rep from * ending last rep with k2 instead of k3.

Row 10: K1, *k2tog, yon (US yo), k1, yon, skp, k1; rep from * to end.

Row 12: K2tog, *yon (US yo), k3, yon, sk2p; rep from * to last 5 sts, yon, k3, yon, skp.

Rep rows 1–12 to form patt.

Back

Using 3mm (US size 2) needles, cast on 103 (109: 115: 121: 127: 133) sts. K 1 row.

Work first 3 rows of lace patt. Change to 3.25mm (US size 3) needles and cont in lace patt until back measures 33 (34: 34: 36: 36: 37)cm/13 (13½: 13½: 14: 14: 14½)in from cast-on edge, ending with RS facing for next row.

Shape armholes

Keeping to patt as set throughout, cast off (US bind off) 5 sts at beg of next 2 rows.

Dec 1 st each end of next 5 rows, then on foll 6 alt rows.

*71 (77: 83: 89: 95: 101) sts.***

Work without shaping until armhole measures 12 (13: 13: 14: 14: 15.5)cm/4¾ (5¼: 5¼: 5¾: 5¾: 6)in, ending with RS facing for next row.

Divide back

Next row (RS): Work 35 (38: 41: 44: 47: 50) sts, then turn, leaving rem sts on a holder.

Work each side separately.

Work without shaping until armhole measures 18 (19: 19: 20: 20: 22)cm/7 (7½: 7½: 8: 8: 8½)in, ending with RS facing for next row.

Shape shoulders and neck

Cast off (US bind off) 6 (7: 8: 8: 9: 10) sts at beg of next row, 12 (13: 14: 14: 14: 15) sts at beg of next row, 6 (7: 8: 9: 10: 10) sts at beg of next row, and 4 (4: 4: 4: 4: 4) sts at beg of next row.

Cast off (US bind off) rem 7 (7: 7: 9: 10: 11) sts.

With RS facing, rejoin yarn and k2tog, then patt to end.

35 (38: 41: 44: 47: 50) sts.

Complete to match first side, reversing all shaping.

Front

Work as for back to **.

Work without shaping until armhole measures 11.5 (12.5: 12.5: 13.5: 13.5: 14.5)cm/4½ (5:

5: 5½: 5½: 5¾)in, ending with RS facing for next row.

Shape neck

Next row (RS): Work 25 (27: 29: 32: 35: 37) sts, then turn, leaving rem sts on a holder.

Work each side separately.

Dec 1 st at neck edge on next 2 rows, then on foll 2 alt rows, then on every 4th row until 21 (23: 25: 25: 25: 27) sts rem.

Work without shaping until armhole matches back to shoulder, ending with RS facing for next row.

Shape shoulder

Cast off (US bind off) 6 (7: 8: 8: 9: 10) sts at beg of next row and 6 (7: 8: 9: 10: 10) sts on foll alt row.

Cast off (US bind off) rem 7 (7: 7: 9: 10: 11) sts.

With RS facing, rejoin yarn and cast off (bind off) centre 21 (23: 25: 25: 25: 27) sts, then work to end. *25 (27: 29: 32: 35: 37) sts.*

Complete to match first side, reversing all shaping.

Sleeves (make 2)

Using 3mm (US size 2) needles, cast on 72 (77: 77: 77: 82: 87) sts.

Row 1 (RS): P2, * k3, p2; rep from * to end.

Row 2: K2, * p3, k2; rep from * to end.

Rows 3–4: Rep rows 1–2.

Change to 3.25mm (US size 3) needles.

Cont in rib patt as set throughout, inc 1 st each end of next row and every foll 4th row until there are 80 (83: 83: 85: 90: 95) sts, taking increased sts into rib.

Work without shaping until sleeve measures 6 (7: 7: 7: 9: 9)cm/2¼ (2¾: 2¾: 2¾: 3½: 3½)in from cast-on edge, ending with RS facing for next row.

Shape cap

Cast off (US bind off) 4 sts at beg next 2 rows. *72 (75: 75: 77: 82: 87) sts.*

Dec 1 st each end of next 5 rows. *62 (65: 65: 67: 72: 77) sts.*

Dec 1 st each end of foll 3 alt rows, then every foll 4th row until 44 (47: 47: 49: 52: 55) sts rem.

Work without shaping for 1 row.

Dec 1 st each end of next and foll 2 alt rows, then foll 3 rows. *32 (35: 35: 37: 40: 43) sts.*

Cast off (US bind off) 4 sts at beg of next 2 rows.

Cast off (US bind off) rem 24 (27: 27: 29: 32: 35) sts.

Ruffle

Using 3mm (US size 2) needles, cast on 13 sts.

Row 1 (WS): K.

Row 2: P5, turn, k5, turn, p5, k3, p5.

Row 3: K5, turn, p5, turn, p5, k3, p5.

Row 4: K5, turn, p5, turn, k13.

Row 5: P5, turn, k5, turn, k13.

Rep rows 2–5 until ruffle measures 18cm (7in) from cast-on edge, ending with a WS row.

Cast off (US bind off).

To finish

Weave in any loose yarn ends.

Press pieces gently using a warm iron over a damp cloth.

Sew both shoulder seams.

Picot edgings

Using 3mm (US size 2) circular needle and with RS facing, pick up and k 16 (17: 18: 18: 18: 19) sts along left back neck, 24 sts down left front neck, 21 (23: 25: 25: 25: 27) sts across centre front neck, 24 sts up right front neck, 16 (17: 18: 18: 18: 19) sts along right back neck, 24 sts down right side of back slit, and 24 sts up left side of back slit.

149 (153: 157: 157: 157: 161) sts.

Do not turn but work picot edging around neck edge as foll:

Round 1 (RS): Cast off (US bind off) next 3 sts, *sl st on right-hand needle back onto left-hand needle and use to cast on 2 sts using knit cast-on, cast off (US bind off) 5 sts; rep from * to end.

Fasten off.

Sew in sleeves.

Sew side and sleeve seams.

Using 3mm (US size 2) circular needle and with RS facing, pick up and k 206 (218: 230: 242: 254: 266) sts around lower edge of garment, then work picot edging as for neck edge.

Sew one button to centre back neck edge to fasten through lace patt.

Sew ruffle to centre front, gathering it slightly as it is sewn on.

Cut a strip of organza 4cm (1½in) wide by 16.5cm (6½in) long, and sew it to top of knitted ruffle, gathering it slightly as it is sewn on as before.

Sew on five buttons at regular intervals down length of ruffle.

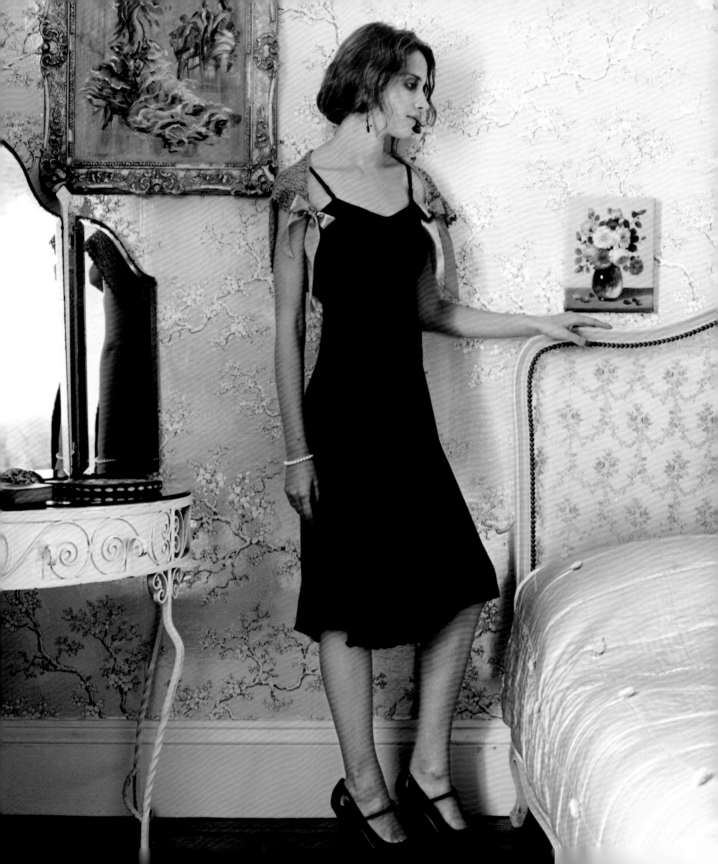

lace shrug

materials

Any super-fine-weight mercerized cotton yarn, such as Yeoman
Cannele 4ply
1 x 245g (8¾oz) cone – or approximately 500 (650: 650)m/
546 (710: 710)yds
Pair of 3.25mm (US size 3) knitting needles
Approximately 2m (2¼yds) of satin ribbon, 4cm (1½in) wide

sizes

to fit bust	81–86	91–97	102–107	cm
	32–34	36–38	40–42	in

knitted measurements

length	40	44	46	cm
	15¾	17¼	18	in
width	57	66	74	cm
	22½	26	29	in

tension (gauge)

25 sts and 44 rows to 10cm (4in) over lace patt using 3.25mm
(US size 3) needles or whatever size necessary to obtain tension
(US gauge).

special abbreviations

skp = slip 1 stitch, knit 1 stitch, pass slipped stitch over stitch just
worked and off right-hand needle.
sk2p = slip 1 stitch, knit 2 stitches together, pass slipped stitch over
stitch just worked and off right-hand needle.

To make shrug

Shrug is worked in one piece.
Using 3.25mm (US size 3) needles, cast on 145 (163: 181) sts loosely.
Work in lace patt as foll:

Row 1 and all odd-numbered rows (WS): P.

Rows 2, 4 and 6: K1, *yon (US yo), skp, k1, k2tog, yon (US yo), k1; rep from * to end.

Row 8: K2, *yon (US yo), sk2p, yon, k3; rep from * ending last rep with k2 instead of k3.

Row 10: K1, *k2tog, yon (US yo), k1, yon (US yo), skp, k1; rep from * to end.

Row 12: K2tog, *yon (US yo), k3, yon (US yo), sk2p; rep from * to last 5 sts, yon (US yo), k3, yon (US yo), skp.

Rep rows 1–12 until shrug measures 38 (42: 44)cm/15 (16½: 17¼)in from cast-on edge.
Cast off (US bind off) loosely.

To finish

Weave in any loose yarn ends.
Lay work out flat and gently steam.

Picot edgings

Using 3.25mm (US size 3) needles and with RS facing, pick up and k 145 (163: 181) sts along cast-on edge of shrug. Work edging as foll:

Picot row: Cast off (US bind off) 3 sts, *slip st on right-hand needle back onto left-hand needle and use to cast on 2 sts using knit cast-on, cast off (US bind off) 5 sts; rep from * to end.

Fasten off.

Work picot edging along cast-off (US bound-off) edge in same way.
Work picot edging along each side edge of shrug in same way, but pick up 95 (105: 111) sts.

Sew corner seams on edging.
Cut ribbon into four equal pieces, and sew two pieces each to cast-on edge and cast-off (US bound-off) edge 7.5cm (3in) from side edges.

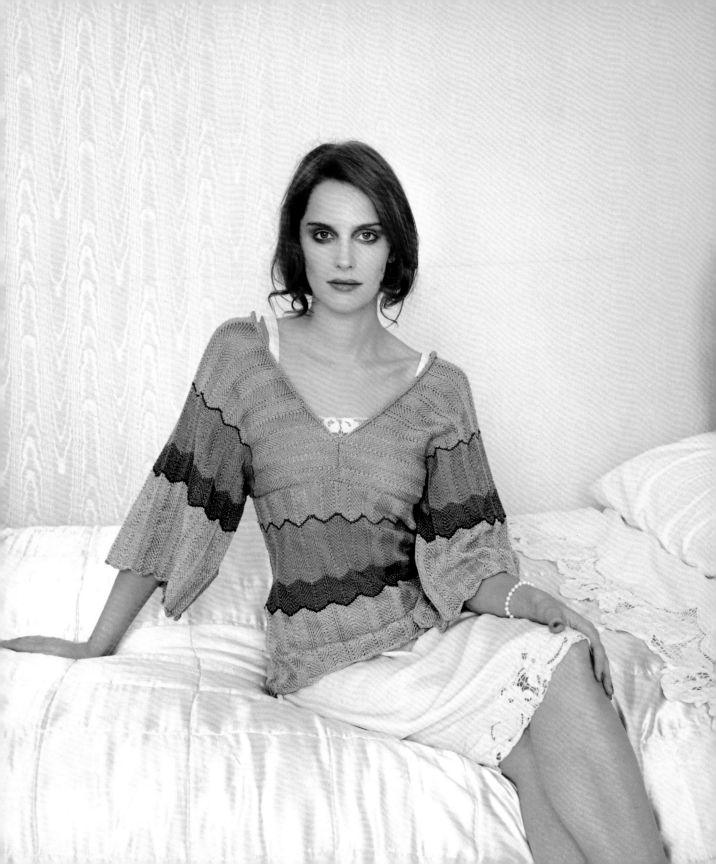

chevron sweater

materials

Any super-fine-weight mercerized cotton yarn, such as Yeoman
 Cannele 4ply
 A: 1 x 245g (8¾oz) cone in beige – or 680 (680: 680: 850: 850: 850)
 m/744 (744: 744: 930: 930: 930)yds
 B: 1 x 245g (8¾oz) cone in grey-brown – or 170 (340: 340: 340:
 510: 510)m/186 (372: 372: 372: 558: 558)yds
 C: 1 x 245g (8¾oz) cone in blue – or 340 (510: 510: 510: 510: 510)
 m/372 (558: 558: 558: 558: 558)yds
 D: 1 x 245g (8¾oz) cone in pink – or 510 (510: 680: 680: 680: 680)
 m/558 (558: 744: 744: 744: 744)yds
Any super-fine-weight metallic yarn, such as Twilleys *Goldfingering*
 E: 1 x 25g (⅞oz) ball in bronze
 F: 1 x 25g (⅞oz) ball in red
Pair of 3.25mm (US size 3) knitting needles
Approximately 1.5m (1¾yds) of ribbon, 3.5cm (1½in) wide (optional)

sizes

to fit bust							
	81	86	91	97	102	107	cm
	32	34	36	38	40	42	in

knitted measurements

around bust	84	92	100	108	116	124	cm
	33	36	39	42	46	49	in
length	60	61	63	65	67	68.5	cm
	23½	24	24½	25½	26½	27	in
sleeve length	45	47	48	49.5	49.5	51	cm
(from centre back)	17¾	18½	19	19½	19½	20	in

tension (gauge)

41 sts (3 repeats plus 2 sts) to 13cm (5in) over chevron patt using 3.25mm (US size 3) needles or whatever size necessary to obtain tension (gauge).

chevron pattern

(worked over multiples of 13 sts plus 2 sts)

Row 1 (RS): *K2, m1, k4, sl 1 knitwise, k2tog, psso, k4, m1; rep from * to last 2 sts, k2.

Row 2: P.

Rep these 2 rows to form patt, using colours as instructed below.

Back

Using 3.25mm (US size 3) needles and A, cast on 132 (145: 158: 171: 184: 197) sts.

**Work in chevron patt until back measures 15cm (6in) from cast-on edge, ending with RS facing for next row.

Cont in chevron patt throughout, working stripes as foll:

Change to E and work 1 row.

Change to B and work 4cm (1½in), ending with RS facing for next row.

Change to C and work 9cm (3½in), ending with RS facing for next row.

Change to F and work 1 row.**

Change to D and work until back measures 33 (34.5: 35.5: 37: 38: 39)cm/13 (13½: 14: 14½: 15: 15½)in from cast-on edge.

Cast off (US bind off).

Front

Work exactly as for back.

Sleeves (make 2)

Using 3.25mm (US size 3) needles and A, cast on 171 (171: 184: 184: 197: 197) sts.

Work as for back from ** to **.

Change to D and work until sleeve measures 45 (47: 48: 49.5: 49.5: 51)cm/17¾ (18½: 19: 19½: 19½: 20)in from cast-on edge.

Cast off (US bind off) firmly.

To finish

Weave in any loose yarn ends.

Lay pieces out flat and gently steam. Pin front and back pieces together and sew side seams.

Fold each sleeve in half and pin side edge of sleeve to cast-off (US bound-off) edge of body as a yoke, so sleeves meet at centre front and centre back to create V-necklines. Sew yoke and sleeve seams.

Then sew centre front and back V-seams for about 7.5cm (3in) from body to create neck plunge desired. Cut ribbon in half and sew one piece to each side of back yoke to tie into a bow in centre back or front as desired.

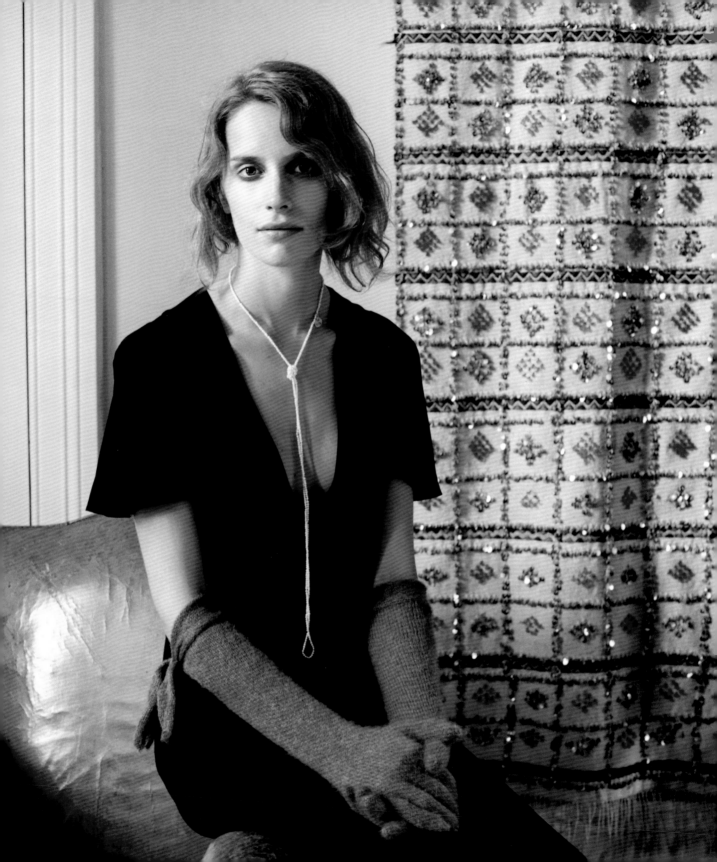

long gloves

materials

Any fine-weight 4ply mohair yarn, such as Rowan *Kidsilk Haze*
 2 x 25g (⅞oz) balls
Pair each of 2.75mm (US size 2) and 3mm (US size 3) knitting needles

size

One size, to fit woman's average-size hand

tension (gauge)

32 sts and 40 rows to 10cm (4in) over st st using 2.75mm (US size 2)
 needles or whatever size necessary to obtain tension (gauge).

pattern note

• Use mattress stitch to sew glove finger seams for an invisible finish.

Right glove

Using 3mm (US size 3) needles, cast on 62 sts very loosely.
Beg with a k row, work in st st, dec 1 st at each end of 3rd row and every foll 8th row until 54 sts rem.
Change to 2.75mm (US size 2) needles and work without shaping until piece measures 20cm (8in) from cast-on edge, ending with RS facing for next row.**

Shape thumb

Row 1 (RS): K28, k into front and back of next st, k2, k into front and back of next st, k22. *56 sts.*

Cont in st st throughout, work 3 rows.

Row 5 (RS): K28, k into front and back of next st, k4, k into front and back of next st, k22. *58 sts.*
Work 3 rows.
Cont to inc in same way, inc 2 sts on next row and every foll 4th row until there are 68 sts.
Work 3 rows.

Next row (RS): K46, turn, cast on 2 sts.

Next row: P20, turn, cast on 2 sts.

***Work 5cm (2in) on these 22 sts, ending with RS facing for next row.

Next row (RS): *K2tog, k2; rep from * to last 2 sts, k2.
Work 1 row.

Next row (RS): *K2tog; rep from * to last st, k1. *9 sts.*
Cut off yarn and thread end through these 9 sts. Pull up tightly, secure firmly and sew thumb seam.
With RS facing, rejoin yarn and pick up and k 6 sts from base of thumb, then k to end. *56 sts.*
Work without shaping until piece measures 4cm (1½in) from pick-up row, ending with RS facing for next row.

Shape first finger

Next row (RS): K36, turn, cast on 1 st.

Next row: P17, turn, cast on 1 st. *18 sts.*

Work 6cm (2½in) on these 18 sts, ending with RS facing for next row.

Next row (RS): *K2tog, k2; * rep from * to last two sts, k2.

Work 1 row.

Next row (RS): *K2tog; rep from * to end. *7 sts.*

Cut off yarn and thread end through these 7 sts. Pull up tightly, secure firmly and sew finger seam.

Shape second finger

With RS facing, rejoin yarn and pick up and k 2 sts from base of first finger, then k7, turn, cast on 1 st.

Next row (WS): P17, turn, cast on 1 st. *18 sts.*

Work 7cm (2¾in) on these 18 sts, ending with RS facing for next row.

Next row (RS): [K2tog, k2] 4 times, k2.

Work 1 row.

Next row (RS): [K2tog] 7 times. *7 sts.*

Cut off yarn and thread end through these 7 sts. Pull up tightly, secure firmly and sew finger seam.

Shape third finger

With RS facing, rejoin yarn and pick up and k 2 sts from base of second finger, then k7, turn, cast on 1 st.

Next row (WS): P17, turn, cast on 1 st. *18 sts.*

Work 6cm (2½in) on these 18 sts, ending with RS facing for next row.

Next row (RS): [K2tog, k2] 4 times, k2.

Work 1 row.

Next row (RS): [K2tog] 7 times. *7 sts.*

Cut off yarn and thread end through these 7 sts. Pull up tightly, secure firmly and sew finger seam.

Shape fourth finger

With RS facing, rejoin yarn and pick up and k 4 sts from base of third finger, then k to end.

Next row (WS): P16.

Work 5cm (2in) on these 16 sts, ending with RS facing for next row.

Next row (RS): [K2tog, k2] 4 times. *12 sts.*

Work 1 row.

Next row (RS): [K2tog] 6 times.

Cut off yarn and thread end through these 6 sts. Pull up tightly, secure firmly and sew finger seam and side seam, leaving last 7cm (2¾in) open to create a slit at end of glove where ties are attached.

Left glove

Work as for right glove to **.

Shape thumb

Row 1 (RS): K22, k into front and back of next st, k2, k into front and back of next st, k28. *56 sts.*

Cont in st st throughout, work 3 rows.

Row 5 (RS): K22, k into front and back of next st, k4, k into front and back of next st, k28. *58 sts.*

Work 3 rows.

Cont to inc in same way, inc 2 sts on next row and every foll 4th row until there are 68 sts.

Work 3 rows.

Next row (RS): K40, turn, cast on 2 sts.

Next row: P20, turn, cast on 2 sts. *22 sts.*

Complete as for right glove from ***.

Ties (make 2)

Using 3mm (US size 3) needles, cast on 18 sts and work 50cm (20in) in st st.

Cast off (US bind off).

To finish

Weave in any loose yarn ends. Fold each tie in half lengthwise to find centre, then pin centre of one tie to centre of cast-on edge of each glove. Sew tie to glove along cast-on edge, leaving excess unattached. Sew side seams and knot tie ends together.

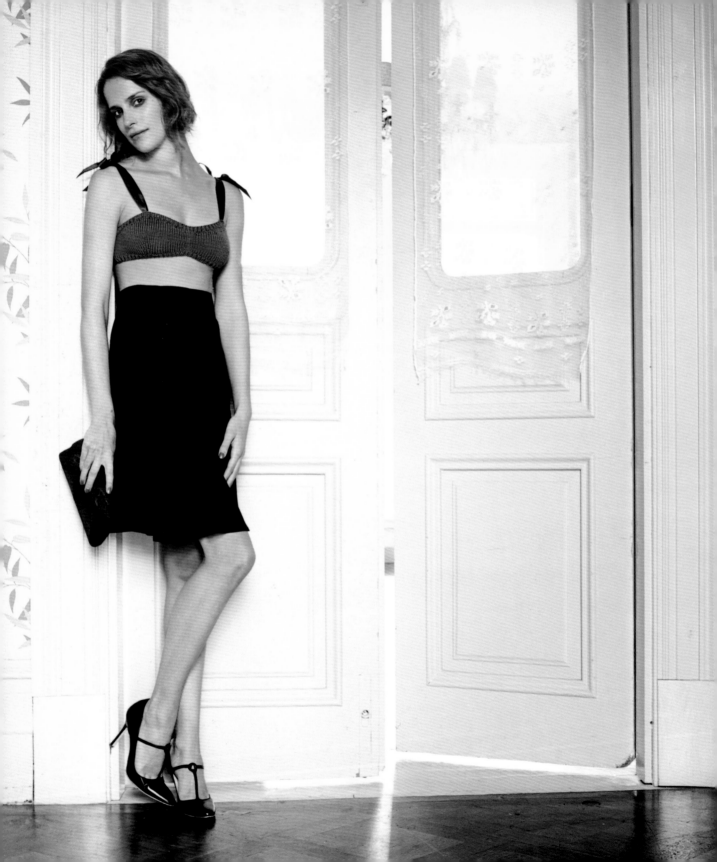

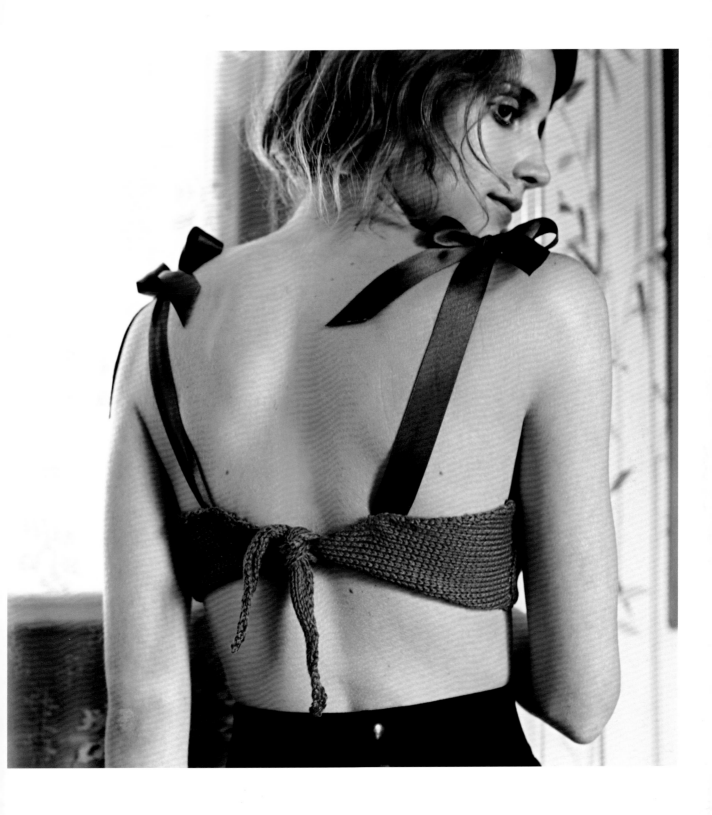

satin bra top

materials

Any double-knitting-weight silk yarn, such as Debbie Bliss
Luxury Silk DK
 2 (3: 3) x 50g (1¾oz) balls
Pair each of 3.25mm (US size 3) and 4mm (US size 6) knitting needles
Approximately 2m (2¼yds) of satin ribbon, 2.5cm (1in) wide, for
 shoulder straps

sizes

to fit bust	81–86	91–97	102–107	cm
	32–34	36–38	40–42	in

knitted measurements

bra-cup length	14.5	16	17.5	cm
	5¾	6¼	7	in
length from tie	96.5	112	127	cm
end to tie end	38	44	50	in

tension (gauge)

22 sts and 28 rows to 10cm (4in) over st st using 4mm (US size 6)
 needles or whatever size necessary to obtain tension (US gauge).

Right front

Using 3.25mm (US size 3) needles, cast on 38 (44: 50) sts.
Work 4 rows in k1, p1 rib, dec 1 st in centre of last row.
37 (43: 49) sts.
Change to 4mm (US size 6) needles and beg with a k row, work 4 (6: 6) rows in st st.
Next row (RS): K18 (21: 24), m1, k1, m1, k18 (21: 24). *39 (45: 51) sts.*
Working in st st throughout, cont to inc 1 st on each side of centre st as set on every foll 4th row until there are 43 (49: 55) sts.
Work without shaping for 5 (5: 7) rows, ending with RS facing for next row.

Shape top
Shape top by working short rows as foll:
Next row (RS): K39 (45: 51), bring yarn to front of work between needles, slip next st onto right needle, take yarn to back of work between needles, then slip the slipped st back onto left needle and turn work.
Next row: P35 (41: 47), slip next st onto right needle, take yarn to back of work between needles, then slip the slipped st back onto left needle and turn work.
Cont working 4 sts less on every row as set 8 times more, then turn after last row and k to end.

Next row: P across all sts.
Leave sts on a holder.

Left front

Work exactly as for right front.

Front neck edge

Sew centre front seam, using backstitch and stitching tightly to ease in knitting and slightly shorten seam length.
Using 3.25mm (US size 3) needles and with RS facing, work in k1, p1 rib across 86 (98: 110) sts from holders.
Work 3 rows more in k1, p1 rib.
Cast off (US bind off) in rib.

Left back

Using 4mm (US size 6) needles, cast on 26 (29: 31) sts.
Row 1 (RS): K1, p1, k to last st, p1.
Row 2: K1, p to last 2 sts, k1, p1.
Rep rows 1 and 2 once more.
Next row (RS): K1, p1, k to last 3 sts, k2tog, p1.
Cont is st st keeping edge sts as set, work 2 rows.
Next row (WS): K1, p2tog, p to last 2 sts, k1, p1.
Cont as set, dec 1 st at same edge on every 3rd row until 4 sts rem.
Dec 1 st at same edge on every foll 4th row twice. *2 sts.*
Next row: K2tog and fasten off.

Right back

Using 4mm (US size 6) needles, cast on 26 (29: 31) sts.
Row 1 (RS): P1, k to last 2 sts, p1, k1.
Row 2: P1, k1, p to last st, k1.
Rep rows 1 and 2 once more.
Next row (RS): P1, k2tog, k to last 2 sts, p1, k1.
Cont in st st keeping edge sts as set, work 2 rows.
Next row (WS): P1, k1, p to last 3 sts, p2tog, k1.
Cont as set, dec 1 st at same edge on every 3rd row until 4 sts rem.
Dec 1 st at same edge on every foll 4th row twice. *2 sts.*
Next row: K2tog and fasten off.

To finish

Weave in any loose yarn ends.
Press pieces gently using a warm iron over a damp cloth.
Sew cast-on edges of backs to side seams of fronts, easing in backs to fit.
Cut ribbon into four equal pieces for shoulder straps. Sew one piece to highest point on each bra cup.
Tie on bra and mark corresponding positions on backs for two remaining straps. Sew these straps in place, then tie ribbon straps into bows at shoulder.

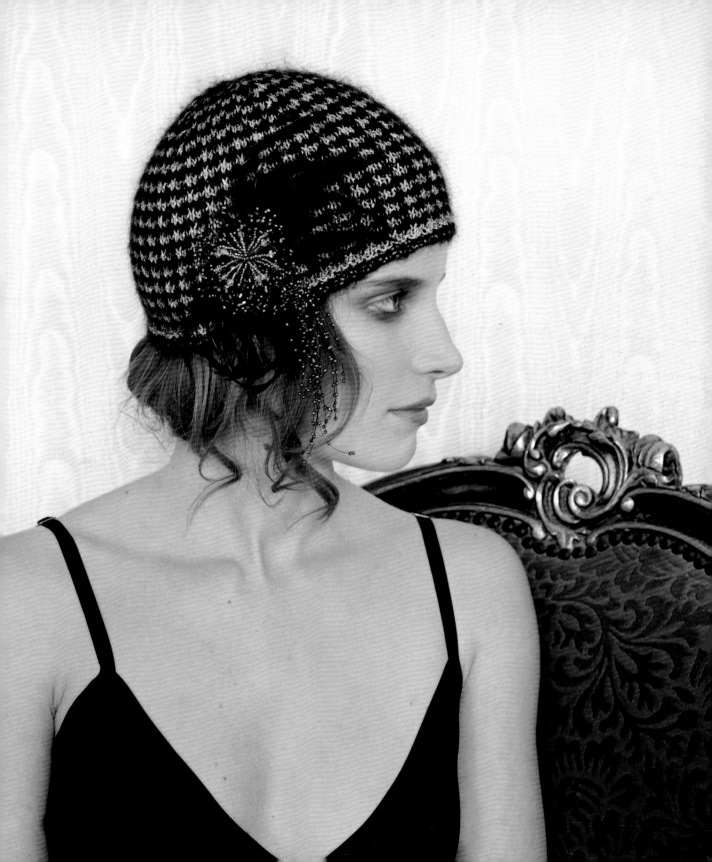

checked cloche

materials

Any super-fine-weight metallic yarn, such as Twilleys *Goldfingering*
 A: 1 x 25g (⅞oz) ball in pink
Any fine-weight mohair yarn, such as Rowan *Kidsilk Night*
 B: 1 x 25g (⅞oz) ball in black
Pair each of 3mm (US size 3) and 3.75mm (US size 5) knitting needles

size

One size

tension (gauge)

23 sts and 32 rows to 10cm (4in) over st patt using yarn B doubled and yarn A single aand 3.75mm (US size 5) needles or whatever size necessary to obtain tension (US gauge).

pattern notes

- Use two strands of B held together throughout and use a single strand of A throughout.
- Use mattress stitch to sew up hat for a neat finish.

To make hat

Using 3mm (US size 3) needles and two strands of yarn B held together, cast on 120 sts.

Change to A and work 1 row in k1, p1 rib.

Change to B and work 2 rows in rib as set.

Change to A and work 1 row in rib as set.

Change to 3.75mm (US size 5) needles and k 1 row (WS).

Cont in patt as foll:

Row 1 (RS): Using A, k1, *sl 1 purlwise, k2; rep from * to last 2 sts, sl 1 purlwise, k1.

Row 2: Using A, p.

Row 3: Using B, *sl 1 purlwise, k2; rep from * to end.

Row 4: Using B, p.

Rep last 4 rows until hat measures 12cm (5in) from cast-on edge, ending with WS facing for next row.

Shape crown

Keeping patt correct throughout, shape crown as foll:

Row 1 (WS): [P17, p3tog] 6 times. *108 sts.*

Work 3 rows.

Row 5: [P15, p3tog] 6 times. *96 sts.*

Work 3 rows.

Row 9: [P13, p3tog] 6 times. *84 sts.*

Work 1 row.

Row 11: [P11, p3tog] 6 times. *72 sts.*

Work 1 row.

Row 13: [P9, p3tog] 6 times. *60 sts.*

Work 1 row.

Row 15: [P7, p3tog] 6 times. *48 sts.*

Work 1 row.

Row 17: [P5, p3tog] 6 times. *36 sts.*

Work 1 row.

Row 19: [P3, p3tog] 6 times. *24 sts.*

Work 1 row.

Row 21: [P1, p3tog] 6 times. *12 sts.*

Cut off yarn, leaving a long end. Thread end through sts, pull up tightly and secure.

To finish

Weave in any loose yarn ends, leaving long end for seam.

Press gently using a warm iron over a damp cloth.

Sew back seam.

Trim with your favourite brooch.

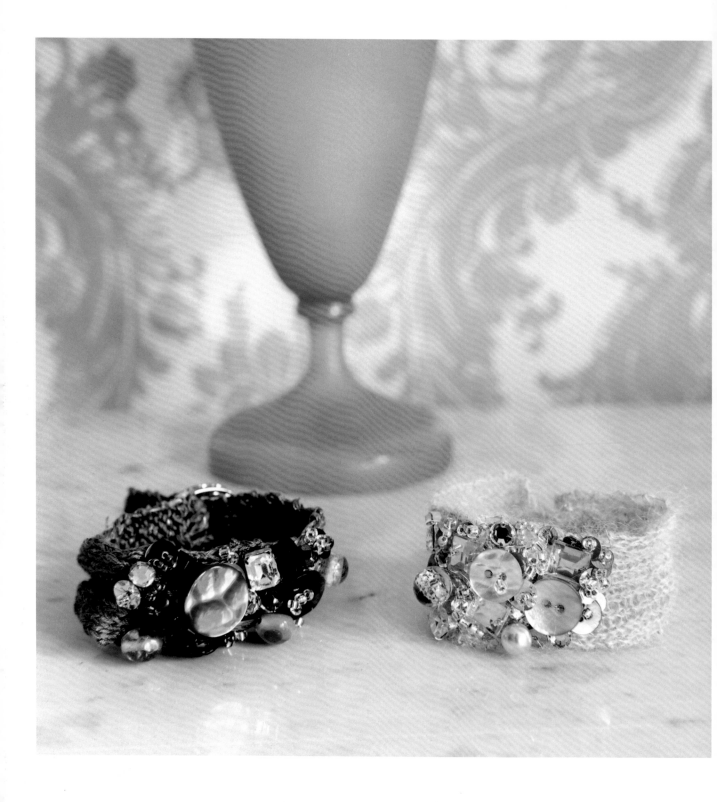

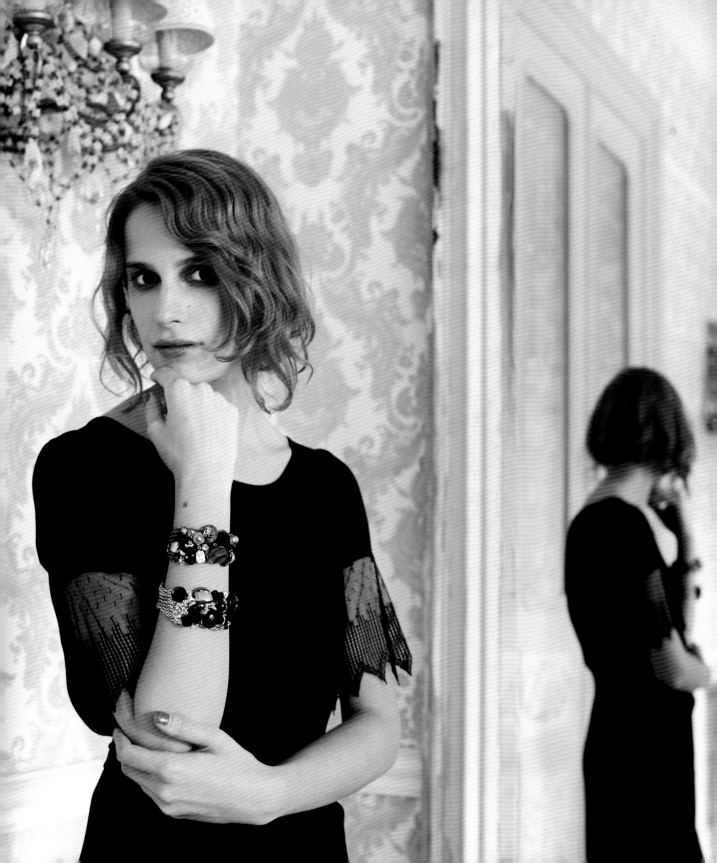

beaded cuffs and choker

materials

button cuff

Any super-fine-weight mercerized cotton yarn or fine-weight mohair
yarn, such as Yeoman *Cannele 4ply* and Rowan *Kidsilk Haze*
1 x 25g (⅞oz) ball
Button for fastening

buckle cuff

Any super-fine-weight mercerized cotton yarn or fine-weight mohair
yarn, such as Yeoman *Cannele 4ply* and Rowan *Kidsilk Haze*
2 x 25g (⅞oz) balls
Buckle for fastening

choker

Any super-fine-weight mercerized cotton yarn or fine-weight mohair
yarn, such as Yeoman *Cannele 4ply* and Rowan *Kidsilk Haze*
1 x 25g (⅞oz) ball
Approximately 1m (1yd) of satin ribbon, 1.5cm (⅝in) wide, for ties

both cuffs & choker

Pair of 3mm (US size 3) knitting needles
1 spool of fine silver beading wire
Assorted buttons, beads and sequins, for decoration
Matching thread, for sewing on decoration

sizes

Button cuff: approximately 22cm (8¾in) long by 3cm (1¼in) wide
Buckle cuff: approximately 24cm (9½in) long by 3cm (1¼in) wide
Choker: approximately 30cm (11¾in) long by 3cm (1¼in) wide

tension (gauge)

29 sts and 39 rows to 10cm (4in) over st st using 3mm (US size 3)
needles or whatever size necessary to obtain tension (US gauge).

pattern notes

- Use one strand of yarn with one strand of fine wire together throughout.
- For decoration, collect old buttons and beads of various sizes and shapes in your desired colour scheme.

button cuff

To make button cuff
Using 3mm (US size 3) needles and one strand of yarn and one strand of wire held together, cast on 10 sts. Beg with a k row, work 4 rows in st st. Make buttonhole as foll:
Next row (RS): K4, cast off (US bind off) next 2 sts, k to end.
Next row: P4, cast on 2 sts, p to end.
Work 6 rows st st, then rep buttonhole rows.
Cont in st st until cuff measures 22cm (8¾in) (or desired length) from cast-on edge.
Cast off (US bind off).

To finish
Weave in any loose yarn ends. Wrap band around wrist, mark where button should fasten and sew on button.

To embellish
Sew on buttons, beads and sequins randomly, clustering them together for maximum impact.

buckle cuff

To make buckle cuff
Using 3mm (US size 3) needles and one strand of yarn and one strand of wire held together throughout, cast on 4 sts.
Beg with a k row, work 4 rows st st. Cont in st st throughout, inc 1 st at each end of next row and every foll 6th row twice. *10 sts.*
Work 17cm (6¾in) on these 10 sts, ending with RS facing for next row.
Shape end of buckle as foll:
Dec 1 st at each end of next and foll 4th row. *6 sts.*
P 1 row.
Cast off (US bind off).

To finish
Weave in any loose yarn ends. Thread cast-on edge through buckle bar and sew in place to secure buckle.

To embellish
Sew on buttons, beads and sequins randomly, clustering them together for maximum impact.

choker

To make choker
Using 3mm (US size 3) needles and one strand of yarn and one strand of wire held together throughout, cast on 8 sts.
Beg with a k row, work in st st until choker measures 30cm (11¾in) from cast-on edge.
Cast off (US bind off).

To finish
Weave in any loose yarn ends. Cut ribbon in half and sew one piece to each end of choker for ties.

To embellish
Sew on buttons, beads and sequins randomly, clustering them together for maximum impact.

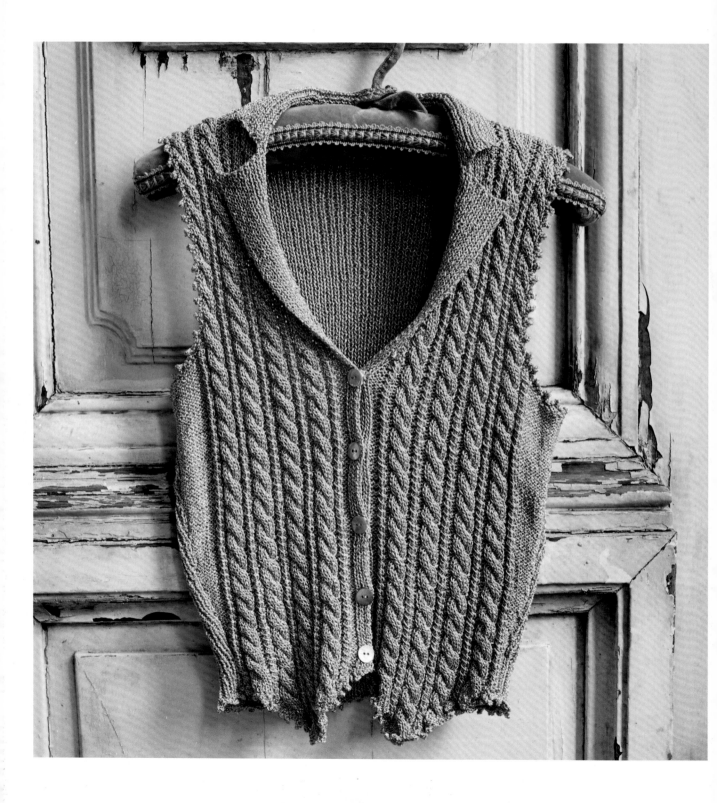

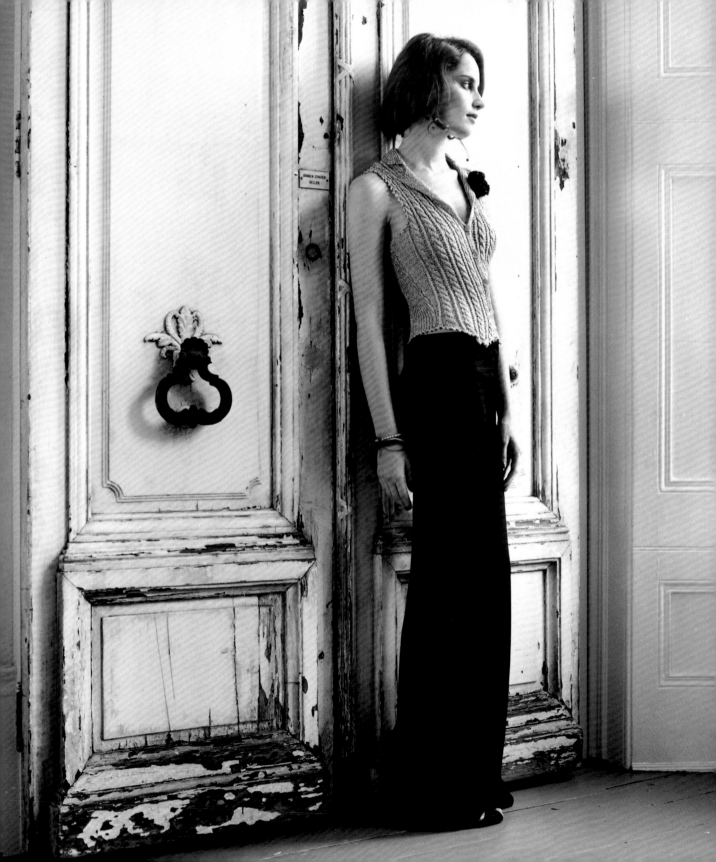

cable vest

materials

Any super-fine-weight metallic yarn, such as Twilleys *Goldfingering*
 9 (9: 10: 10: 11) x 25g (⅞oz) balls
Pair each of 3mm (US size 2) and 3.25mm (US size 3) knitting needles
3mm (US size 2) long circular knitting needle
Cable needle
5 to 7 press studs (US snaps)
5 to 7 mother-of-pearl buttons

sizes

to fit bust	81	86	91	97	102	107	cm
	32	34	36	38	40	42	in

knitted measurements

around bust	76	81	86	91	97	102	cm
	30	32	34	36	38	40	in
length	43	43	45	47	48	50	cm
	17	17	18	18½	19	19½	in

tension (gauge)

32 sts and 32 rows to 10cm (4in) over single rib using 3.25mm
 (US size 3) needles or whatever size necessary to obtain tension
 (US gauge).
36 sts and 32 rows to 10cm (4in) over cable patt using 3.25mm
 (US size 3) needles or whatever size necessary to obtain tension
 (US gauge).

special abbreviations

C2F (cable 2 front) = slip next st onto cn and leave at front of work,
 k1, k1 from cn.
C6F (cable 6 front) = slip next 3 sts onto cn and leave at front of
 work, k3, k3 from cn.

Back

Using 3.25mm (US size 3) needles, cast on 110 (118: 126: 134: 142: 150) sts.

Work in k1, p1 rib throughout as foll:

1st and 2nd sizes only

Inc 1 st at each end of 7th row and every foll 6th row until there are 136 (144) sts.

3rd, 4th, 5th and 6th sizes only

Inc 1 st at each end of 7th row and every foll 6th and 7th row alternately until there are – (–: 152: 160: 168: 176) sts.

All sizes

Work without shaping until 86 rows have been completed and work measures 24 (24: 25.5: 25.5: 25.5: 27)cm/9½ (9½: 10: 10: 10: 10½)in from cast-on edge.

Shape armholes

Cast off (US bind off) 5 (5: 5: 5: 5: 5) sts at beg of next 2 rows, 4 (4: 4: 5: 5: 5) sts at beg of foll 2 rows, 3 (3: 4: 4: 4: 4) sts at beg of foll 2 (2: 2: 2: 2: 4) rows, and 2 sts at beg of next 4 (6: 6: 6: 6: 6) rows. *104 (108: 114: 120: 128: 128) sts.*

Dec 1 st at each end of next row and every foll alt row until 98 (102: 106: 110: 114: 116) sts rem.

Work without shaping until armhole measures 19 (19: 20: 21.5: 23: 24)cm/7½ (7½: 8: 8½: 9: 9½)in.

Shape shoulders and neck

Cast off (US bind off) 9 (9: 9: 10: 11:

12) sts at beg of next 2 rows.

Next row: Cast off (US bind off) 9 (9: 10: 10: 11: 11) sts, work until there are 13 (14: 15: 15: 15: 15) sts on right-hand needle, then turn, leaving rem sts on a holder.

Work each side separately.

Cast off (US bind off) 4 sts at beg of next row.

Cast off (US bind off) rem 9 (10: 11: 11: 11: 11) sts.

Rejoin yarn to rem stitches on holder, cast off (US bind off) centre 36 (38: 38: 40: 40: 40) sts and work to end.

Cast off (US bind off) 9 (9: 10: 10: 11: 11) sts at beg of next row and 4 sts at beg of foll row.

Cast off (US bind off) rem 9 (10: 11: 11: 11: 11) sts.

Left front

Using 3.25mm (US size 3) needles, cast on 4 sts.

Row 1 (RS): K4, cast on 2 sts. *6 sts.*

Row 2: K1, p5, cast on 3 sts. *9 sts.*

Row 3: P2, k6, p1, cast on 2 sts. *11 sts.*

Row 4: P1, k2, p6, k2, cast on 3 sts. *14 sts.*

Row 5: P1, C2F, p2, C6F, p2, k1, cast on 2 sts. *16 sts.*

Row 6: K1, p2, k2, p6, k2, p2, k1, cast on 3 sts. *19 sts.*

Row 7: K2, p2, C2F, p2, k6, p2, C2F, p1, cast on 2 sts. *21 sts.*

Row 8: P1, k2, p2, k2, p6, [k2, p2] twice, cast on 3 sts. *24 sts.*

Row 9: K5, p2, C2F, p2, k6, p2, C2F, p2, k1, cast on 2 sts. *26 sts.*

Row 10: P3, k2, p2, k2, p6, k2, p2, k2, p5, cast on 3 sts. *29 sts.*

Row 11: P2, k6, p2, C2F, p2, C6F, p2, C2F, p2, k3, cast on 2 sts. *31 sts.*

Row 12: P5, [k2, p2, k2, p6] twice, k2, cast on 3 sts. *34 sts.*

Row 13: P1, C2F, p2, [k6, p2, C2F, p2] twice, k5, cast on 2 sts. *36 sts.*

Row 14: K1, p6, [k2, p2, k2, p6] twice, k2, p2, k1, cast on 3 sts. *39 sts.*

Row 15: K2, [p2, C2F, p2, k6] 3 times, p1, cast on 2 sts. *41 sts.*

Row 16: P1, k2, [p6, k2, p2, k2] 3 times, p2, cast on 3 sts. *44 sts.*

Row 17: K5, [p2, C2F, p2, C6F] 3 times, p2, k1, cast on 2 sts. *46 sts.*

Row 18: K1, [p2, k2, p6, k2] 3 times, p2, k2, p5, cast on 3 sts. *49 sts.*

Row 19: [P2, k6, p2, C2F] 4 times, p1, cast on 2 sts. *51 sts.*

Row 20: K3, [p2, k2, p6, k2] 4 times, cast on 4 (8: 3: 3: 3: 3) sts. *55 (59: 54: 54: 54: 54) sts.*

Row 21: P2 (6: 1: 1: 1: 1), [C2F, p2, k6, p2] 4 times, C2F, p3, cast on 5 sts (for centre front band). *60 (64: 59: 59: 59: 59) sts.*

Row 22: [P1, k1] twice, p1, k3, [p2, k2, p6, k2] 4 times, p2, k2 (6: 1: 1: 1: 1), cast on 0 (0: 5: 3: 3: 3) sts. *60 (64: 64: 62: 62: 62) sts.*

1st, 2nd and 3rd sizes only
Row 23 (RS): P2 (6: 6), [C2F, p2, C6F, p2] 4 times, C2F, p3, [k1, p1] twice, k1.
Row 24: [P1, k1] twice, p1, k3, [p2, k2, p6, k2] 4 times, p2, k2 (6: 6), cast on 0 (0: 4) sts.
60 (64: 68) sts.
Row 25: P2 (6: 10), [C2F, p2, k6, p2] 4 times, C2F, p3, [k1, p1] twice, k1.
Row 26: [P1, k1] twice, p1, k3, [p2, k2, p6, k2] 4 times, p2, k2 (6: 10).

4th, 5th and 6th sizes only
Row 23 (RS): K2, [p2, C2F, p2, C6F] 4 times, p2, C2F, p3, [k1, p1] twice, k1.
Row 24: [P1, k1] twice, p1, k3, [p2, k2, p6, k2] 4 times, p2, k2, p2, cast on 5 sts.
– (–: –: 67: 67: 67) sts.
Row 25: P1, k6, [p2, C2F, p2, k6] 4 times, p2, C2F, p3, [k1, p1] twice, k1.
Row 26: [P1, k1] twice, p1, k3, [p2, k2, p6, k2] 4 times, p2, k2, p6, k1, cast on 5 sts. *– (–: –: 72: 72: 72) sts.*
Row 27: [P2, C2F, p2, k6] 5 times, p2, C2F, p3, [k1, p1] twice, k1.
Row 28: [P1, k1] twice, p1, k3,

[p2, k2, p6, k2] 5 times, p2, k2, cast on – (–: –: 0: 4: 8) sts.
– (–: –: 72: 76: 80) sts.
Row 29: P – (–: –: 2: 6: 10), [C2F, p2, C6F, p2] 5 times, C2F, p3, [k1, p1] twice, k1.
Row 30: [P1, k1] twice, p1, k3, [p2, k2, p6, k2] 5 times, p2, k
– (–: –: 2: 6: 10).

All sizes
This sets patt, with 5-st k1, p1 rib at centre front edge, 5 (5: 5: 6: 6) C2F cables (crossed on every RS row), 4 (4: 4: 5: 5: 5) C6F cable panels (crossed on every 6th row), and 2 (6: 10: 2: 6: 10) sts in rev st st at side-seam edge.
There are *60 (64: 68: 72: 76: 80) sts* and RS is facing for next row.
Side-seam shaping
**Keeping to patt as set throughout, work 2 (2: 6: 6: 6: 6) rows in patt, ending with RS facing for next row. Inc 1 st at beg (side-seam edge) of next row, then at same edge on every foll 6th row 12 times, taking all inc sts into rev st st, ending with WS facing for next row.
*73 (77: 81: 85: 89: 93) sts.***
Work without shaping for 5 rows, ending with RS facing for next row.

Neck, armhole and shoulder shaping
1st and 2nd sizes only
Next row (RS): Cast off (US bind off) 5 sts (at armhole edge), patt to last 8 sts, p2tog, p1, slip rem 5 sts onto a safety pin. *62 (66) sts.*
Work without shaping for 1 row.
To shape armhole, cast off (US bind off) 4 sts at beg of next row, 3 sts at beg of foll alt row, 2 sts at beg of foll 2 alt rows, then dec 1 st at beg of foll 2 alt rows, **and at the same time** beg shaping V-neck by dec 1 st at end (neck edge) of next row and at neck edge on every foll alt row 5 times, ending with WS facing for next row. *43 (47) sts.*
Work without shaping for 1 row.
***Keeping armhole edge straight, dec 1 st at neck edge on next row, then at same edge on every foll alt row twice, then on every foll 3rd row 15 times. *25 (29) sts.*
Work without shaping for 2 rows, ending with RS facing for next row.***
Next row (RS): Cast off (US bind off) 5 (9) sts, patt to last 2 sts, work last 2 sts tog. *19 sts.*
Work without shaping for 1 row.

Cast off (US bind off) 9 sts at beg of next row. *10 sts.*

Dec 1 st at beg of next row.

Cast off (US bind off) rem 9 sts.

3rd, 4th, 5th and 6th sizes only

Next row (RS): Patt to last 8 sts, p2tog, p1, slip rem 5 sts onto a safety pin. – *(–: 75: 79: 83: 87) sts.*

Work without shaping for 1 row.

Dec 1 st at end (neck edge) of next row, then at same edge on every foll alt row – (–: 0: 0: 1: 2) times. – *(–: 74: 78: 81: 84) sts.*

Work without shaping for 1 row.

To shape armhole, cast off (US bind off) 5 sts at beg of next row, 4 sts at beg of foll alt row, 3 sts at beg of foll alt row, 2 sts at beg of foll 2 alt rows, then dec 1 st at beg of foll 2 alt rows, **and at the same time** cont shaping V-neck by dec 1 st at end (neck edge) of next row and on every foll alt row - (-: 6: 6: 6: 5) times, ending with WS facing for next row. – *(–: 49: 53: 56: 60) sts.*

Work without shaping for – (–: 1: 1: 2: 0) rows.

Keeping armhole edge straight, dec 1 st at neck edge on next row and every foll 3rd row – (–: 17: 19: 19: 19) times. – *(–: 31: 33: 36: 40) sts.*

3rd size only

Work without shaping for 2 rows, ending at armhole edge.

Next row (RS): Cast off (US bind off) 9 sts, patt to last 2 sts, work last 2 sts tog. *21 sts.*

Work without shaping for 1 row.

Cast off (US bind off) 10 sts.

Cast off (US bind off) rem 11 sts.

4th, 5th and 6th sizes only

Work without shaping for – (–: –: 0: 1: 5) rows, ending at armhole edge.

Cast off (US bind off) – (–: –: 11: 12: 13) sts at beg of next row and foll alt row.

Cast off rem (US bind off) – (–: –: 11: 12: 14) sts.

Right front

Using 3.25mm (US size 3) needles, cast on 4 sts.

Row 1 (RS): K4.

Row 2: P4, cast on 2 sts. *6 sts.*

Row 3: P1, k5, cast on 3 sts. *9 sts.*

Row 4: K2, p6, k1, cast on 2 sts. *11 sts.*

Row 5: K1, p2, C6F, p2, cast on 3 sts. *14 sts.*

Row 6: K1, p2, k2, p6, k2, p1, cast on 2 sts. *16 sts.*

Row 7: P1, C2F, p2, k6, p2, C2F,

p1, cast on 3 sts. *19 sts.*

Row 8: [P2, k2] twice, p6, k2, p2, k1, cast on 2 sts. *21 sts.*

Row 9: K1, p2, C2F, p2, k6, p2, C2F, p2, k2, cast on 3 sts. *24 sts.*

Row 10: P5, k2, p2, k2, p6, k2, p2, k2, p1, cast on 2 sts. *26 sts.*

Row 11: K3, p2, C2F, p2, C6F, p2, C2F, p2, k5, cast on 3 sts. *29 sts.*

Row 12: [K2, p6, k2, p2] twice, k2, p3, cast on 2 sts. *31 sts.*

Row 13: K5, [p2, C2F, p2, k6] twice, p2, cast on 3 sts. *34 sts.*

Row 14: K1, [p2, k2, p6, k2] twice, p2, k2, p5, cast on 2 sts. *36 sts.*

Row 15: P1, [k6, p2, C2F, p2] twice, k6, p2, C2F, p1, cast on 3 sts. *39 sts.*

Row 16: P2, [k2, p2, k2, p6] 3 times, k1, cast on 2 sts. *41 sts.*

Row 17: K1, [p2, C6F, p2, C2F] 3 times, p2, k2, cast on 3 sts. *44 sts.*

Row 18: P5, [k2, p2, k2, p6] 3 times, k2, p1, cast on 2 sts. *46 sts.*

Row 19: P1, [C2F, p2, k6, p2] 3 times, C2F, p2, k5, cast on 3 sts. *49 sts.*

Row 20: [K2, p6, k2, p2] 4 times, k1, cast on 2 sts. *51 sts.*

Row 21: P3, [C2F, p2, k6, p2] 4 times, cast on 4 (8: 3: 3: 3: 3) sts.

55 (59: 54: 54: 54: 54) sts.

Row 22: K2 (6: 1: 1: 1: 1), [p2, k2, p6, k2] 4 times, p2, k3, cast on 5 sts (for centre front band).
60 (64: 59: 59: 59: 59) sts.

Row 23: [K1, p1] twice, k1, p3, [C2F, p2, C6F, p2] 4 times, C2F, p2 (6: 1: 1: 1: 1), cast on 0 (0: 5: 3: 3: 3) sts. *60 (64: 64: 62: 62: 62) sts.*

1st, 2nd and 3rd sizes only
Row 24 (WS): K2 (6: 6), [p2, k2, p6, k2] 4 times, p2, k3, [p1, k1] twice, p1.
Row 25: [K1, p1] twice, k1, p3, [C2F, p2, k6, p2] 4 times, C2F, p2 (6: 6), cast on 0 (0: 4) sts. *60 (64: 68) sts.*
Row 26: K2 (6: 10), [p2, k2, p6, k2] 4 times, p2, k3, [p1, k1] twice, p1.

4th, 5th and 6th sizes only
Row 24 (WS): P2, [k2, p2, k2, p6] 4 times, k2, p2, k3, [p1, k1] twice, p1.
Row 25: [K1, p1] twice, k1, p3, [C2F, p2, k6, p2] 4 times, C2F, p2, k2, cast on 5 sts.
– (–: –: 67: 67: 67) sts.
Row 26: K1, [p6, k2, p2, k2] 4 times, p6, k2, p2, k3, [p1, k1] twice, p1.
Row 27: [K1, p1] twice, k1, p3, [C2F, p2, k6, p2] 4 times, C2F, p2, k6, p1, cast on 5 sts.
– (–: –: 72: 72: 72) sts.

Row 28: [K2, p2, k2, p6] 5 times, k2, p2, k3, [p1, k1] twice, p1.
Row 29: [K1, p1] twice, k1, p3, [C2F, p2, C6F, p2] 5 times, C2F, p2, cast on – (–: –: 0: 4: 8) sts.
– (–: –: 72: 76: 80) sts.
Row 30: K – (–: –: 2: 6: 10), [p2, k2, p6, k2] 5 times, p2, k3, [p1, k1] twice, p1.

All sizes
This sets patt, with 5-st k1, p1 rib at centre front edge, 5 (5: 5: 6: 6) C2F cables (crossed on every RS row), 4 (4: 4: 5: 5: 5) C6F cable panels (crossed on every 6th row), and 2 (6: 10: 2: 6: 10) sts in rev st st at side-seam edge.
There are *60 (64: 68: 72: 76: 80) sts* and RS is facing for next row.
Side-seam shaping
Work as for left front from ** to **.
Work without shaping for 6 rows, ending with WS facing for next row.
Neck, armhole and shoulder shaping
1st and 2nd sizes only
Next row (WS): Cast off (US bind off) 5 sts (at armhole edge), patt to last 8 sts, k2tog, k1, slip rem 5 sts onto a safety pin. *62 (66) sts.*
To beg V-neck shaping, dec 1 st at

beg of next row (neck edge) and at neck edge on every foll alt row 5 times, **and at the same time** shape armhole by casting off (US binding off) 4 sts at beg of foll alt row, 3 sts at beg of foll alt row, 2 sts at beg of foll 2 alt rows, then dec 1 st at armhole edge of foll 2 alt rows, ending with RS facing for next row. *43 (47) sts.*
Work as for left front from *** to ***.
Dec 1 st at beg of next row.
24 (28) sts.
Cast off (US bind off) 5 (9) sts at beg of next row. *19 sts.*
Work without shaping for 1 row.
Next row (WS): Cast off (US bind off) 9 sts, patt to last 2 sts, work last 2 sts tog.
Cast off (US bind off) rem 9 sts.

3rd, 4th, 5th and 6th sizes only
Next row (WS): Patt to last 8 sts, k2tog, k1, slip rem 5 sts onto a safety pin. *– (–: 75: 89: 83: 87) sts.*
Dec 1 st at end (neck edge) of next row, then at same edge on every foll alt row – (–: 1: 1: 2: 3) times.
– (–: 73: 77: 80: 83) sts.
Work without shaping for 1 row.
To shape armhole, cast off (US bind off) 5 sts at beg of next row, 4 sts at

230

beg of foll alt row, 3 sts at beg of foll alt row, 2 sts at beg of foll 2 alt rows, then dec 1 st at beg of foll 2 alt rows, and **at the same time** cont shaping V-neck by dec 1 st at beg (neck edge) of every foll alt row – (–: 7: 7: 6: 5) times, and every foll 3rd row – (–: 0: 0: 0: 1) time. – (–: 48: 52: 56: 59) sts.
Work without shaping – (–: 2: 2: 1: 2) rows.
Keeping armhole edge straight, dec 1 st at neck edge on next row and every foll 3rd row – (–: 17: 18: 19: 18) times. – (–: 30: 33: 36: 40) sts.
Work without shaping for – (–: 0: 1: 2: 6) rows, ending at armhole edge.
Cast off (US bind off) – (–: 9: 11: 12: 13) sts at beg of next row and – (–: 10: 11: 12: 13) sts at beg of foll alt row.
Cast off (US bind off) rem – (–: 11: 11: 12: 14) sts.

To finish
Weave in any loose yarn ends.
Sew both shoulder seams.
Front lapel and collar
Using 3.25mm (US size 3) needles and with RS of work facing, rejoin yarn to one set of 5 sts left on safety pin and working in rib as set, inc 1 st at inside edge on next and every foll

alt row until there are 30 sts, ending at straight edge.
Cast off (US bind off) first 16 sts, return st on right-hand needle to left-hand needle and cast on 16 sts, rib to end.
Work without shaping until collar fits without stretching to centre back neck.
Cast off (US bind off) in rib.
Work other side to match, reversing all shaping.

Picot edgings
Using 3mm (US size 2) circular needle and with RS facing, pick up and k 125 (125: 131: 137: 143: 149) sts evenly along edge of armhole.
Work picot edging as foll:
Row 1 (WS): Cast off (US bind off) 3 sts, *slip st on right-hand needle back onto left-hand needle and use to cast on 2 sts using knit cast-on, cast off (US bind off) 5 sts; rep from * to end.
Fasten off.
Sew side seams.
Work picot edging around lower edge as foll:
Using 3mm (US size 2) circular needle with RS facing, pick up and k 4 sts along left front band, 30 sts along left front slope, 40 (44: 50: 54: 60: 64) sts along other side of left

front slope, 106 (112: 118: 124: 130: 136) sts across back, 40 (44: 50: 54: 60: 64) sts along right front slope, 30 sts along other right front slope, and 4 sts along right front band.
254 (268: 286: 300: 318: 332) sts.
Work picot edging as for armhole edging.
Fasten off.
Sew press studs (US snaps) evenly spaced along front edge to start of V-neck shaping.
Sew a button on top of each press stud (US snap).

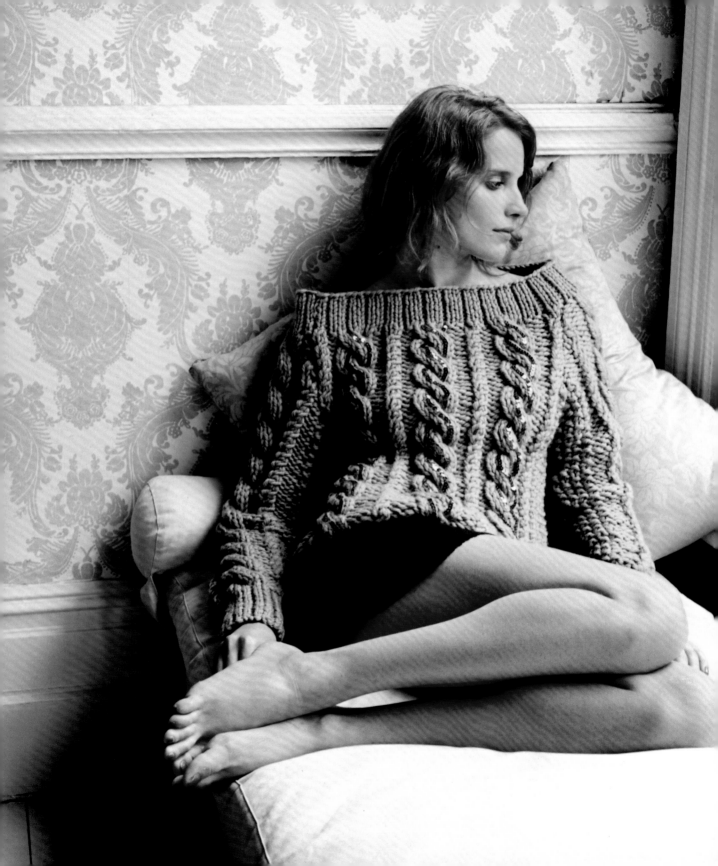

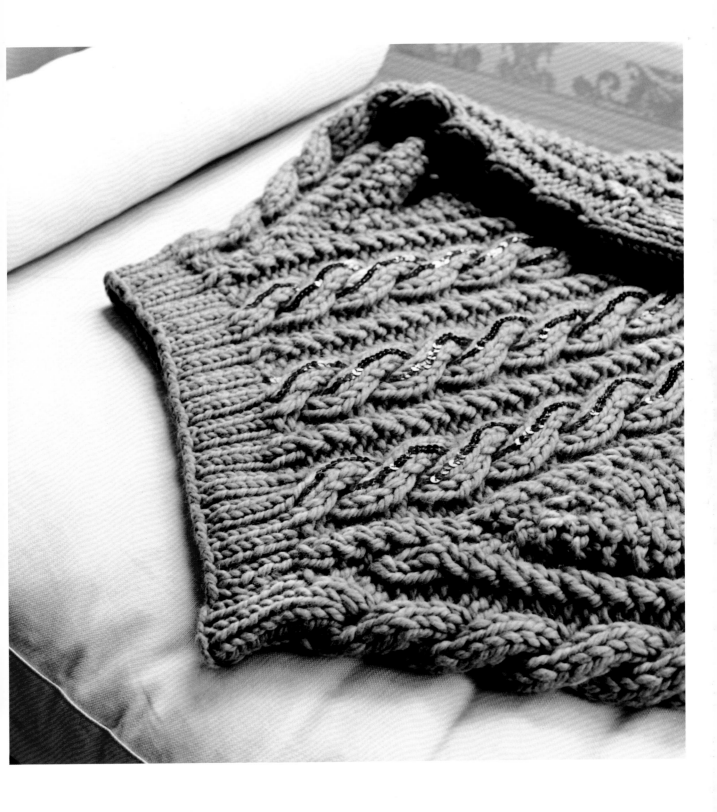

cable sweater

materials

Any super-chunky/bulky-weight wool yarn, such as Erika Knight
Maxi Wool
 8 (8: 9: 10: 11: 11) x 100g (3½oz) balls
Pair each of 8mm (US size 11) and 12mm (US size 17) knitting needles
Cable needle
Approximately 5m (5½yds) of sequin trimming (optional)

sizes

to fit bust	81	86	91	97	102	107	cm
	32	34	36	38	40	42	in

knitted measurements

around bust	86.5	91.5	101.5	106.5	112	122	cm
	34	36	40	42	44	48	in
length	43	46	48	51	53.5	56	cm
	17	18	19	20	21	22	in
sleeve seam	43	44.5	44.5	46	46	47	cm
	17	17½	17½	18	18	18½	in

tension (gauge)

8 sts and 12 rows to 10cm (4in) over st st using 12mm (US size 17)
 needles or whatever size necessary to obtain tension (US gauge).

special abbreviations

C2F (cable 2 front) = slip next st onto cn and leave at front of work,
 k1, k1 from cn.

C6F (cable 6 front) = slip next 3 sts onto cn and leave at front of
work, k3, k3 from cn.

moss stitch (US seed stitch)

(worked over a multiple of 2 sts plus 1 st)
Row 1: K1, *p1, k1; rep from * to end.
Rep this row.

pattern notes

- Remember to adjust moss stitch (US seed stitch) when increasing.
- It is easier to attach lengths of sequins with a simple overcast stitch, catching behind the sequins to secure rather than sewing through the holes.

Back
Using 8mm (US size 11) needles, cast on 48 (52: 56: 60: 64: 68) sts.
Work 3 rows k1, p1 rib.
Change to 12mm (US size 17) needles and work as foll:

1st, 2nd, 3rd and 4th sizes only
Row 1 (RS): Moss st (US seed st) 3 (5: 7: 9: –: –), [p2, k2, p2, k6] 3 times, p2, k2, p2, moss st (US seed st) 3 (5: 7: 9: –: –).
Row 2: Moss st (US seed st) 3 (5: 7: 9: –: –), [k2, p2, k2, p6] 3 times, k2, p2, k2, moss st (US seed st) 3 (5: 7: 9: –: –).
Row 3: Moss st (US seed st) 3 (5: 7: 9: –: –), [p2, C2F, p2, k6] 3 times, p2, C2F, p2, moss st (US seed st) 3 (5: 7: 9: –: –).

Row 4: Rep row 2.
Row 5: Moss st (US seed st) 3 (5: 7: 9: –: –), [p2, C2F, p2, C6F] 3 times, p2, C2F, p2, moss st (US seed st) 3 (5: 7: 9: –: –).

5th and 6th sizes only
Row 1 (RS): Moss st (US seed st) – (–: –: –: 7: 9), [p2, k2] twice, [p2, k6, p2, k2] 3 times, p2, k2, p2, moss st (US seed st) – (–: –: –: 7: 9).
Row 2: Moss st (US seed st) – (–: –: –: 7: 9), [k2, p2] twice, [k2, p6, k2, p2] 3 times, k2, p2, k2, moss st (US seed st) – (–: –: –: 7: 9).
Row 3: Moss st (US seed st) – (–: –: –: 7: 9), [p2, C2F] twice, [p2, k6, p2, C2F] 3 times, p2, C2F, p2, moss st (US seed st) – (–: –: –: 7: 9).
Row 4: Rep row 2.

Row 5: Moss st (US seed st) – (–: –: –: 7: 9), [p2, C2F] twice, [p2, C6F, p2, C2F] 3 times, p2, C2F, p2, moss st (US seed st) – (–: –: –: 7: 9).
All sizes
Row 6: Rep row 2.
Row 7: Rep row 3.
Row 8: Rep row 2.
Rep rows 3–8 until back measures 29 (31: 33: 35: 37: 39)cm/11½ (12: 13: 14: 14½: 15)in from cast-on edge, ending with RS facing for next row.
Shape armholes
Keeping patt correct as set throughout, cast off 2 sts at beg of next 2 rows.
Dec 1 st at each end of next 4 (4: 4: 6: 6: 6) rows.

36 (40: 44: 44: 48: 52) *sts.*
Work without shaping for 10 (12: 14:
14: 16: 16) rows.
Cast off (US bind off) loosely.

Front
Work exactly as for back.

Sleeves (make 2)
Using 8mm (US size 11) needles, cast
on 24 (24: 27: 27: 30: 30) sts.
Row 1 (RS): *K2, p1; rep from *
to end.
Row 2: *K1, p2; rep from * to end.
Rep rows 1 and 2 until sleeve
measures 8cm (3½in) from cast-on
edge, ending with WS facing for
next row.
Next row (WS): Rib as set, inc at
end of row on 3rd and 4th sizes and
each end of row on 5th and 6th sizes.
24 (24: 28: 28: 32: 32) sts.
Change to 12mm (US size 17)
needles.
Work in patt as foll **and at the same
time** inc 1 st at each end of 5th and
every foll 14th (14th: 14th: 14th: 14th:
16th) row until there are 30 (30: 34:
34: 38: 38) sts, taking inc sts into moss
st (US seed st).
Row 1 (RS): Moss st (US seed st) 3 (3:
5: 5: 7: 7), p2, k2, p2, k6, p2, k2, p2,
moss st (US seed st) 3 (3: 5: 5: 7: 7).
Row 2: Moss st (US seed st) 3 (3: 5: 5:
7: 7), k2, p2, k2, p6, k2, p2, k2, moss
st (US seed st) 3 (3: 5: 5: 7: 7).
Row 3: Moss st (US seed st) 3 (3: 5:
5: 7: 7), p2, C2F, p2, k6, p2, C2F, p2,
moss st (US seed st) 3 (3: 5: 5: 7: 7).
Row 4: Rep row 2.
Row 5: Work as for row 3 but inc at
each end and working C6F instead
of k6.
Row 6: Work as for row 2 but with 1
extra moss st (US seed st) at each end.
Row 7: Work as for row 3 but with 1
extra moss st (US seed st) at each end.
Row 8: Work as for row 2 but with 1
extra moss st (US seed st) at each end.
Rep rows 3–8 until sleeve measures
43 (44.5: 44.5: 46: 46: 47)cm/
17 (17½: 17½: 18: 18: 18½)in from
cast-on edge, ending with RS facing
for next row.
Shape cap
Keeping patt correct as set
throughout, cast off (US bind off) 2 sts
at beg of next 2 rows.
26 (26: 30: 30: 34: 34) sts.
Dec 1 st at each end of next and
every foll alt row until 8 (10: 12: 10:
12: 11) sts rem.
Work 1 row.
Cast off (US bind off).

To finish
Weave in any loose yarn ends.
Lay work out flat and gently steam.
Sew sleeves into armholes, leaving left
back armhole seam open.
Neckband
Using 8mm (US size 11) needles and
with RS facing, pick up and k 8 (10:
12: 10: 12: 12) sts across top of sleeve,
36 (40: 44: 44: 48: 52) sts across front,
8 (10: 12: 10: 12: 12) sts across top of
sleeve, and 36 (40: 44: 44: 48: 52) sts
across back.
88 (100: 112: 108: 120: 128) sts.
Row 1: *P2, k1; rep from * to last
1 (1: 1: 0: 0: 2) sts, p1 (1: 1: 0: 0: 2).
Row 2: K1 (1: 1: 0: 0: 2), *p1, k2; rep
from * to end.
Rep last 2 rows until rib measures
6 (6: 6: 8: 8: 8)cm/2½ (2½: 2½: 3¼:
3¼: 3¼)in.
Cast off (US bind off) loosely.
Sew left back armhole seam.
Sew side and sleeve seams.
Cut sequin trimming into
approximately 65cm (25in) lengths
and sew to cable, weaving under
and over following curve of cable
and overcasting stitching in place by
catching in behind sequins.

recommended yarns

Although I have recommended specific yarn for each of the projects in the book, you can use substitutes if you like. A description of each of the yarns used is given here.

If you decide to use an alternative yarn, purchase a substitute that is as close as possible to the original in thickness, weight and texture so that it will work with the pattern instructions. Buy only one ball to start with, so you can test the effect. Calculate the number of balls you will need by meterage/yardage rather than by weight. The recommended knitting-needle size and knitting tension/gauge (measured over stocking/stockinette stitch) on the yarn labels are extra guides to the yarn thickness. Additionally, the yarns are listed according to the standard yarn-weight categories determined by the Craft Yarn Council of America (YarnStandards.com).

To obtain yarns, go to the websites below to find a mail-order stockist or store in your area. If a shade or yarn appears to have been suddenly discontinued, it is always worth checking at your preferred store or online site as you never know, they may still have it in stock!

For Erika Knight yarns used in book:
www.erikaknight.co.uk
www.johnlewis.co.uk
www.tbramsden.co.uk

For other yarns used in book:
www.debbieblissonline.com
www.knitrowan.co.uk
www.lanaknits.com
www.quinceandco.co.uk
www.tbramsden.co.uk
www.yeoman-yarns.co.uk

SUPER-FINE YARNS (6) SUPER FINE

This yarn-weight category includes UK 4ply-weight yarn and US sock, fingering and baby yarns.

Twilleys *Goldfingering*
80% viscose, 20% metallized polyester; 100m/108yds per 25g/⅞oz ball; 28–33 sts & 36–44 rows per 10cm/4in over st st using 3–3.25mm (US size 3) needles.

Yeoman *Cannele 4ply*
100% mercerized cotton; 850m/930yds per 245g/8⅝oz cone; 28–33 sts & 36–44 rows per 10cm/4in over st st using 3–3.25mm (US size 2–3) needles.

FINE-WEIGHT YARNS (2) FINE

This yarn-weight category includes UK yarns berween 4ply and double-knitting weights and US sport and baby yarns.

Rowan *Cotton Glacé*
100% mercerized cotton; 115m/126yds per 50g/1¾oz ball; 23 sts & 32 rows per 10cm/4in over st st using 3.25 (US size 3) needles.

Rowan *Kidsilk Haze*
70% super kid mohair, 30% silk; 210m/229yds per 25g/⅞oz ball; 18–25 sts & 23–34 rows per 10cm/4in over st st using 3.25–5mm (US size 3–8) needles.

LIGHTWEIGHT YARNS (3) LIGHT

This yarn-weight category includes UK double knitting (DK) yarn and US light worsted yarn.

Debbie Bliss *Luxury Silk DK*
100% mulberry silk; 100m/109yds per 50g/1¾oz ball; 22 sts & 30 rows per 10cm/4in over st st using 3.75mm (US size 5) needles.

Debbie Bliss *Rialto DK*
100% extra-fine merino wool; 105m/115yds per 50g/1¾oz ball; 22 sts & 30 rows per 10cm/4in over st st using 4mm (US size 6) needles.

Erika Knight *British Blue Wool*
100% Blue-Faced Leicester wool; 55m/60yds per 25g/⅞oz ball; 22 sts & 30 rows per 10cm/4in over st st using 4mm (US size 6) needles.

Erika Knight for John Lewis *Double Knit*
100% wool; 110m/120yds per 50g/1¾oz ball; 22 sts & 28 rows per 10cm/4in over st st using 3.75–4mm (US size 5–6) needles.

Lanaknits *Allhemp6*
100% mercerized hemp; 150m/165yds per 100g/3½oz skein; 22 sts to 10cm/4in over st st using 3.75mm (US size 5) needles.

Rowan *Alpaca Merino DK*
83% alpaca, 10% nylon, 7% wool; 105m/115yds per 25g/⅞oz ball; 22 sts & 30 rows per 10cm/4in over st st using 4.5mm (US size 7) needles.

Rowan *Creative Linen*
50% linen, 50% cotton; 200m/219yds per 100g/3½oz skein; 21 sts & 28 rows per 10cm/4in over st st using 4.5mm (US size 7) needles.

Rowan *Superfine Merino DK*
100% extra-fine merino wool; 115m/125yds per 50g/1¾oz ball; 22 sts & 30 rows per 10cm/4in over st st using 4mm (US size 6) needles.

Rowan *Truesilk*
100% mulberry silk; 150m/164yds per 50g/1¾oz ball; 23 sts & 32 rows per 10cm/4in over st st using 4mm (US size 6) needles.

Rowan *Wool Cotton*
50% wool, 50% cotton; 113m/124yds per 50g/1¾oz ball; 22–24 sts & 30–32 rows per 10cm/4in over st st using 3.25–4mm (US size 3–6) needles.

Wendy *Supreme Luxury Cotton DK*
100% mercerized cotton; 201m/220yds per 100g/3½oz ball; 22 sts & 31 rows per 10cm/4in over st st using 3.25–4mm (US size 3–6) needles.

MEDIUM-WEIGHT YARNS (4) MEDIUM

This yarn-weight category includes UK aran-weight yarn and US worsted and afghan yarns.

Erika Knight for John Lewis *Aran*
100% wool; 160m/175yds per 100g/3½oz ball; 18 sts & 24 rows per 10cm/4in over st st using 5–5.5mm (US size 8–9) needles.

Erika Knight *Vintage Wool*
100% pure British wool; 87m/95yds per 50g/1¾oz skein; 18 sts & 24 rows per 10cm/4in over st st using 5mm (US size 8) needles.

Rowan *Felted Tweed Aran*
50% merino wool, 25% alpaca, 25% viscose; 87m/95yds per 50g/1¾oz ball; 16 sts & 23 rows per 10cm/4in over st st using 5mm (US size 8) needles.

Rowan *Hemp Tweed*
75% wool, 25% true hemp; 95m/104yds per 50g/1¾oz ball; 19 sts & 25 rows per 10cm/4in over st st using 4.5mm (US size 7) needles.

Rowan *Lima*
84% baby alpaca, 8% merino wool, 8% nylon; 110m/120yds per 50g/1¾oz ball; 20 sts & 26 rows per 10cm/4in over st st using 5.5mm (US size 9) needles.

Rowan *Super Fine Merino Aran*
100% extra-fine merino wool; 85m/93yds per 50g/1¾oz ball; 19 sts & 25 rows per 10cm/4in over st st using 4.5mm (US size 7) needles.

CHUNKY/BULKY YARNS (5) BULKY

This yarn-weight category includes chunky/bulky, craft and rug yarns.

Debbie Bliss *Rialto Chunky*
100% extra-fine merino wool; 60m/65yds per 50g/1¾oz ball; 15 sts & 21 rows per 10cm/4in over st st using 6.5mm (US size 10½) needles

Erika Knight for John Lewis *Chunky*
100% wool; 115m/125yds per 100g/3½oz ball; 14 sts & 16 rows per 10cm/4in over st st using 7mm (US size 10½) needles.

SUPER-CHUNKY/BULKY YARNS
SUPER BULKY

This yarn-weight category includes UK super-chunky yarn and US super-bulky yarn.

Erika Knight for John Lewis *Super Chunky*
100% wool; 75m/82yds per 100g/3½oz ball; 10 sts & 11 rows per 10cm/4in over st st using 10–12mm (US size 15–17) needles.

Erika Knight *Maxi Wool*
100% pure British wool; 80m/87yds per 100g/3½oz hank/ skein; 8 sts & 12 rows per 10cm/4in over st st using 12mm (US size 17) needles.

Quince & Co *Puffin*
100% American wool; 102m/112yds per100g/3½oz skein; 10–12 sts per 10cm/4in over st st using 6.5–9mm (US size 10½–13) needles.

abbreviations

The following are the abbreviations used in this book. Any special abbreviations are given with individual patterns. Note that the patterns are written with UK terminology and where this differs from US terminology the US equivalent follows inside parentheses.

alt	alternate
beg	begin(ning)
cn	cable needle)
cont	continu(e)(ing)
dec	decreas(e)(ing)
garter st	garter stitch (k every row)
foll	follow(s)(ing)
inc	increas(e)(ing)
k	knit
m1	make one—pick up horizontal strand between st just knit and next st with tip of left needle and work into back of it (to increase one st)
p	purl
patt	pattern; or work in pattern
psso	pass slipped stitch over
rem	remain(s)(ing)
rep	repeat(s)(ing)
rev st st	reverse stocking (US stockinette) stitch—p all RS rows, k all WS rows
RS	right side(s)
sl	slip
st(s)	stitch(es)
st st	stocking (US stockinette) stitch—k all RS rows, p all WS rows
tbl	through back of loop(s)
tog	together
WS	wrong side(s)
yfwd	yarn forward and over right needle to make a new stitch (US yo)
yfrn	yarn forward and around right needle to front again to make a new stitch (US yo)
yon	yarn over right needle to make a new stitch (US yo)
yrn	yarn around right needle and to front again to make a new stitch (US yo)
[] *	Repeat instructions between brackets, or after or between asterisks, as many times as instructed.

acknowledgements

My personal thanks and appreciation just have to go to the exceptional people who have collaborated to create this book.

It is a priviledge to work with Quadrille Publishing, a publisher of style and insight, who consistently push the boundary. Alison Cathie for exciting company and team, most especially my Editorial Director and mentor, Jane O'Shea, whose vision, encouragement and style have nurtured my career as an author. Creative Director, Helen Lewis, for her exacting innovation for each new project. Lisa Pendreigh, project manager, whose rigorous support and inimitable professionalism is without equal and Claire Peters who has brought a new vitality to the design.

It has been simply fantastic to have Katya de Grunwald photograph this collection; her exceptional and distinctive vision, together with Beth Dadswell's unique and inspirational styling, continually surprise, delight and surpass all my expectations.

My immense appreciation goes to Sally Lee for her contribution; my amazing creative practitioner for her ready support, enthusiasm, expertise and friendship. To Mary Potter and Christine Dilley for their superb work, and also Hilary Jagger, a craft designer of rare and exceptional calibre. My heartfelt thanks to Rosy Tucker; her diligence and meticulous hard work in checking all the patterns is invaluable.

Special thanks to Stephen Sheard of Coats Craft UK, as well as Kate Buller and the team at Rowan Yarns. Tony Brooks of Yeoman Yarns, Debbie Bliss and Designer Yarns and Lana Hames of Lanaknits for primarily creating yarns of the highest quality but invaluably for their generosity in contributing both yarns and enthusiastic support for this project.

Finally, this book is dedicated to the 'creative spirit' – that power that makes us go beyond the ordinary, the purely practical, to adorn and decorate and make something our own.